The Borgias

and

Their Enemies

1431–1519

CHRISTOPHER HIBBERT

The Borgias

and
Their Enemies
1431–1519

Mariner Books / Houghton Mifflin Harcourt

BOSTON NEW YORK

First Mariner Books edition 2009
Copyright © 2008 by Christopher Hibbert and Mary Hollingsworth

For information about permission to reproduce selections from this book,
write to Permissions, Houghton Mifflin Harcourt Publishing Company,
215 Park Avenue South, New York, New York 10003.

www.hmhbooks.com

Library of Congress Cataloging-in-Publication Data
Hibbert, Christopher, 1924–
The Borgias and their enemies: 1431–1519/Christopher Hibbert.—1st ed.
 p. cm.
Includes bibliographical references and index.
1. Borgia family. 2. Italy—History—15th century. 3. Italy—History—
1492–1559. 4. Nobility—Italy—Biography. I. Title.
DG463.8.B7H53 2008
945´.050922—dc22 2008003076
ISBN 978-0-15-101033-2
ISBN 978-0-547-24781-6 (pbk.)

Text set in Requiem Text
Designed by Lydia D'moch

Printed in the United States of America
DOC 10 9 8 7 6

~ Contents ~

CHAPTER 22 Castles and Condottieri 221

CHAPTER 23 The Death of the Pope 244

CHAPTER 24 Conclaves 254

CHAPTER 25 Cesare at Bay 264

CHAPTER 26 Duchess of Ferrara 274

CHAPTER 27 The End of the Affair 290

CHAPTER 28 The Death of the Duchess 302

CHAPTER 29 Saints and Sinners 311

 Bibliography 315

 Index 321

The Borgias
and
Their Enemies
1431-1519

~ Chapter 1 ~

The Crumbling City

"OH GOD, HOW PITIABLE IS ROME"

"YOU MUST HAVE heard of this city from others," wrote a visitor to Rome in the middle of the fifteenth century.

> There are many splendid palaces, houses, tombs and temples here, and infinite numbers of other edifices, but they are all in ruins. There is much porphyry and marble from ancient buildings but every day these marbles are destroyed in a scandalous fashion by being burned to make lime. And what is modern is poor stuff. . . . The men of today, who call themselves Romans, are very different in bearing and conduct from the ancient inhabitants. . . . They all look like cowherds.

Other visitors wrote of moss-covered statues, of defaced and indecipherable inscriptions, of "parts within the walls that look like

thick woods or caves where forest animals were wont to breed, of deer and hares being caught in the streets . . . of the daily sight of heads and limbs of men who had been executed and quartered being nailed to doors, placed in cages or impaled on spears."

This was the state of the city that had once been the capital of a mighty empire; now two-thirds of the area inside the walls, which had been built to protect a population of 800,000, was uninhabited, acres of open countryside used for orchards, pasture, and vineyards, and dotted with ancient ruins, which provided safe hiding places for thieves and bandits. And this was the state of the true home of the pope, the leader of the church who could trace his predecessors back in an unbroken line to St. Peter, the apostle entrusted by Christ himself with the care of his flock.

For most of the fourteenth century, even the papacy had abandoned Rome. In 1305, distressed by the unrest and bloody disturbances in the city, the French Pope Clement V (1305–14) had set up his court in Avignon, in the rambling palace on the east bank of the Rhône, which is known as the Palais des Papes. In Rome there had been constant calls for the papacy to return from its French exile. Most recently these calls had come from an elderly woman, who could be seen almost every day in the crumbling city, sitting by the door of the convent of San Lorenzo, begging for alms for the poor.

She was Birgitta Gudmarsson, the daughter of a rich Swedish judge and widow of a Swedish nobleman, to whom she had been married at the age of thirteen and for whom she had borne eight children. Founder of the Brigittines, she had left Sweden after experiencing a vision in which Christ had appeared before her, commanding her to leave immediately for Rome and to remain there

until she had witnessed the pope's return. As she went about Rome, from church to crumbling church, house to ruinous house, she claimed to have had further visions; both Jesus and his mother Mary, she said, had spoken to her, and they had strengthened her faith in the restoration of the pope and in the eventual salvation of the city.

Around the house where she lived stretched the charred shells of burned-out buildings, piles of rotting refuse, deserted palaces, derelict churches, stagnant swamps, fortresses abandoned by their rich owners, who had gone to live on their estates in the Campagna, hovels occupied by families on the verge of starvation. Pilgrims took home with them stories of a gloomy city, whose silence was broken only by the howling of dogs and wolves, and the shouts of rampaging mobs.

In Avignon the popes remained deaf to the calls for their return, heedless of the prayers that the saintly Birgitta Gudmarsson uttered so fervently and of the letters that the poet Francesco Petrarch wrote, describing the "rubbish heap of history" that Rome had become. This once-superb imperial capital was now a lawless ruin, a city torn by violence in which belligerent factions paraded through the streets with daggers and swords, where houses were invaded and looted by armed bands, pilgrims and travellers were robbed, nuns violated in their convents, and long lines of flagellants filed through the gates, barefoot, their heads covered in cowls, claiming board and lodging but offering no money, scourging their naked bloody backs, chanting frightening hymns outside churches, throwing themselves weeping, moaning, bleeding before the altars.

Goats nibbled at the weeds growing up between the stones littering the piazzas and flourishing in the overgrown, rat-infested

ruins of the Campo Marzio; cattle grazed by the altars of roofless churches; robbers lurked in the narrow alleys; at night wolves fought with dogs beneath the walls of St. Peter's and dug up corpses in the nearby Campo Santo. "Oh God, how pitiable is Rome," an English visitor lamented, "once she was filled with great nobles and palaces, now with huts, wolves and vermin; and the Romans themselves tear each other to pieces."

In 1362, while Petrarch was urging the papacy to return to Rome, a sixth Frenchman was elected to the line of Avignon popes: the austere and unworldly Urban V. Encouraged by Emperor Charles IV, who offered to accompany him, he recognized the necessity of return, not only for the sake of the neglected and decaying city but also for the papacy itself, now in danger at Avignon, both from the mercenary bands roaming throughout western Europe as well as from the English, who were fighting the French in wars that were to last intermittently for a hundred years.

Five years after his election, Urban V travelled across the Alps, knelt in prayer before the grave of St. Peter, and took up residence in the stuffy, dismal rooms that had been prepared for him in the Vatican Palace. His visit to Rome, however, was brief. He found the city even more dilapidated and depressing than he had feared; and, feeling that he could undertake the role of mediator between England and France more effectively from Avignon than from Rome, he went back to France in 1370. Having ignored Birgitta Gudmarsson's warning that he would die if he abandoned the city, he then fulfilled her prophecy by expiring within just a few months of his return to the Palais des Papes.

It was his successor, Gregory XI, another Frenchman and the last of the Avignon popes, who finally moved the Curia back to

Rome, fearful that the Church and her estates in Italy would be lost to the papacy forever. He died there, however, in March 1378, little more than a year after his return, and his death provoked a papal election of extraordinary animosity. Terrified by the Roman mob, which had invaded the Vatican during the course of the conclave, the cardinals chose the Neapolitan Bartolomeo Prignano, who took the title of Urban VI. The French cardinals, however, refused to accept him, declaring the election invalid and electing their own candidate, a Frenchman, naturally, Clement VII. The Great Schism had begun; the lame and wall-eyed Clement VII returned to Avignon, while the rough and energetic Urban VI remained in Rome.

By now it was not just the sight of the city, little more than a decayed provincial town, that distressed visitors. Corruption was rife in the Church and shocked the pilgrims who came to Rome to receive indulgences, which were now being dispensed on an unprecedented scale. Abandoning in despair their attempts to form a strong and stable political state, the Romans allowed Urban VI's successor, the clever and avaricious Boniface IX, another Neapolitan, to assume full control of their city, to turn the Vatican as well as the enlarged Castel Sant'Angelo into fortified strongholds, and to appoint his relations and friends to positions of power and profit. On his death in 1404, fear of the powerful Kingdom of Naples led to the election of another pontiff known to be on good terms with the king: the ineffective Innocent VII from the Abruzzi, against whom the Romans roused themselves to revolt in a tragic uprising that was to end in humiliating retreat; and after the death of Innocent VII in 1406, the election of Gregory XII, a Venetian who seemed disposed to come to terms with the anti-pope

in Avignon, led to the invasion of Rome in 1413 by the king of
Naples, who was determined not to lose his influence by ending
the Great Schism.

Meanwhile, a fresh attempt had been started to end the schism,
which had divided Europe, by summoning a council of the Church
at Pisa. The council's solution was to charge both the Avignon and
Roman popes with heresy and to depose them. In their place the
council elected a cardinal from the island of Crete, Petros Philar-
gos, who took the title of Alexander V and who promptly ad-
journed the council, whose decision was, in any case, not recognized
by either of his rivals. There were now three popes instead of two,
each claiming legitimate descent from St. Peter and each of whom
excommunicated the others.

A second attempt to disentangle the imbroglio was now made by
Emperor Sigismund, who summoned another Church council at
Constance. By this time a new pope had appeared on the scene in
the unlikely person of Baldassare Cossa, successor of Alexander V,
the pope chosen at Pisa, whom he was widely supposed to have
murdered. Once a pirate and then a dissolute soldier, John XXIII
was sensual, unscrupulous, and extremely superstitious. He came
from an old Neapolitan family and established himself in Rome
with the help of a mutually suspicious alliance with the king of
Naples. On June 8, 1413, in breach of their understanding, the king
attacked Rome, driving the pope out of the city. John XXIII fled
with his court along the Via Cassia, beside which several prelates
died of exhaustion and the rest were robbed by their own mer-
cenaries. Yet again, the city behind them was plundered. The
Neapolitan soldiers, unchecked by their commander, set fire to
houses, looted the sacristy of St. Peter's, stabled their horses in this

ancient basilica, ransacked sanctuaries and churches, and sat down amid their loot with prostitutes, drinking wine from consecrated chalices.

John XXIII travelled to the council at Constance, where he found himself accused of all manner of crimes, including heresy, simony, tyranny, murder, and the seduction of some two hundred ladies of Bologna. After escaping from Constance in the guise of a soldier of fortune, he was recognized, betrayed, and brought back to face the council, which deposed both him and the Avignon pope and which, once the Germans and the English had united with the Italians to keep out the French, managed to elect a new pope, the Roman Martin V.

Martin V was a member of the Colonna family, one of the old baronial dynasties of Rome. When he returned to the city in 1420 under a purple baldachin, jesters danced before him and the people ran through the streets with flaming torches, shouting their welcome long into the night. He was to reign in Rome for over ten years, followed by two more Italians, Eugenius IV and Nicholas V. There was hope at last that a new age was dawning for the city.

Nicholas V, who had been elected in 1447, in appearance at least looked peculiarly unsuited for his role as the champion of this new age. Small, pale, and withered, he walked with stooped shoulders, his bright black eyes darting nervous glances around him. But no one doubted either his generosity or his kindliness, just as all those who knew him praised his piety and his learning: "He owed his distinction not to his birth," wrote one contemporary, "but to his erudition and intellectual qualities." They also praised his determination to reconcile the Church with the secular culture of the burgeoning Renaissance, sending his agents all over Europe and

beyond in his search for manuscripts of the literary and theoretical works of antiquity, many of which were preserved in monastic libraries, and then generously rewarding the humanist scholars who translated and copied these ancient texts.

The Rome of Nicholas V, however, was still a crumbling, dirty medieval city, bitterly cold in winter, when the *tramontana* blew across the frozen marshes, unhealthy in summer when malaria was rife. The inhabitants, a large proportion of them foreigners and many of the rest born outside the city, numbered no more than 40,000, less than a twentieth of the population that had lived in Rome in the days of Emperor Nero. The city was small also by the standards of the time—Florence had a population of 50,000, whereas Venice, one of the largest cities in Europe, could boast over 100,000 inhabitants. Rome, however, was the true heart of the Christian world, and those who made the long pilgrimage there each year provided the city with its one highly profitable trade.

At the beginning of 1449, Nicholas V proclaimed a Holy Year for 1450, and the surge of pilgrims who came to Rome to celebrate the Jubilee brought immense profits to the Church—not least from the sale of indulgences. So much money, in fact, that Nicholas V was able to deposit 100,000 golden sovereigns in the Medici bank and to continue confidently with his plans to restore the city. In the judgement of Enea Silvio Piccolomini, the cardinal of Siena, "he built magnificent edifices in his city, though he started more than he finished."

The focus of Nicholas V's new Christian capital was St. Peter's, the church built by Emperor Constantine over the tomb of the first pope and restored by Nicholas. He also moved his official residence from the Lateran to the Vatican Palace, and the influx of artists who

came to Rome to work on his projects was soon to make the city a leading centre for goldsmiths and silversmiths, as well as painters and sculptors. It also became home for a time to Fra Angelico, who decorated Nicholas V's lovely private chapel in the Vatican with scenes from the lives of two early Christian martyrs, St. Stephen and St. Laurence. This small and saintly Dominican friar knelt to pray before starting to paint each morning and was so overcome with emotion when painting Christ upon the Cross that tears poured down his cheeks.

~ Chapter 2 ~

Elections and Celebrations

"There was not a place where horns and trumpets did not sound"

Shortly after the death of Nicholas V, on March 24, 1455, there was held in Rome the annual ceremony of the Exposition of the Vernicle, the handkerchief that was alleged to have belonged to St. Veronica. Tradition had it that when she wiped the sweat from Christ's face on his way to Calvary, his features were miraculously impressed upon her handkerchief. A few days later those cardinals resident in Rome, and such others as had been able to reach the city in time, took part in the magnificent procession, accompanied by the papal choir intoning the hymn "Veni Creator Spiritus," from St. Peter's to the Vatican, where they would choose Nicholas V's successor. Trumpets sounded; drums were beaten; the cardinals entered the apartments where the conclave was to take place; the doors were locked; the entrances bricked up; and the discussions and arguments began.

Hour after hour the talks went on. Promises were made, veiled threats issued, bribes offered. Night fell and no decision was reached. No agreement was possible between the mutually antagonistic candidates supported by the rival Roman barons, the Colonna and Orsini families. Many hoped for the election of the elderly, frail John Bessarion, who suffered excruciatingly from kidney stones, a common complaint of the time. He was a distinguished theologian and humanist who had been brought up as a member of the Orthodox Church but had recently converted to Rome. "Shall we give the Latin Church to a Greek Pope?" asked one of the French cardinals in the conclave. "How can we be sure that his conversion is sincere?" he added. "Shall he be the leader of the Christian army?"

At length a compromise was proposed: it was decided to support the candidature of a man who would probably not live long. The names of two elderly candidates emerged in the discussions; both were considered unobjectionable, although both were unfortunately Spaniards and, therefore, not likely to prove a popular choice with the Roman people, notoriously hostile to the Catalans, as Spaniards were generally known. Of these two, the less objectionable was the modest and scholarly bishop of Valencia, and it was he who was eventually chosen to succeed Nicholas V.

Again the trumpets in the piazza of St. Peter's sounded; a cloud of smoke rose into the sky as a signal that the conclave had come to a conclusion, and it was greeted with shouts by the large crowd gathered there; the recently erected brickwork was knocked down. The doors opened and the dean of the college of cardinals appeared to announce the conclave's decision: "I proclaim to you great joy," he said, "we have a new pope, Lord Alfonso de Borja, Bishop of Valencia; he desires to be known as Calixtus the Third."

The Borjas, or Borgias as they were known in Italy, were a family of some consequence in Spain, descended, as they claimed, from the ancient royal House of Aragon. Alfonso, born in 1378, was the son of the owner of an estate at Játiva near Valencia; he had studied and then taught law at Lérida and, at the age of thirty-eight, had been appointed to the prestigious post of private secretary to King Alfonso V of Aragon, in whose service he was to remain for forty-two years. He helped to arrange the abdication of the anti-pope Clement VIII, thus paving the way for the ending of the Great Schism, and was given the bishopric of Valencia as a reward for his services. In 1442 he moved to Naples, still in the service of his king, who had conquered the city to become Alfonso I of Naples.

As the king's private secretary, he was closely involved in the negotiations to reconcile his master with Pope Eugenius IV, who rewarded Alfonso Borgia with a cardinal's hat and the splendid titular Church of Santi Quattro Coronati. By the time of the conclave of April 1455, he was living in Rome, an austere, modest, and increasingly gouty old man in his late seventies, in such poor health that it was doubted that he would survive the arduous ceremonies of his coronation. These involved a long service in St. Peter's during which he would receive from the cardinal archdeacon the Triple Crown and Cross, the Keys, and the Mantle of Jurisdiction. This coronation would be followed by a long procession to the Church of San Giovanni in Laterano, where, in another lengthy ceremony, the new pope would be enthroned as bishop of Rome.

The procession from St. Peter's to the Lateran, known as the *possesso*, was one of the most colourful and, to the Roman populace, exciting sights that the city had to offer. Vatican guards and choristers, preceded by falconers with their hawks and rat catchers with

dogs to clear the vermin from the low-lying land by the Tiber, marched along the streets, followed by the bearers of sweet-smelling herbs. Then came the officials of the government of Rome, the bishops and cardinals, and, finally, Pope Calixtus III himself, riding a saddle horse beneath a canopy of gold supported by dignitaries and escorted by lancers and foot soldiers, to keep at a distance the importunate crowds of sightseers.

Waiting as the procession approached Monte Giordano stood a rabbi together with a crowd of his fellow Jews, who, as custom dictated, offered the pope a bejewelled copy of the Torah, the book of the Jewish laws. Calixtus III accepted it, then threw it to the ground with the traditional words, "This is the law we know; but we do not accept your interpretation of it." As he spoke, a number of onlookers scrambled to take possession of the book beneath the palfrey and the horses of the guards.

By the steps of the Church of San Giovanni in Laterano, Calixtus III knelt down submissively, as his white-and-gold vestments were removed to be replaced by a black soutane. He raised his hands in a gesture of benediction as a fight broke out, as it so often did, between the rival supporters of the constantly feuding Orsini and Colonna families.

No sooner had he been elected, the new pope now set his heart upon the organization of a crusade that would free Constantinople from the grip of the Turks, who had captured the city in May 1453. "He vowed to focus all his efforts against the heretic Turks," wrote Enea Silvio Piccolomini, whom Calixtus III created the cardinal of Siena, "giving absolution for the sins of all who enlisted." The pope's determination surprised many; it was well known that he was suffering increasingly from painful attacks of gout, and it had

been expected that he would continue to live a quiet and pious life in the Vatican, rather than embark on such an ambitious venture.

Money was raised by the imposition of taxes and by the selling of works of art, including the precious book bindings that had been bought at such expense by Nicholas V; Calixtus III went so far as to pawn his own mitre and sent numerous preachers armed with indulgences all over Europe; he also put a stop to various works of restoration and rebuilding in Rome, which had been initiated by his predecessor.

Self-willed, parsimonious, and obstinate, Calixtus III would tolerate no opposition from those cardinals who were opposed to his bellicose ambitions, and in the end he raised enough funds to finance the building of galleys and to muster troops for the conduct of a holy war. Yet while his soldiers and sailors enjoyed some minor successes, including the defeat of a Turkish army outside Belgrade in July 1456 and the partial destruction of a Turkish fleet off Lesbos in August the following year, his ambitions were not shared by all the European powers, many of whom failed to contribute either money or men to the scheme. Moreover, the favours he bestowed upon his relations and his fellow Spaniards, the hated Catalans, had begun to cause widespread resentment in Rome.

Three of his nephews received special favour. Two were created cardinals before they were thirty years old, and Calixtus III appointed one of them, Rodrigo Borgia, to the post of vice-chancellor of the Holy See, the most influential office in the papal government. The third, Pedro Luis Borgia, elder brother of Rodrigo, was given the title Duke of Spoleto and appointed captain general of the church, prefect of Rome, and governor of Rome's great fortress, Castel Sant'Angelo.

Calixtus III's death on August 6, 1458—just three years after his elevation, in the small, dark bedchamber where ill health had obliged him to spend so much of his time—was greeted by riots in Rome, in protest against the detested Catalans whom he had so provocatively indulged. Once again the cardinals converged on Rome to play their part in a conclave at which, so it was hoped, a pope would be elected in whom the papacy and Rome, by now indissolubly interwoven, could take pride.

At this conclave the divisions within the college were greater than they had been three years earlier: "The richer and more important cardinals," as Enea Silvio Piccolomini, the cardinal of Siena, recalled, "made promises and threats, and some, shamelessly abandoning all vestiges of decency, pleaded their own cases for election." Guillaume d'Estouteville, the wealthy cardinal of Rouen, offered tempting prizes: "Not a few were won over by Rouen's grandiose promises, caught like flies by their greed," and they schemed all night in the communal lavatories, "being a secluded and private place."

Early the next morning, the cardinal of Siena went to visit the young Spaniard Rodrigo Borgia, the vice-chancellor, to ask him if he, too, was promised to Rouen. "What would you have me do?" responded Borgia, who had been assured by d'Estouteville that he would keep the lucrative post of vice-chancellor in return for his vote: "The election is certain." Piccolomini cautioned the twenty-seven-year-old Rodrigo: "You young fool, will you put faith in a man who is not to be trusted? You may have the promise but it is the Cardinal of Avignon who will have the post, for what has been promised to you has also been promised to him," he said, adding wisely, "Will a Frenchman be more friendly to a Frenchman or to a Catalan?"

The next day after Mass, the cardinals assembled in the papal chapel to cast their votes, and when they had written their choices on slips of paper, they rose, one by one, in order of rank, and walked across to the altar, where they placed their votes in the gilded ceremonial chalice. The voting over, the cardinals resumed their seats and the names on each ballot paper were solemnly read out. "There was not a cardinal in the room who did not take note of those named, to ensure that there was no chance for trickery." Much to everyone's surprise, it was found that Piccolomini had amassed nine votes, d'Estouteville had just six, and several others had one or two. As neither of the front-runners had achieved the necessary two-thirds majority, the cardinals decided to see if it would be possible to elect the new pope that morning by the method known as "accession."

"All sat in their places, silent and pale, as though they had been struck senseless. No one spoke for some time, no one so much as moved a muscle apart from his eyes which glanced first to one side, then to the other. The silence was astonishing. Suddenly the young Rodrigo Borgia stood up: 'I accede to the Cardinal of Siena,' he announced." But after this declaration, all fell into silence once more, until two cardinals, reluctant to commit themselves, hurriedly left the others, "pleading the calls of nature."

Then another cardinal rose to announce his support for Piccolomini. Yet even this did not secure the necessary two-thirds majority. One more vote was still required. No one spoke; no one moved. At length the aged Prospero Colonna rose unsteadily to his feet and "was about to pronounce his vote" for the cardinal of Siena when "he was seized about the waist" by the wily, ambitious

Frenchman Guillaume d'Estouteville, archbishop of Rouen, and by Cardinal Bessarion, who still entertained hopes of being elected himself. They rebuked Cardinal Colonna harshly; and when he persisted in his intention to vote for Piccolomini, they tried to remove him from the room by force. Provoked by this indignity, Colonna, who had voted for d'Estouteville in the scrutiny, now called out in loud protest, "I also accede to Siena and I make him Pope."

"Your Holiness, we are thankful for your election and we have no doubts that it is of God," Cardinal Bessarion equivocated, after the election had been ratified according to custom. "The reason we did not vote for you was your illness; we thought that your gout would be a handicap for the Church which stands in much need of an active man with physical strength," he explained. "You, on the other hand, need rest." Piccolomini responded with dignity: "What is done by two-thirds of the Sacred College is surely the work of the Holy Spirit," he said, before removing his cardinal's red robes and donning the "white tunic of Christ." When he was asked by what name he wished to be known, he announced "Pius," and his election was proclaimed to the crowds gathered in the piazza in front of St. Peter's.

That night of August 19, 1458, there was great rejoicing in the streets and piazzas of Rome, as men and women celebrated the news that an Italian had been chosen rather than a Frenchman or another Spaniard:

There was laughter and joy everywhere and voices crying "Siena! Siena! Oh, fortunate Siena! Viva Siena!" . . . As night fell, bonfires blazed at every crossroads . . . men sang in the

streets; neighbour feasted neighbour; there was not a place where horns and trumpets did not sound, nor a quarter of the city that was not alive with public joy. The older men said they had never seen such popular rejoicings in Rome before.

Piccolomini, prematurely old at fifty-three, had up until now led a more or less dissolute life. He was the father of several bastards and had distinguished himself as a diplomat, orator, and writer rather than as a churchman; he was the author of, among other works, a widely read novel, *Euryalus and Lucretia*; a distinguished series of biographies, *On Famous Men*; his own memoirs; a book on the correct way to educate young boys; and a history of Bohemia—this last work he wrote while resting at the famous baths at Viterbo, where he hoped to ease his gout "but not expecting a cure, because this illness, once it has become chronic and firmly rooted, is only ended by death."

He had received his cardinal's hat at Christmas 1456 and just over eighteen months later had entered the conclave with quiet confidence that he would be elected; and while prepared to promote the interests of friends and family, and to indulge their whims, in the manner of so many of his predecessors, he was also determined to become a worthy occupant of his holy office. He undertook to bear always in mind the words he had spoken to a friend when he was ordained deacon and had accepted that the chastity he confessed to dread must now replace his former licentiousness. "I do not deny my past. I have been a great wanderer from what is right, but at least I know it and hope that the knowledge has not come too late."

Like his predecessor, he had the same overriding ambition: "Of all the intentions he had at heart, there was none so dear as that of inciting Christians against the Turks and declaring war on them." He discussed at length the means of achieving the organization of a crusade that could resist the advance of the Turks into Europe with Rodrigo Borgia, whose position as vice-chancellor of the Church Pius II had confirmed within hours of his election, in grateful thanks for Rodrigo's support in the conclave.

A Man of Endless Virility

"THE DANCES WERE IMMODEST
AND THE SEDUCTION OF LOVE BEYOND BOUNDS"

THE MOST TALENTED of Calixtus III's nephews, Rodrigo Borgia had been created a cardinal at the age of twenty-five. He had made a brief study of canon law at Bologna University, where he took his degree after less than a year's residence, which, since the normal course of study was five years, led to a widespread supposition that money had exchanged hands, a not unusual occurrence.

Nor did Rodrigo Borgia's appointment to the influential and lucrative position of vice-chancellor at the age of twenty-seven, after an equally brief military career, pass without angry complaint; nor had his appointment to his uncle's valuable see of Valencia. Yet it had to be conceded that while nepotism had been largely responsible for these appointments, Rodrigo was a highly competent administrator, "an extraordinarily able man," as Pius II commented, and that if indeed he did take immoderate care to ensure that his

tenure in the office of vice-chancellor was an extremely profitable one—thanks to the bribes he readily accepted for all manner of favours, from the arranging of divorces to the licensing of incestuous marriages by means of forged documents—it could not be denied that he performed the duties of the post conscientiously. He was enormously rich, with a taste for extravagance; as Jacopo Gherardi da Volterra commented:

> Borgia's various offices, his numerous abbeys in Italy and Spain, and his three bishoprics of Valencia, Porto and Cartagena yield him a vast fortune; and it is said that that the office of Vice-Chancellor alone brings him in 8,000 gold florins. His plate, his pearls, his clothes embroidered with silk and gold, and his books in every department of learning are very numerous, and all are magnificent. I need not mention the innumerable bed-hangings, the trappings of his horses . . . the gold embroideries, the richness of his beds, his tapestries in silver and silk, nor his magnificent clothes, nor the immense amount of gold he possesses.

"Beautiful women are attracted to him in a most remarkable way, more powerfully than iron is drawn to the magnet," wrote one observer. He was also, in the guarded words of Johannes Burchard, who later became his master of ceremonies, a man of "endless virility." It was well known that his sexual appetite was consuming and that attractive women who came to him for advice or favours were more than likely to take part in such orgies as those that were brought to the notice of Pius II, who thus admonished his vice-chancellor in these terms:

We have learned that three days ago a large number of women
of Siena, adorned with all worldly vanity, assembled in the gar-
dens of . . . Giovanni di Bichio, and that your Eminence, in
contempt of the dignity of your position, remained with them
from one o'clock until six and that you were accompanied by
another cardinal. . . . We are told that the dances were im-
modest and the seduction of love beyond bounds and that you
yourself behaved as though you were one of the most vulgar
young men of the age. . . . I should blush to record all that I
have been told. The mere mention of such things is a dishon-
our to the office you hold. In order to have more freedom for
your amusements you forbade entry to the husbands, fathers,
brothers and other male relations who came with these young
women. . . . It seems at present nothing else is spoken of in
Siena. . . . We are more angry than we can say. . . . Your be-
haviour gives a pretext to those who accuse us of using our
wealth and our high office for orgies. . . . The Vicar of Christ
himself is an object of scorn because it is believed he closes
his eyes to these excesses. . . . You rule the pontifical chan-
cellery; and what renders your behaviour more reprehensible
is that you are close to us, the Sovereign Pontiff, as Vice-
Chancellor of the Holy See. We leave it to your own judge-
ment to say if it befits your high office to flaunt with women,
to drink a mouthful of wine and then have the glass carried to
the woman who pleases you most, to spend a whole day as a
delighted spectator of all kinds of lewd games. . . . Your faults
reflect upon us, and upon Calixtus, your uncle of happy mem-
ory, who is accused of a grave fault of judgement for having

laden you with undeserved honours. Let your Eminence then decide to put an end to these frivolities.

Rodrigo had no intention of putting an end to such "frivolities"; but he did take considerably more care in the future not to take part in them in places or in company from which reports were likely to reach the ears of the stern Pius II. Such entertainments as those enjoyed in the garden at Siena were now to be held within the walls of his luxurious palace, which the vice-chancellor's new wealth, both legitimately and fraudulently acquired, enabled him to build in Rome.

During Easter week in 1462, a grand procession was held in Rome to escort the skull of St. Andrew, brother of St. Peter, which Pius II had acquired after the relic had been saved from the Turks invading Greece. "Such crowds had blocked the streets that the soldiers guarding the Pope, who were armed with truncheons, were hardly able to open a path for him." The whole city was adorned. Narrow streets were "covered with canopies and branches of greenery to shade them from the sun and all the houses were decked with hangings and tapestries in canopies," wrote Pius II. "Everyone vied with each other in doing honour to the Apostle." Of all the magnificently ornamented palaces along the route, none was more lavishly decorated than that of Cardinal Rodrigo Borgia. As the pope wrote in his memoirs:

All the cardinals who lived along the route of the procession had decorated their houses splendidly. . . . But all were eclipsed in cost and ingenuity by that of Rodrigo, the Vice-Chancellor.

His huge towering house, built on the site of the ancient mint, was bedecked with marvellous and costly tapestries. . . . He had decorated his neighbours' houses as well as his own, so that the surrounding square was transformed into a sort of park, filled with music and song and his own palace seemed to be gleaming with gold, such as they say the Emperor Nero's palace once did.

The interior of the Borgia palace was equally splendid. One visitor described the ever-increasing magnificence:

The walls of the entrance hall are hung with tapestries depicting various historical scenes. A small drawing-room, also decorated with fine tapestries, leads off it. The carpets on the floor harmonize with the furniture, which includes a sumptuous day-bed upholstered in red satin with a canopy over it, and a chest on which is displayed a large and beautiful collection of gold and silver plate. Beyond this drawing-room there are two more reception rooms, one of them with another canopied day-bed covered with velvet, the other with a sofa covered with cloth-of-gold. In this latter room is a large table on which is spread a fine velvet cloth and around which is a set of finely carved chairs.

In this palace and its outbuildings and stables, as many as two hundred servants, several of them slaves, lived and worked, wearing the dark mulberry red and yellow of the Borgia livery. In addition to the grooms and guards and domestic servants, there were numerous courtiers, secretaries, and clerks installed in the rooms

above, as well as the cardinal's lawyer, Camillo Beneimbene, discreet and reliable, the repository of many secrets.

In the square outside the palace on festive occasions, the populace was regaled with allegories and pantomimes, fireworks, the roar of cannons, and the savagery of bullfights, while cups of wine were offered to the crowds of spectators by Rodrigo's numerous servants.

Despite the huge sums expended upon his palace and its furnishings, Rodrigo had enough money to spare for such gestures as the supply and equipment of a galley for the Venetian fleet in Christendom's war against the Turkish infidels, and for generous contributions to the crusade, which Pius II was planning with missionary zeal and which he intended to lead in person. Accompanied by Rodrigo, he left Rome for Ancona, where, already a gravely ill man, he died in the episcopal palace on August 15, 1464.

Rodrigo, too, fell ill at Ancona, a notoriously unhealthy city, possibly with the plague or with some sexually transmitted disease. "The Vice-Chancellor is stricken with illness," the governor of Ancona was informed, "and this is its symptom: he has pain in his ears and a swelling under his arm. The doctor who has seen him says that he has little hope of curing him, especially considering that a short while ago he did not sleep alone in his bed." Certainly on his way to Ancona, Rodrigo had not stinted himself in enjoying the masked balls and nocturnal parties that were given at his request so that the "passage of the dignitaries of the Holy Church," northeast across the Apennines to the Adriatic coast, would not "depress the social life" of the towns through which he passed.

Rodrigo, however, turned out not to be as seriously ill as his doctors first thought, and he was back in Rome in time to attend the

conclave to choose the new pope. The cardinals' choice this time was a Venetian, Pietro Barbo, a handsome, self-regarding, and pleasure-loving man who had originally intended becoming a merchant like his rich father; but when his uncle had been elected to succeed Martin V as Pope Eugenius IV, he decided that the Church might well offer a life more suited to his character. His love of display, indeed, was soon indulged by building a fine palace in central Rome, the Palazzo San Marco, now the Palazzo di Venezia; he moved the papal court there in 1466 and lived in the palace, in ostentatious splendour, surrounded by his superb collection of antique cameos, bronzes, marble busts, and precious gems until his death in 1471.

At the conclave following Paul II's death, Rodrigo played a key role in manoeuvring the election of Francesco della Rovere, who took the name Sixtus IV. A large, ambitious, gruff, and toothless man with a huge head, a flattened nose, and an intimidating presence, Sixtus IV had been born into an impoverished fishing community in Liguria and became a Franciscan, rising though the ranks of the order to become its minister general. "This pope was the first," claimed Niccolò Machiavelli, "to show just how much a pontiff could do and how many actions which would have been called errors in earlier times were now hidden under the cloak of papal authority." Others praised his nobility, "not of birth but of character and erudition," and many commented on his fervent devotion to the Virgin.

From the moment of his election, this apparently austere friar was unremitting in granting to his relations offices, money, and profitable lordships in the Papal States—those lands in central Italy that belonged to the pope, the Patrimony of St. Peter. He soon be-

came notorious for the particularly lucrative preferments he lavished upon two young nephews, Pietro Riario and Giuliano della Rovere, both of whom he made cardinals within months of his election and appointed to numerous abbacies, benefices, and bishoprics. He also gave red hats to another four of his relations, a total of six of the thirty-four cardinals he created during his long pontificate, not all of whom were as unworthy as his family.

The two nephews played a prominent part in the reception of the young Neapolitan princess Eleonora of Aragon as she passed through Rome in June 1473 on her way north to marry Ercole d'Este, the Duke of Ferrara. Such was the grandeur of the apartments furnished for her at Pietro Riario's palace at Santi Apostoli that, as she recounted in a letter to her father, the king of Naples, even her chamber pot was a vessel of gilded silver. "The treasure of the Church," she wrote, in astonishment, "is being put to such uses." The sumptuous banquet Pietro hosted for her lasted six hours, a relentless succession of opulent dishes, eaten to the accompaniment of music, poetry, and dancing: gilded and silvered breads, peacocks, pies filled with live quail that ran about the table when the crust was removed, a whole bear, plates of silvered eels and sturgeon, and ships made of sugar filled with silver acorns, the della Rovere emblem.

Pietro Riario and Giuliano della Rovere, who had both followed their uncle into the Franciscan order, rapidly abandoned their vows to poverty and chastity once they were cardinals. Pietro, described by one contemporary as another Caligula, was the pope's favourite; indeed, it was widely rumoured that he was in fact Sixtus IV's son. With an income of over 50,000 ducats a year from his benefices,

he could indulge freely in the luxuries of life and flaunt his mistress, whom he installed in his palace at Santi Apostoli, where her shoes, reputedly, were sewn with pearls. He died suddenly in January 1474, leaving debts of over 60,000 ducats, after suffering severe stomach pains that many thought were the result of poison but were more probably due to appendicitis. Giuliano now became Sixtus IV's right-hand man in the college and started to build up his position at the papal court, where he would soon begin to rival Rodrigo.

Yet for all his persistent nepotism, Sixtus IV was a great benefactor to Rome and to the Roman people; and, largely by means of the heavy taxation of foreign churches and the sale of ecclesiastical offices, he was able to carry out numerous public works. Streets were paved and widened; at the same time the numerous conduits of ancient Rome, which had once brought fresh water to hundreds of the city's fountains, were cleared and once again gave the Roman people a clean supply.

Hundreds of churches were repaired and rebuilt, so many indeed that Sixtus IV was hailed by his humanists as a second Augustus, following in the footsteps of the emperor who had found Rome built in brick and left it in marble. He sold off Paul II's magnificent collection of valuable antiquities, for money or for political favour, and spent the proceeds on improving the city of Rome. A foundling hospital was established; new palaces appeared where desolate ruins had once stood; the city's main market was moved to the Piazza Navona, the site of ancient Rome's imperial circus, the infamous Stadium of Domitian.

The University of Rome, the Sapienza, was re-formed; in preparation for the Holy Year of 1475, the pope laid the foundation stone

of the Ponte Sisto, standing up in a boat as he dropped several gold coins into the murky waters of the Tiber. Most memorably of all, it was Sixtus IV who was responsible for the Sistine Chapel, which was built for him by Giovannino de' Dolci with its walls decorated with scenes of the lives of Moses and Christ by some of the most gifted artists of his time, including Botticelli, Ghirlandaio, Perugino, and Pinturicchio.

Sixtus IV had been quick to reward Rodrigo for his support in the conclave, promoting him to the cardinal-bishopric of Albano and giving him the lucrative abbey of Subiaco, which included the lordship of the surrounding area and a castle that would provide the cardinal and his family with a pleasing summer retreat. The pope also appointed him as papal legate to Spain, to sort out the tricky situation that had developed there regarding the consanguineous marriage of Ferdinand of Aragon and Isabella of Castile, which had already taken place using a forged papal dispensation, much to the fury of the archbishop of Seville, who opposed the union of the two Spanish kingdoms.

Rodrigo left Rome in May 1472 and received a rapturous reception in Valencia, his episcopal seat. In Spain he displayed his intelligence, tact, discretion, good humour, and confidence to do what was necessary to regularize the marriage and to negotiate peace with the archbishop, who was placated with a cardinal's hat; he also gained Spanish support for another crusade against the Turks. He left Spain fourteen months later, but on his journey home his galley ran into a violent storm and was wrecked off the coast of Tuscany. He was taken to Pisa to recover from his ordeal, and while there he was invited as guest of honour to a banquet,

where he met an attractive and intelligent woman some ten years younger than himself, named Vannozza de' Catanei.

A courtesan of charm and discretion from a family of the lesser nobility, Vannozza de' Catanei seems to have intrigued the cardinal from the very beginning of their acquaintance. So as to facilitate what was to become a loving and lasting relationship, Rodrigo's confidential legal adviser and notary, Camillo Beneimbene, arranged for her marriage to a complaisant husband, an elderly lawyer called Domenico da Rignano, who could be relied upon not to make any unwanted demands upon his wife.

In 1475, a year after Rodrigo had made his appearance, dressed in the red robes befitting a cardinal, at the marriage of his mistress, she gave birth to a son, who was named Cesare—Sixtus IV showed his approval of his vice-chancellor by legitimizing the boy. Soon after this Vannozza's well-rewarded husband died, and the widow gave birth to two more of Rodrigo's children—another boy, Juan, a year younger than Cesare, and four years after that a girl, Lucrezia. Vannozza did not remain a widow long; she was married twice again to men selected by the cardinal and gave birth to Jofrè, yet another son for Rodrigo, and Ottaviano, who may or may not have been his progeny.

Certainly their good-natured mother profited from the arrangement, being able to establish herself in a comfortable house in Rome and to buy a plot of land near the Baths of Diocletian on which she had another house built. She also acquired a lucrative interest in three of Rome's best inns, while her third husband, Carlo Canale, made a handsome profit from his appointment as governor of Rome's prison, the Torre Nuova, where the incarcerated men were charged for such privileges as they could afford.

Vannozza's were by no means the only children who were generally believed to have been fathered by Cardinal Rodrigo. There were at least three others, all older than Vannozza's offspring, who were widely assumed to be his, although very few people in Rome knew who their mother was. Two of these children were girls—one of them, Gerolama, having been quietly married into an unassuming though noble family, died young; the other, Isabella, lived into old age, dying in the middle of the sixteenth century, an object of much curiosity that she haughtily ignored. The third was a son, named Pedro Luis after Rodrigo's brother, and he was created Duke of Gandía but, like Gerolama, died young, having spent much of his short life as an apparently worthy officer in the army in Spain.

Around 1483, when Cesare was eight years old and his brother Jofrè still a baby, Rodrigo had taken his children away from their mother and placed them in the care of his cousin Adriana da Mila. Despite her evident charms and his affection for her, Vannozza's background made her unsuitable for the upbringing of their family; Adriana, on the other hand, was a Spanish noblewoman and had married into one of the most powerful clans in Rome, the Orsini. In 1489 her son, Orsino Orsini, was married in Rodrigo's palace in Rome to Giulia Farnese, a beautiful nineteen-year-old girl of very modest fortune. Giulia—"la Bella" as she was known throughout Rome—now became Rodrigo's new mistress, while her husband withdrew to his family's country estate at Bassanello.

Rodrigo seemed to be obsessed by the Farnese girl, his lovely carefree young mistress who now lived in a house shared with Adriana da Mila and the children of the pliable, good-natured Vannozza. Indeed, he appeared, for the first time in his life, to be capable of an intense jealousy, even of Giulia's tiresome husband,

whom she insisted on going to see in the country from time to time, provoking Rodrigo to write such letters as this:

> We have heard that you have again refused to return to us [from Bassanello] without Orsini's consent. We know the evil of your soul and of the man who guides you but we would never have thought it possible for you to break your solemn oath not to go near Orsino. But you have done so . . . to give yourself once more to that stallion. We order you, under pain of eternal damnation, never again to go to Bassanello.

Evidently alarmed by this letter, Orsini sent his wife back to the cardinal. Although almost forty years older than Giulia Farnese, Rodrigo was quite as virile as he had ever been; his sexual appetite was still said to be voracious. Sumptuous as were the meals served in his palace, he ate sparingly himself, often contenting himself with a single course. And while other cardinals were carried about Rome on litters or in carriages, he preferred to walk. He hunted; he wrestled; he enjoyed falconry; he took pride in having "the slender waist of a girl."

Sixtus IV had died in August 1484, and his successor was the affable and ineffective Giovanni Battista Cibò, Innocent VIII, not a man of much distinction. Having obtained the papal tiara by undertaking to grant favours to various cardinals the night before his election, he was soon reduced to creating various supererogatory offices and selling them to the highest bidder, to meet the vast debts incurred by his predecessor. His finances were further strained by the importunities of several illegitimate children and

by his quarrel with King Ferrante I of Naples, who refused to pay his papal dues.

Meanwhile Cardinal Rodrigo's career prospered. Jovial and carefree by nature, he was nevertheless most conscientious in his attendance to the business of his office as vice-chancellor, an office that he was to hold in five pontificates.

"It is now thirty-seven years since his uncle Calixtus III appointed him a cardinal and in that time he never missed a Consistory except when prevented by illness, and that was rare indeed," his secretary was to write in 1492. "[For almost forty years] he was at the centre of affairs. . . . He well knew how to dominate, how to shine in conversation and how to impose his will on other men. Also, majestic in stature, he had the advantage over other men."

He also became steadily richer and more influential, well able to afford the bribes that he would need to offer discreetly at the next conclave. "Altogether it is thought," wrote Jacopo Gherardi da Volterra, "that he possesses more gold and riches of every kind than all the other cardinals combined, excepting only d'Estouteville," the wealthy cardinal of Rouen.

Rome, however, under the easygoing and unassertive leadership of Innocent VIII, known as "the Rabbit," had relapsed into the kind of anarchy that had been all too familiar a century before. Armed men again roamed through the city at night, and in the mornings the bodies of men who had been stabbed lay dead and dying in the streets; pilgrims and even escorted ambassadors were regularly robbed outside the city gates; cardinals' palaces became fortified strongholds with crossbowmen and artillery at the windows and on the castellated roofs.

Justice had become a commodity to sell, like every other favour in this corrupt city. A man who had murdered his two daughters was permitted to buy his liberty for 800 ducats. Other murderers purchased their pardons from the Curia, the papal administration, as well as safe-conduct passes that allowed them to walk the streets with armed guards to protect them from avengers. When an important official was asked why malefactors were not punished, he answered with a smile in the hearing of the historian Stefano Infessura, "Rather than the death of a sinner, God wills that he should live—and pay."

During the unpleasantly hot summer of 1492, Innocent VIII fell seriously ill, unable to keep down any nourishment other than mother's milk. Among the cardinals who had gathered, as was the custom, at his bedside were Rodrigo Borgia and Giuliano della Rovere, who were soon involved in a heated argument. Rodrigo voiced his disapproval of the pope's decision to distribute the reserves of cash in the papal coffers—some 47,000 ducats—to his relatives, and Giuliano defended the action, which, after all, had been agreed by the college, and made an insulting remark about Rodrigo's Spanish heritage. The vice-chancellor retorted that, were they not in the presence of the pope, he would show Giuliano who he was, and the unseemly quarrel would have quickly deteriorated into a fight had the two not been restrained by some of their colleagues.

It was soon clear that Innocent VIII was dying, and the sacred college was much preoccupied with the choice of a suitable successor. No scholar was needed now, still less a saint. The next pope, they agreed, must be one of strong personality rather than moral worth, a man who could protect the Patrimony of St. Peter from its

rivals and enemies, and one who could restore order to Rome and inject some vigour into its artistic and scholarly life. Innocent VIII died on July 25, 1492, and it was with these thoughts in mind that the cardinals entered the Vatican on August 6 in order to elect his successor.

~ Chapter 4 ~

Servant of the Servant of God

"I am Pope! I am Pope!"

For four gruelling days, the cardinals plotted and negotiated and placed their voting slips in the gilded chalice, locked, in the intolerable summer heat, inside the Vatican and living, in considerable discomfort, in the tiny cubicles that had been erected for each cardinal in the Sistine Chapel. In the evening of the fourth day, rumours began to seep out of the Vatican and into the streets and taverns of Rome that the conclave was in deadlock. The crowds that had gathered so expectantly on the piazza in front of St. Peter's beneath the first-floor windows of the palace, waiting for the result of the election, began to disperse as night fell. The few who remained there overnight were astonished when, shortly after daybreak on the morning of August 11, 1492, the long-awaited announcement was made: *"Habemus Papam!"*

"*Deo Gratias!*" came the response and then, from the window above, fluttered down several pieces of paper on which were written the words "We have for Pope, Alexander VI, Rodrigo Borgia of Valencia." The new pope himself then appeared at the window, wearing the largest of the three sizes of papal robes that had been made in advance and laid out for the successful candidate. He was clearly much excited by his victory; instead of modestly declaring "*volo,*" as custom required, he repeatedly shouted, "I am Pope! I am Pope!"

He had, it was said, spent large sums of money in becoming so. As the sixteenth-century Florentine author of *The History of Italy,* Francesco Guicciardini, explained:

> [Rodrigo] had been a cardinal for many years and had become one of the most influential men at the papal court; his succession to the papacy was due to the conflict between Cardinal Ascanio Sforza and Cardinal Giuliano della Rovere, but principally his election was due to the fact that he had unashamedly bought the votes of many cardinals in a manner that was unprecedented in those times, using not only money but also the promise of his offices and benefices, which were plentiful.

There were, indeed, widespread rumours that he had paid bribes to no fewer than thirteen cardinals, including his main ally, Cardinal Ascanio Sforza, brother of the Duke of Milan and perhaps the most *papabile* of all the cardinals. In return for relinquishing his own ambitions to further those of Rodrigo, Ascanio was promised not

only gold, which was reported to have been sent under cover of darkness to Ascanio's palace on four heavily laden mules, but also the influential and lucrative office of vice-chancellor, which Rodrigo would have to surrender if he became pope. And along with the job would come the official residence, Rodrigo's magnificent palace, known as the Cancelleria Vecchia. (It is now the Palazzo Sforza-Cesarini and was completely rebuilt in 1888 to the designs of Pio Piacentini, who retained just one side of the elegant fifteenth-century courtyard.)

According to Burchard's account, "Only five cardinals wished to receive nothing, namely the cardinals of Naples, Siena, Lisbon, San Pietro in Vincoli and Santa Maria in Porticu; they alone refused the gratuities, saying that the votes to elect a pope should be given freely and should not be purchased with presents." In the end, however, according to the Florentine ambassador's report of the election, there was only one dissenting voice in the conclave and that was Sixtus IV's nephew Giuliano della Rovere, the cardinal of San Pietro in Vincoli.

Yet even those who had been most ready to condemn the methods by which the new pope had secured his election were now forced to concede that, guilty as he may well have been of simony, bribery, and sexual incontinence, Alexander VI was both conscientious and competent in the discharge of his duties. Approachable, affable, and good-natured, he was also determined to put a stop to the riotous lawlessness into which Rome had fallen during the pontificate of his predecessor, Innocent VIII.

Accordingly, during September 1492, as Burchard outlined, "he established a body of prison inspectors; he also appointed four commissioners whom he charged with listening to all those who

had complaints to make in Rome; similarly he reorganized the functions of the governor of the city and his officers." The pope "also decided that he would hold an audience every Tuesday which would be open to all citizens, men and women; he himself listened to their complaints and rendered justice in an admirable manner." It was not long, therefore, before order was restored; and the Romans could look forward to the pontificate of a man with a highly developed taste for ceremony and pageantry.

"There was an incredible crowd of prelates," wrote Bernardino Corio, the Milanese chronicler, describing the scene outside St. Peter's on August 27, 1492, the day of Alexander VI's coronation. "It was a most wonderful thing to see for each prelate was wearing his mitre and each was clothed according to his particular office; one after another the cardinals approached the Pope to kiss his feet, his hand and his mouth."

Led by the papal cavalry, the prelates, cardinals, and foreign ambassadors then took part in the *possesso,* the ceremonial procession through the streets of Rome out into the uninhabited area and on through fields and orchards to the Church of San Giovanni in Laterano. Ascanio Sforza, the new vice-chancellor, was attended by twelve pages, "each dressed in doublets of crimson satin and purple capes, carrying batons and bearing the arms of his family." Altogether there were "seven hundred priests and cardinals with their retinues in splendid cavalcade with long lances and glittering shields."

Riding a snow-white horse sat Alexander VI, "serene of countenance and supremely dignified," wrote another witness of the parade with fulsome hyperbole. "How wonderful is his tranquil bearing, how noble his face, how open, how frank. How greatly

does the honour we feel him increase when we behold the dignity of his bearing. . . . He showed himself to the people and blessed them. . . . His glance fell upon them and filled every heart with joy."

It was a stiflingly hot day; the crowds lining the route were described as immense; the air was thick with dust that the street sweepers had vainly tried to allay with bucketfuls of water; it was "almost impossible to see the sky." The route from the Castel Sant'Angelo to the Lateran took the procession past the ruins of the Colosseum, the great amphitheatre built by Emperor Vespasian, where once audiences of fifty-five thousand had thrilled to gladiatorial games and other spectacles; its cavernous vaults now converted into workshops and storerooms. They passed through enormous triumphal arches specially erected for the occasion and decorated with representations of a huge black bull grazing on a golden field, the striking emblem of the Borgia family, which could also be seen on the flags, pennants, and gonfalons waving in the hands of the cheering crowds.

The festivities over, Alexander VI surveyed his achievements. He was now "Sovereign Pontiff, servant of the servants of God, supreme Lord of Rome and of the Papal States." As pope and Vicar of Christ, he was also president of the Roman Rota, the court of appeal for the ecclesiastical affairs of Christendom, and one of the most powerful rulers in Europe. His own realm stretched north of Rome as far as Bologna and Ravenna, from Civitavecchia, on the shores of the Mediterranean, to Ancona and Rimini on the Adriatic coast. The Patrimony of St. Peter would yield him an annual income of some 100,000 florins a year, a sum that had recently been much increased by the discovery of rich deposits of alum (a sulphate of aluminium and potassium essential to the tanning and

clothing industries) in the hills north of Rome at Tolfa near Civitavecchia.

These Tolfa deposits had been discovered by a Florentine, Giovanni di Castro, who had written to Pius II of his belief that this discovery would save enormous sums in the way of tolls that Italian merchants had hitherto been obliged to pay to the authorities in Asia Minor ever since the European alum mines had been exhausted.

> Holy Father [Giovanni di Castro had written], today I bring you victory over the Turks. Every year they extort more than 300,000 ducats from the Christians . . . because the alum mines of Lipari have been worked out. Today I have found seven mountains so rich in alum that they could furnish seven worlds. You will be able to supply enough alum to dye the cloth of the whole of Europe and thus snatch away the profits of the infidel.

Since this letter was written, the alum mines north of Rome had contributed handsomely to the income enjoyed by the papacy. While not as large as that of several other European states, it was now sufficient for the balancing of the papal budget, which had been much in debt in the time of Alexander VI's predecessors. The mines also helped to maintain a small army for the protection of the Papal States and contributed to the gifts that the treasurer of the Apostolic Chamber, the pope's cousin Francisco Borgia, was authorized to pass on to His Holiness's indulged children, as well as to the expenses of the elaborate entertainments provided at the papal court.

Powerful and possessed of the sums needed to exercise his authority, Alexander VI was a fortunate man, indeed. He was now sixty-one years old; he had grown rather fat in recent years, and his large and fleshy nose seemed more pronounced than ever. Yet he remained an attractive man capable of exercising great charm, lively in conversation, attentive, and responsive, with an ingratiating manner and ready smile, a sensual nature, a commanding presence, and a sonorous voice. "He is handsome, of a most glad countenance," his tutor had written of him, and "he is also gifted with honeyed eloquence." Jacopo Gherardi da Volterra observed of him that he was blessed with a "powerful intellect and great imagination," adding, "He is brilliantly skilled in the conduct of affairs of state."

The historian Francesco Guicciardini judged him to be a man who

possessed singular cunning and shrewdness, excellent perspicacity, amazing powers of persuasion, and an incredible agility and concentration when dealing with affairs of state; but these qualities were far outweighed by his vices: the most obscene manners, hypocrisy, immodesty, mendacity, infidelity, profanity, insatiable greed, unrestrained ambition, a predilection for viciousness that was worse than barbaric, and a fervent hunger to exalt his many children, among whom there were several no less repellent than the father.

Men soon learned that it was dangerous to cross Alexander VI and never to be less than wary in his presence. This was an ambitious pope, powerful, rich, politically astute, and determined to establish his own family in the ranks of Europe's ruling elite.

Marriages and Alliances

HE WOULD "SHOW THEM WHO WAS POPE
AND . . . WOULD MAKE MORE CARDINALS,
WHETHER THEY LIKED IT OR NOT"

LIVING IN THE LUXURIOUS surroundings of Palazzo Monte-giordano, the Orsini residence in Rome, under the care of Adriana da Mila, Rodrigo's children had grown up protected from the violence and squalor of the city beyond its walls. It seems that Lucrezia received her early education from the ladies of the household, from Spanish tutors, from a priest who presided over the children's schoolroom, and from the nuns of a nearby convent to which she was regularly conducted. While she spoke Spanish with her brothers and her father, she was also fluent in Italian and French, as well as Latin, and knew some Greek; her syllabus had included rhetoric and humanist literature; she enjoyed reading poetry and wrote her own verses. She was also an accomplished dancer and, indeed, regularly took part in the exhibitions of Valencian dancing arranged by

Rodrigo for the entertainment of himself and his guests. She was a happy, cheerful, and pretty child, adored by all her family.

Like other girls of noble birth, Lucrezia was expected to marry young, to a man of her father's choice whose connections would be beneficial to the family. In 1490, when she was just ten years old, she was betrothed to a young Spanish nobleman, some fifteen years older than herself, Don Juan de Centelles. The proposed marriage was, however, abandoned a year later when another more desirable suitor appeared in the form of a Spanish grandee, Don Gasparo di Procida, the Count of Aversa, whose lawyers entered into negotiations with those of the cardinal. These lawyers were still negotiating the details of the marriage contract when Rodrigo was elected pope. Now he could set his sights much higher and, according to Burchard, gave the young man "3,000 ducats to buy his silence and break the contract"; the pope, he continued, "intended thus to raise the status of his daughter." Alexander VI's choice of bridegroom, however, would be one who also brought significant political advantages for himself.

On February 12, 1493, in a ceremony at the Vatican, Lucrezia was formally betrothed, by proxy, to Giovanni Sforza, Lord of Pesaro, a widower twice her age but cousin to Ludovico Sforza, ruler of Milan, and to his brother Cardinal Ascanio, the vice-chancellor.

Four months later, on June 9, Giovanni Sforza arrived in Rome for the marriage, accompanied by forty pack animals and some 280 horsemen, all richly dressed. He made his official entrance into the city through the gate of Santa Maria del Popolo, welcomed by a large crowd and escorted to the Vatican, where he ceremonially kissed the pope's foot.

The marriage took place three days later, on June 12, when, according to Burchard, "the illustrious Giovanni Sforza, Count of Cotignola and Lord of Pesaro, took as his legitimate wife, Lucrezia Borgia, virgin, in her tenth year, or thereabouts"—Burchard was, unusually for him, misinformed about her age; she had in fact celebrated her thirteenth birthday a few weeks earlier. On the morning of her wedding, in obedience to the instructions of their father, Lucrezia's brother Juan escorted the young bride from the residence of Gianbattista Zen, cardinal of Santa Maria in Porticu, where she was then living, to the Vatican Palace. Her train was carried by one black girl, while another carried that of her principal attendant, a granddaughter of Innocent VIII. They were followed by well over 150 Roman ladies, led by Giulia Farnese, aptly described by Alexander VI's master of ceremonies, Johannes Burchard, in his account of the event, as "the concubine of the Pope."

The procession of ladies entered the room where the pope sat on his throne, accompanied by ten cardinals, five seated on each side of him, as well as several priests and deacons. As the ladies filed past the papal throne, much to the annoyance of the master of ceremonies most of them failed to genuflect, despite his scolding, though he was pleased to see that Lucrezia did observe this custom. Then Juan and Lucrezia approached to kiss the pope's foot, followed this time by all the ladies. Brother and sister remained on their knees, while the rest of the ladies moved back toward the wall. Here also stood Cesare, seemingly annoyed by the prominent role that his younger brother had been accorded in the ceremony.

Alexander VI's trusted lawyer, Camillo Beneimbene, now stepped forward to address the twenty-four-year-old bridegroom,

Giovanni Sforza, who knelt on a cushion next to his bride. "Most worthy Lord," began the notary, "I believe that Your Lordship has recently undertaken to marry the illustrious Donna Lucrezia Borgia, who is here present, and that your proctor has submitted the matrimonial contract in your name. . . . Are you ready to accept, and do you promise to observe what has been contracted?"

"I perfectly understand the terms of the contract and accept them," the bridegroom responded, "and hereby promise to observe and undertake all its obligations." Then Camillo asked, "Most worthy Lord, do you agree to take the illustrious Lucrezia Borgia here present to be your lawful spouse?" "I will," he replied, "most willingly."

The cardinals and the others present were enjoined to be witnesses to Sforza's oath, and the bride was then asked if she was prepared to become his "lawful spouse." She also replied, "I will." The bishop of Concordia then stepped forward and placed a ring on the ring finger of the bride's left hand and another on the second finger while Niccolò Orsini, Count of Pitigliano and captain general of the papal armies, held a drawn sword over the heads of the couple. There followed a sermon by the bishop about the sacrament of marriage.

The bride was then escorted by Juan Borgia into the Sala Reale, specially hung for the occasion with lavish silks, velvets, and tapestries, where Alexander VI and his mistress, Giulia Farnese, played host to the bridegroom and the bride's ladies. "An assortment of all kinds of sweets, marzipans, crystallized fruits and wines were served," noted Burchard, and "over 200 dishes were carried in by the stewards and squires, each with a napkin over his shoulder, offering them first to the Pope and his cardinals, then to the bridal

couple and lastly the guests. Finally they flung what was left out of the window to the crowds of people below in such abundance that I believe more than 100 pounds of sweetmeats were crushed and trampled underfoot."

The party was a lively and lecherous affair. The diarist Stefano Infessura noted that in their excitement, some of the male guests "threw the sweetmeats into the cleavages of many ladies, especially the good-looking ones," and those cardinals who remained behind to dine with the pope and his mistress were each seated between two pretty girls. The guests were regaled with what Burchard described as "a series of entertainments," including a comedy performed with "such elegance that everyone loudly applauded" the actors; Infessura reported that "lascivious comedies and tragedies were performed which provoked much laughter in the audience."

Once dinner was over, Alexander VI himself accompanied his daughter and her husband to the palace of Santa Maria in Porticu by the grand steps leading up to the Basilica of St. Peter's. "There the groom took marital possession of his bride," reported Infessura, adding, rather enigmatically, that "I could tell you many other things but I will not recount them because some are not true and those that are, are anyway unbelievable."

This marriage had been arranged in the shadow of a bitter quarrel between King Ferrante of Naples and Ludovico Sforza, ruler of Milan. Ludovico was a "wise man," in the opinion of the French chronicler Philippe de Commynes, "but very timorous and humble when he was in awe, and false when it was to his advantage to be so; and this opinion I do not hold by hearsay but as one that knew him well, having had much business to do with him." Handsome in his way, despite the ugly, massive nose to be seen in the portrait

attributed to Leonardo da Vinci, he was known as Il Moro on account of his cunning and his resourceful nature, which were generally supposed to be characteristics of the Moors of North Africa. He was also greedy for power. When his brother Duke Galeazzo Maria was assassinated in 1476, leaving his seven-year-old nephew, Gian Galeazzo, as heir, Ludovico had seized control of Milan to rule in the young duke's name. Together with his beautiful and clever wife, Beatrice d'Este, Ludovico presided over an impressively splendid court to which Leonardo was welcomed as painter and musician, as well as military engineer.

The sickly and insipid Gian Galeazzo was not too troubled by this deprivation, which allowed him the time and opportunity to hunt in the pleasant countryside around the castle of Pavia, where he was confined. His ambitious wife, Isabella of Aragon, granddaughter of King Ferrante, however, was far from satisfied with this arrangement and jealously resented the position that Beatrice occupied as wife of "the Moor," a position to which she herself felt entitled as the wife of the rightful duke. In 1493 she wrote a letter of bitter complaint to her father in Naples:

Everything is in his [Gian Galeazzo's] power, while we are obliged to live as though we were private people. Yet Ludovico, not Giangaleazzo is Duke. His wife has lately given birth to a son who, everyone thinks, will succeed to the dukedom. Royal honours were paid to him at birth while we and our children are treated with contempt. We live here in Milan at risk to our very lives. . . . If you have fatherly compassion . . . I implore you to come to our help and deliver your daughter

and son-in-law from the fear of slavery, restoring them to their rightful place in the world.

Isabella's father would willingly have responded to this call, but her grandfather, King Ferrante, advised caution. Both sides appealed to Alexander VI for papal support in their quarrel. At first the pope was inclined to support the Sforzas in their endeavour; after all, theirs was a family into which his daughter was to be married and, indeed, was married on June 12, 1493.

Soon after Lucrezia's wedding, however, an envoy of the Spanish sovereigns, Ferdinand of Aragon and Isabella of Castile, arrived in Rome and told the pope that his master and mistress supported the Spanish claim to Naples. They proposed a double alliance: Alexander VI's son Jofrè should become Prince of Squillace, a Neapolitan grandee, and be married to Sancia, the illegitimate daughter of King Ferrante's son, while Juan Borgia, the pope's second and favourite son, who had inherited the Spanish title Duke of Gandía after the death of his half-brother, should now marry Maria Enriquez, a cousin of King Ferdinand.

In August Juan left for Spain, accompanied by four galleys laden with jewels and luxurious furnishings for his new palace. By November reports were reaching Rome of his misbehaviour, his mistreatment of his new wife, his reluctance to consummate the marriage, his extravagance, and his gambling. "Try to fulfil the hope which His Holiness has always founded upon you," Cesare wrote to his brother, adding, "If you have my own feelings at heart, do see that these reports, which give His Holiness so much pain, should cease."

In a subsequent letter, Cesare wrote of their father's decision that their brother Jofrè was to be granted the title of Prince of Squillace and an income of 40,000 ducats a year, and that Juan should add the Neapolitan title of Prince of Tricarico to his Spanish dukedom.

> This agreement was reached ten or twelve days ago [Cesare told Juan] and your Grace will be amazed that I should not have informed you of it earlier but, finding myself somewhat indisposed when the aforesaid agreements were reached, I left for the baths at Stigliano, where I have been until yesterday, returning in health by God's good grace.... We have reason, my Lord brother, to kiss the ground on which His Holiness walks and to pray always for the life of him who has made us so great; and therefore I pray you to seek continually to serve and please His Holiness, in a manner that you may show him on our behalf our gratitude in every way that we can.

While the arrangements for Jofrè's marriage to Sancia were being made, negotiations were also in progress to arrange a cardinal's hat for Cesare, to join his cousin Juan Borgia-Lanzol, who had been created cardinal of Monreale a fortnight after Alexander VI's election. As Cesare had been declared legitimate by Sixtus IV, the two cardinals entrusted with establishing his status were able to declare that he was eligible for admission to the sacred college; and so he was admitted at the age of eighteen, though he was not yet even in holy orders, which he would take the following year in Holy Week, and was admittedly "very young in all his actions."

"Such discord has never been seen," wrote the Mantuan ambassador when the list of proposed new cardinals was placed before the college on September 18, 1493. In an attempt to gain control of the college, Alexander VI wanted to flood it with his own candidates by creating an unprecedented thirteen new red hats. Three of the proposed candidates were Alexander VI's secretaries; another was Alessandro Farnese, "brother of Giulia, the Pope's concubine," as Burchard recorded; and another was Cesare, "the Pope's son." The college objected in the strongest terms; upon being told that several cardinals strongly objected to a certain name on the list, Alexander VI angrily declared that he would "show them who was Pope, and that at Christmas he would make more cardinals, whether they liked it or not." A majority of the cardinals did not like this elevation of a mere boy to the college.

Two days later, on September 20, eleven cardinals arrived for the consistory meeting, and seven of those present agreed to vote the issue through; the other four, reluctant to be party to this unprecedented act, all abstained. Ten more cardinals, led by Giuliano della Rovere, showed their outright opposition to the scheme by refusing to attend the consistory. The decision to give Cesare a cardinal's hat was greeted with cries of outrage. The violent Giuliano della Rovere, a longtime enemy of Alexander VI (and who later was to become pope himself as Julius II), was said "to howl with rage," so furious, indeed, that he had to take to his bed with a high fever. And when Alexander VI invested Cesare with his red hat in a grand ceremony in St. Peter's and assigned him his titular church on September 23, Giuliano and his supporters refused to play their customary part in the proceedings.

Alexander VI's narrow victory reflected just how insecure his position was during those early days of his pontificate. He realized that he would have to tread carefully if he were to benefit from his position. There was also the fear that his enemy Cardinal Giuliano della Rovere, a formidable opponent, might well call for a council that would have the power to depose him. Already della Rovere was accusing him of trying to gain control of the college of cardinals by filling it with Spaniards and other foreigners. Alexander VI also needed to proceed cautiously in his relations with France, where the Spanish marriage alliances of two of his children were causing due unease.

As if to echo the precariousness of his position, the storms that autumn were more violent and dramatic than usual. Torrential rain caused huge damage in the fields and vineyards around Rome, and the Tiber burst its banks, flooding the city streets. "Bolts of lightning struck in many places," Burchard recorded, "and one hit the Vatican palace in the very room in which the Pope was in at that precise moment; he was so shocked and terrified that he lost the power of speech; two of his servants lost consciousness"; luckily they all recovered.

That autumn plague also broke out in Rome, brought, it was widely believed, by the Jews who had been expelled from Spain by Ferdinand and Isabella and who had taken refuge in Rome, setting up their tents in a camp outside the city walls by the gate leading out onto the Via Appia. As the death toll climbed into the hundreds and claimed one cardinal as a victim, Alexander VI decided to move the papal court to Viterbo. Appointing his nephew the cardinal of Monreale to take charge of Rome in his absence, the pope and his huge entourage, which included a horse carrying

the Tabernacle of the Eucharist, left the city; they stayed a few days at Alexander VI's castle at Nepi and at the Bell Inn at Ronciglione before arriving at their destination. The pope and his court stayed at Viterbo, where Alexander VI could indulge his passion for hunting in the wooded hills around the city, for six weeks, accompanied by eighteen cardinals, one of whom was Cesare. Giuliano della Rovere was conspicuous by his absence.

On December 18, the day before his return, a proclamation was read out in Rome "to tell all the inhabitants to be present tomorrow on the return of His Holiness," reported Burchard. "Each must clean the area of street in front of his house, hang out all their tapestries and other items, and do all necessary to honour the Pope, as is his due."

~ Chapter 6 ~

The French in Rome

"Twice our great guns were ready to fire on Castel Sant'Angelo"

Francesco Guicciardini described Italy as "never having enjoyed such prosperity or known so favourable a situation as that in which it found itself in the years immediately before and after 1490." He continued:

The greatest peace and tranquillity reigned everywhere. . . . Not only did Italy abound in inhabitants, merchandise and riches, but she was also highly renowned for the magnificence of many princes, for the splendour of so many most noble and beautiful cities, as the seat and majesty of religion, and flourishing with men most skilful in the administration of public affairs and most nobly talented in all disciplines and distinguished and industrious in all the arts. Nor was Italy lacking in military glory according to the standards of the time, and

adorned with so many gifts that she deservedly held a cele-
brated name and a reputation among all the nations.

Had Guicciardini described Italy as it was to become a few years
later, during the pontificate of Alexander VI, he would have
painted a less comforting picture. The quarrel between King Fer-
rante I of Naples and Ludovico Sforza of Milan was to have far
wider political implications, involving France and Spain, each of
which laid claim to Naples, and it now brought the threat of im-
minent war. For, in order to dispose of his enemy, Ludovico Sforza
decided to suggest to King Charles VIII of France that he should
invade Italy to assert his claim to Naples, as heir to the rights of the
House of Anjou, which had been ousted from Naples by Ferrante
I's father, Alfonso of Aragon, some fifty years earlier.

Charles VIII's belief that he was the rightful king of Naples had
been "instilled in him from an early age, so that it was almost an
innate instinct, and it had been nourished under the guidance of
several close advisers," so Guicciardini said, and these men played
on his vanity and his youthful inexperience, suggesting that, by en-
forcing his claim to the kingdom, he would "surpass the glory of his
ancestors," and that, having taken Naples, it would be just a simple
step to seize the Holy Land from the Turks. ·

On January 25, 1494, Ferrante I died, "without the light of grace,
without the cross and without God," as Burchard stated. "On 21
January he visited the baths at Tripergole because he did not feel
well"—Tripergole, once famous for its sulphur baths, was buried
after a volcanic eruption covered it with lava in 1538. On the fol-
lowing day Ferrante "returned to Naples and, on dismounting from
his horse in the courtyard of Castel Nuovo, suffered a fainting fit;

three days later he died, without confession and without receiving the sacraments." This, so it seemed, was his own choice: "Although his confessor, a Franciscan friar, came into the bedroom and, standing before him, urged him to repent of his sins," Ferrante I refused to do so. "The friar, it was said, did not see a single sign of repentance from the King."

Ferrante I died at the age of seventy, loathed by his subjects for the cruel way he had exercised his authority. There was, however, little talk of poison; many in Italy thought it likely he had died of misery at the prospect of seeing his kingdom seized by the powerful armies of Charles VIII, which were poised to leave France on their long march to conquer Naples.

Charles VIII was just twenty-four years old, and he was the "ugliest man" that one observer had ever seen, "in all [his] days—tiny, deformed with the most appalling face that ever man had." The chronicler Philippe de Commynes added that "neither his treasury, nor his understanding, nor his preparations were sufficient for such an important enterprise as the conquest of Naples." Commynes believed he never said a word to anyone that could "in reason, cause displeasure." This unprepossessing but adventurous young monarch also had the most grandiose ideas; he was contemplating a march upon Naples not only to take possession of his ancestor's throne but also to go on from there to conquer Jerusalem and, on the way, to reform the corrupt papacy of Alexander VI.

In Italy, where the forthcoming conflict now seemed inevitable, reactions varied. Ludovico Sforza promised his support, as did his father-in-law, the Duke of Ferrara, and his cousin Giovanni Sforza, husband of Lucrezia and Lord of Pesaro, who sent details of papal

troop deployments to Milan with the warning that "if any word of what I am doing is known, I will be in the greatest danger." The Republic of Venice remained neutral; Florence and the Papal States were both ill-equipped to fight a war; the Neapolitan army was a more formidable force than any other in Italy, but it had no hope of halting the French advance on its own.

The issue had become even more complicated for Alexander VI since Ferrante I's death in January and the succession of Alfonso II as the new king. The pope now faced a stark choice—Naples was a papal fief and he had either to crown Alfonso II or to agree to the demands of Charles VIII to invest him as the rightful ruler.

Throughout March Alexander VI sought to placate both sides; he sent Charles VIII the papal rose, a mark of his favour, but when the ambassadors of Alfonso II arrived in Rome, their French counterparts made a point, as they had been ordered to do, of pointedly refusing to meet them. By Easter, which fell on March 30 that year, it was clear that Alexander VI had decided in favour of his alliance with Naples. At the Great Mass in St. Peter's on Easter Sunday, led by the pope in person, it was the cardinal of Naples who acted as his assistant. "The Pope gave communion to all the cardinal-deacons, except for the Cardinal of Valencia, who was absent," noted Johannes Burchard, using the title by which Cesare had chosen to be known in the college, and "afterwards the Lance of Christ was shown twice to the people and the Vernicle three times."

On the Tuesday after Easter, Alexander VI went to the Church of Santa Maria sopra Minerva to hear Mass, which was celebrated by the bishop of Concordia. Cardinal Ascanio Sforza made a witty aside, recorded by Burchard, to the effect that "when the Pope is in

concord with the King of Naples, he asks the Bishop of Concordia to celebrate the mass; the Pope, who overheard this remark, asked me to tell Ascanio that his choice had not been premeditated but that it had been coincidence." Alexander VI then quipped, much to the discomfiture of his vice-chancellor, that "when there is peace between His Holiness and Ludovico Sforza," the pope would "have mass celebrated by the Bishop of Pace"—*pace* is the Italian for peace and also the Latin name for the Spanish city of Badajoz.

The college of cardinals was deeply divided by the quarrel, Alexander VI's Spanish cardinals firmly opposing the French party, led by Cardinal Giuliano della Rovere, the pope's inveterate enemy, and those loyal to Milan, notably Ascanio Sforza. Alexander VI was even approached by one of della Rovere's supporters, who threatened him bluntly that if he did not agree to the crowning of Charles VIII as king of Naples, it would no doubt become necessary to summon a council to investigate the charge that the pope had been guilty of simony in securing his election to high office. Whether or not persuaded by this threat, Alexander VI was induced to agree that Charles VIII should be crowned in Naples when the French army entered the city.

The issue of crowning Alfonso II as king of Naples was discussed at length in a secret consistory that lasted eight hours; it was finally agreed that the pope's nephew, the cardinal of Monreale, would be appointed legate to Naples and would go there to "anoint and crown" Alfonso as king. Two days later Burchard himself left for Naples to make the necessary preparations; orders for the reception of the legate, for the carrying of the baldachin, the itinerary to be followed for the cardinal of Monreale's entry into Naples, and his procession to the cathedral were all listed by the methodi-

cal master of ceremonies, together with "the roles of the legate and the King on the day of the coronation."

On April 30 Burchard had an audience with Alfonso II in order to explain to him the details of the ceremony and to fix the date, which was to be May 8, chosen by the king because it was the Feast of the Ascension.

The day before the coronation, in grateful thanks to Alexander VI for his support, Alfonso II announced his gifts to the pope's children. Cesare was given lucrative Neapolitan benefices; Juan was to get fiefs and the offer of 33,000 ducats a year to serve as a condottiere for Naples; Jofrè was given six Neapolitan fiefs, worth 4,000 ducats a year, including the prestigious title of Prince of Squillace, and the king invested him as a knight of the royal chivalric Order of the Ermine. He also ratified the marriage contract between his illegitimate daughter, Sancia of Aragon, and the twelve-year-old Jofrè, who, as Prince of Squillace, carried the crown during the coronation ceremony.

Three days later, as rain cascaded down in torrents outside, Jofrè and Sancia were married in the chapel of Castel Nuovo. After the wedding banquet, the couple were accompanied to their bedchamber, "where their bed had been prepared," reported Burchard.

The legate and the King remained waiting outside; the newly-weds were now undressed by maids-of-honour and placed together in the bed, the groom on the right of the bride. When the two, now naked, had been covered with the sheets and blanket, the legate and the King entered. In their presence, the newly-weds were uncovered by the maids-of-honour as far as the navel, or thereabouts, and the groom embraced his

bride without shame. The legate and the King remained there, talking between themselves, for about half an hour before leaving the couple.

Burchard, meanwhile, had taken the opportunity to do some sightseeing around the Bay of Naples, visiting various sites of interest, including the hot springs at Pozzuoli and the sulphur and salt baths at Bagnoli, before leaving Naples with a four-year-old mule, named Idrontina, which he was given as a present by the king, together with 100 gold ducats in gratitude for services rendered.

On July 12 Alexander VI, accompanied by several cardinals, including the nineteen-year-old Cesare, left Rome for Tivoli, where he intended to stay a few days in order to escape the stifling summer heat and to attend a meeting with Alfonso II at the nearby fortress of Vicovaro, a castle belonging to Virginio Orsini, one of the condottieri captains fighting with the Neapolitan army. They discussed at length the measures that would be needed for the defence of Naples against the French. A plan of action was agreed upon; but, before it could be put into operation, an immense French army, thirty thousand strong with forty powerful cannons, under the personal command of Charles VIII, crossed the Alps in early September and started its long march south.

In Rome Alexander VI's open alliance with Naples and Spain made life very uncomfortable for the supporters of Milan and France, not least in the college. Cardinal Giuliano della Rovere had fled to France in April; Cardinal Ascanio Sforza left at the end of June. With the plague raging, the celebrations for the anniversaries of Innocent VIII's death and of Alexander VI's accession were both cancelled, adding to the pall of dread that hung over the city,

and which grew daily as news bulletins of Charles VIII's slow but relentless approach were delivered. There had been a moment of hope soon after the French crossed the Alps when it was learned that Charles VIII had taken to his bed in Asti, suffering from smallpox; but the moment was brief, and the king soon recovered enough to continue on his way.

Guicciardini recorded many signs and portents of impending doom that were seen at about this time:

> In Puglia one night three suns were seen in the sky, sur-
> rounded by clouds and accompanied by terrifying thunder and
> lightning. In the territory of Arezzo huge numbers of armed
> soldiers riding enormous steeds were seen for many days pass-
> ing across the sky with a terrible clash of trumpets and drums.
> All over Italy holy images and statues were seen to sweat and
> everywhere monstrous babies and animals were born ...
> whence the people were filled with unbelievable dread, fright-
> ened as they already were by the reputation of French power.

The French troops met with little opposition; it was said that they conquered Italy with the bits of chalk that the quartermasters used in order to mark the doors of the houses they occupied on their march south. Certainly the army was one of the most power-ful ever assembled, and it was "provisioned by a large quantity of ar-tillery," wrote Guicciardini, "of a type never before seen in Italy." The French had developed new weapons: "These were called can-non and they used iron cannonballs instead of stone, as before, and this new shot was considerably larger and heavier than that previ-ously deployed." Not only were they more powerful than anything

seen before; they were also more manoeuvrable; the massive can-
nons were transported to Italy by ship and unloaded in the harbour
at Genoa, where they were loaded onto specially made gun car-
riages. "This artillery," concluded Guicciardini, "made Charles
VIII's army formidable."

After outflanking the weak resistance of the Neapolitan forces in
the Romagna and routing the Neapolitan fleet at Rapallo, they
crossed the Apennines in October and seized the fortress of
Sarzana, one of Florence's key border defences. Alexander VI ap-
pointed the cardinal of Siena, Francesco Todeschini Piccolomini, as
legate to Charles VIII to negotiate, but Cardinal Giuliano della
Rovere, who had joined the French camp, persuaded the king not
to meet him.

On November 17 Charles VIII entered Florence in triumph, to
the wild cheers of the fickle populace, for whom the arrival of the
French army had been the catalyst that had enabled the expulsion
of the detested Piero de' Medici, who had arrogantly exercised his
authority in the city since the death of his father, Lorenzo il Mag-
nifico, two years earlier. After signing an alliance with Florence's
new republican government on November 26, Charles VIII and
his troops continued their march south, sacking and pillaging the
Tuscan countryside as they went.

A few days later in Rome, Alexander VI arrested those promi-
nent supporters of the French who remained in the city, including
Cardinal Ascanio Sforza and the illegitimate son of the great Car-
dinal d'Estouteville, imprisoning them in apartments on the upper
floor of the Vatican Palace. Though the rooms were comfortable
and the prisoners were allowed to attend Mass in the Sistine
Chapel, they were heavily guarded. That same day Alexander VI

informed the ambassadors of France, who had come to Rome to seek free passage for the French army through the Papal States, that their request was refused. Charles VIII ignored the pope and continued to march south; a month after arriving in Florence, the invading army captured Civitavecchia, an important port inside papal territory, while the Orsini surrendered their fortress at nearby Bracciano.

Near Viterbo the vanguard of the French army, under the command of Yves d'Alègre, came across two obviously well-to-do women. One of these turned out to be Giulia Farnese, Alexander VI's beautiful mistress, who was returning to Rome from a visit to her husband on his country estate. The other was Adriana da Mila, her friend and the pope's cousin, who had been entrusted by him with the care of his children. A messenger was sent to the king informing him of this unexpected encounter, and Charles VIII declared that the French did not fight against women; but Yves d'Alègre saw no reason why money should not be made out of the captives who had so unexpectedly fallen into his hands, and he accordingly demanded 3,000 ducats for their release.

Alexander VI astutely agreed immediately to pay this ransom, and the two women were sent on to Rome under an escort of four hundred soldiers. Ludovico Sforza was not pleased: "These ladies," he declared, "could have been used as a fine whip for compelling the Pope to do all that was required of him, for he cannot live without them. The French received a mere 3,000 ducats for them when he might well have paid 50,000 or even more to have them back."

With the main body of the French drawing ever closer to Rome, the city grew increasingly fearful; houses and palaces of known supporters of France were ransacked. Alexander VI had been advised

to escape from Rome while he could still do so; but, for the first time in his life, he seemed utterly irresolute. He had called in Neapolitan troops only to dismiss them; he had repeated his refusal to allow the French free passage through the Papal States only to rescind the order; on one occasion he fainted.

Finally the pope decided to stay in Rome and began to consider the ways in which he might secure an agreement with Charles VIII. First he set about ordering the defence of the city and summoned Burchard together with a number of other members of the German colony living in Rome to an audience, to ask for their help. He outlined the "insolent behaviour" of the French king and his invasion of the Papal States; "he did not anticipate a siege by the French," he said, but would welcome any help that the German nation, "in whom he had great confidence," might be able to contribute to the defence of Rome. Burchard continued his account:

> His Holiness suggested that we should appoint constables and officers . . . and arm them with weapons and issue all the requisite orders so that, when the time came, they would be able to defend themselves and the Pope would be able to use this militia within the city, although not outside the walls.

In the end, Burchard failed to persuade his compatriots to agree to the formation of this highly irregular militia; they felt bound, they said, to their promise to obey the captains of their neighbourhood watches, which was what usually happened in an emergency such as this. Nor was the commander of the papal troops, Virginio Orsini, cousin of the lovely Giulia's husband, any more encourag-

ing; he chose to offer no resistance to the French, who were, he considered, irresistible.

With characteristic style, Alexander VI announced that he would defend Castel Sant'Angelo with the troops at his disposal and, if attacked, would stand on its walls in full canonicals, carrying the Blessed Sacrament. He would not leave Rome, he said, to become a prisoner in Naples; he was determined to remain and attempt to come to terms with the French king. Work now started on a deep ditch to surround Castel Sant'Angelo, which involved the demolition of several houses. "On Thursday 18 December," wrote Burchard, "all the Pope's possessions, including even his bed and daily credence-table, were assembled for removal from the Vatican Palace to Castel Sant'Angelo, the vestments from St. Peter's, all the money chests from the sacristy, the palace weapons and stores of food, and all the papal belongings were sent to the castle, whilst the cardinals also prepared to move."

Below the walls of Castel Sant'Angelo, the city was now in an uproar as people fled into the country, having buried or otherwise hidden their valuables to save them from looters and pillaging soldiers. "The discontent of the people is at its height," wrote the Mantuan envoy Fioramonte Bagolo. "The looting is fearful, the murders innumerable; one hears moaning and weeping on every side and never, in the memory of man, has the Church been in such an evil plight." All those who could afford to do so were packing their valuables into carriages and leaving the city. Looking out through the windows of the Vatican, Alexander VI and his son Cesare watched the enemy troops massing on Monte Mario, just north of the palace, thankful that they, too, had taken the precaution of

locking their treasures away in Castel Sant'Angelo and were ready for flight.

Meanwhile, as rumours spread of the atrocities that the French would inflict, Charles VIII attempted to appease the fears of the Romans. The French Cardinal Bertrand Perauld, who had been refused entry into the city on December 22, was heard to say that the troops "would not take a hen or an egg or the smallest item without paying for it in full." The next day he wrote to the German colony saying that the invasion would only happen if the king's "enemies," by which he meant Alexander VI himself, "continue to remain in Rome and prevent an agreement." Moreover, he insisted, "His Majesty promises that his troops will do no harm to any prostitute in the city, nor to any other person, wherever they are from, unless they fight against the King and his followers."

With the city almost surrounded by French troops, the celebrations for the Feast of the Nativity continued with surprising normality: Burchard recorded that the pope himself was present in the Sistine Chapel for Vespers on Christmas Eve. It had been expected that the cardinal of Monreale would celebrate High Mass in the Sistine Chapel on Christmas Day, but before dawn broke that morning, a courier had arrived with an urgent message for Alexander VI to say that Charles VIII desired a peaceful agreement with the pope prior to the king's entry into the city. Having informed the cardinals assembled in the Sala del Pappagallo that he intended to allow Charles VIII to enter Rome, the pope dispatched the cardinal of Monreale to agree to terms with the king, who likewise sent his envoys to the Vatican for the same purpose. At Mass in the Sistine Chapel the next day, the Feast of St. Stephen, Burchard faced an awkward situation, being obliged to organize seating not

only for these French envoys but also for two ambassadors of the king of Naples who were in Rome:

> The latter did not wish to dispute their seats with the new ar-
> rivals, and withdrew, claiming not to know who they were, but
> when on the Pope's orders, I had explained to them that they
> were ambassadors from the King of France, the Neapolitans
> resumed their seats and gave the others precedence in po-
> sition. A great many other Frenchman came in as well, and
> sat down quite indiscriminately next to the clerics on their
> benches. I moved them away and gave them more suitable
> places, but the Pope disliked what I was doing and summoned
> me angrily to say that I was destroying all his efforts and that
> I was to permit the French to stand wherever they wanted. I
> responded in a soothing manner, saying that God knew, he
> was not to become upset over the issue because I understood
> what he wanted and would speak not another word to the
> Frenchmen, wherever they sat in the chapel.

On December 31 Alexander VI sent his master of ceremonies to Charles VIII: "On the orders of His Holiness," Burchard wrote, "I rode out to find the King of France in order to acquaint him with the ceremonial that would accompany his reception in the city and to hear his own wishes and to do all His Majesty ordered me to do." Because of the pouring rain, the roads clogged with mud, "and the speed at which His Majesty was riding," Burchard was unable to greet the king as formally as he would have wished. In answer to Burchard's questions, Charles VIII replied "that he wanted his entry into the city to be conducted without any pomp." He did,

however, invite the master of ceremonies "to continue riding with him, and for about four miles or so he talked with me continually, asking me questions about the health of the Pope and the cardinals." Burchard noted the king's particular interest in Alexander VI's son Cesare, asking many questions about his situation and his status "and many other things, to all of which I was scarcely able to give appropriate answers."

Meanwhile, the main body of King Charles's army entered Rome at about three o'clock in the afternoon of the last day of December. Alexander VI and his family took shelter in Castel Sant'Angelo, while Giulia Farnese was spirited out of the city by her brother, Cardinal Alessandro Farnese. These precautions proved unnecessary. "Twice our great guns were ready to fire on Castel Sant'Angelo," wrote Philippe de Commynes, "but on both occasions the King opposed it."

It took six hours for the French army to file through the gate at Santa Maria del Popolo, and it was long after darkness had fallen that the last stragglers entered the city. By flickering torchlight and the gleam of lanterns, the men and horses marched though the narrow streets, muddy and wet in the pouring rain: Swiss and German infantry carrying broadswords and long lances, Gascon archers, French knights, Scots archers, artillerymen with bronze cannons and culverins. Escorted by cardinals Ascanio Sforza and Giuliano della Rovere, and surrounded by his bodyguard and his magnificently dressed courtiers, rode Charles VIII himself, a short, ugly young man with a huge hooked nose and thick fleshy lips, constantly open.

"There were fires, torches and lights in every house," Burchard recorded, "and people were heard shouting 'France! France!' and

'Vincoli! Vincoli!'" continually (San Pietro in Vincoli was the title of Cardinal Giuliano della Rovere). At the Palazzo Venezia, the great palace built by Paul II at the foot of the Capitol Hill and now the residence of Cardinal Lorenzo Cibò, the king dismounted and was ushered inside by his host. He limped into the dining room and sat by the fire in his slippers, while a servant combed his hair and the wispy scattered strands of his reddish beard. Food was placed upon a table; a chamberlain tasted every dish before the king ate, and the remains were thrown into a silver ewer. Four physicians likewise tested the wine into which the chamberlain dangled a unicorn's horn on a golden chain before His Majesty raised the cup to his lips.

Cardinal Cibò had prepared his best apartments "for housing the ambassadors and other Frenchmen," commented Burchard, adding that the dignitaries "were provided with plenty of straw beds, but I noticed that these sacks of straw were never cleaned; tallow candles hung from the doors and fireplaces, and, even though the walls were decorated with beautiful tapestries, the place resembled a pigsty."

Despite Charles VIII's protestations that his troops would respect the Romans and their property, they did cause a lot of trouble. Burchard reported that "on their way into the city the French troops forced an entrance into houses on either side of the road, throwing out their owners, horses and other goods, setting fire to wooden articles and eating and drinking whatever they found without paying anything." On Thursday, January 8, he recorded, "the house of Paolo Branco, a Roman citizen, was plundered and ransacked by the French who killed his two sons, whilst others, including Jews, were murdered and their houses pillaged; even the

house of Donna Vannozza Catanei, the mother of Cardinal Cesare Borgia, did not escape."

Even poor old Burchard himself was to suffer at the hands of the unruly soldiers: "When I returned to my house after mass, I found that the French had entered it against my will," he wailed. "They had taken out seven of the eight horses, mules and asses that I had in my stable and had billeted in their place seven of their own mounts which were busily eating my hay." His rooms, as well as those of his servants, had all been requisitioned by French nobles and their retinues. Eventually Charles VIII was forced to issue an order forbidding his troops from forcibly entering houses on pain of death.

While Alexander VI played a waiting game from the comfort and security of his apartments in Castel Sant'Angelo, where he was ensconced with Cesare and several of the Neapolitan cardinals, Charles VIII spent his time receiving visits from various cardinals and dealing with the deluge of complaints about his troops. One day, escorted by a company of soldiers, he was conducted on a tour of Rome to view the sights of the city: on another he rode out to the Basilica of San Sebastiano with his household.

It was not until January 16 that the two rulers finally came face-to-face. That day Charles VIII rode across Rome to St. Peter's, where he heard Mass in the French royal chapel, which had been restored by his father, Louis XI, and was dedicated to St. Petronilla, the daughter of the first pope. "If my memory is correct," recorded Burchard, "the mass was not sung." The king was then escorted to the papal palace, where the lavish rooms of Alexander VI's apartments had been prepared for him and his suite to dine. The pope, meanwhile, was on his way from Castel Sant'Angelo to the Vatican

in his ceremonial litter. The ambitious twenty-four-year-old monarch, described by Guicciardini as "not particularly intelligent with regard to political affairs and carried away by his fervent wish to rule and his thirst for glory," was about to be outwitted by the wily pope.

"On being told of His Holiness's approach," wrote Burchard, the eager young king, not well versed in the subtleties of achieving diplomatic advantage, "hurried to the end of the second private garden to greet him." Catching sight of the pope, he approached him and twice genuflected before him: "At first His Holiness pretended not to see this gesture but when His Majesty came closer and was about to genuflect for a third time, the Pope removed his cap and, holding out his hand to restrain the King from kneeling, kissed him."

Alexander VI's informality was calculated, as was his apparent insistence on the equality that was seen to exist between the two rulers. "At this their first meeting," Burchard continued, "both men were bareheaded and the King kissed neither the Pope's foot nor his hand. His Holiness refused to place his cap back on his head until the King had replaced his own hat, but eventually they both covered their heads simultaneously." Later that day Alexander VI displayed a similar deference when, having accompanied Charles VIII to the Sala del Pappagallo, he declined to sit down until his guest had done so.

Alexander VI also acceded to Charles VIII's request to give a cardinal's hat to Guillaume Briçonnet, the bishop of St.-Malo and a trusted member of the king's Privy Council, and to invest him immediately. Burchard was sent off forthwith to find a cardinal's hat and robe. "The hat was supplied by Cardinal Cesare Borgia," he

remarked, "and the cloak was borrowed from the rooms of Cardinal Pallavicini." All the cardinals present were now seated as if for a consistory, and Alexander VI, according to Burchard, "said he was happy to agree to the King's request providing the cardinals also considered the occasion suitable."

One by one the cardinals gave their consent, and the pope duly invested Briçonnet with the insignia of his new rank. "When this had been done the Cardinal of St.-Malo kissed the Pope's foot and hand, and then, raised up by the Pope, he received the kiss on the mouth," not just from Alexander VI but also from all the other cardinals present.

Alexander VI himself now rose from his seat and said that he wished to escort the king back to the royal apartments, but this Charles VIII "categorically refused to allow." He was therefore accompanied by the cardinals as far as the entrance, where they left him. The doors were guarded by Scottish mercenaries, who had the special duty of guarding the French king and allowed none to enter except for members of the royal household.

Two days later, on January 18, having managed neatly to sidestep two of Charles VIII's demands—the calling of a council to address the issue of the reform of the church and papal recognition of his claim to Naples—Alexander VI did give him formal permission to pass freely through the Papal States, a somewhat Pyrrhic victory for the young king, who already held most of the territory north of Rome and knew that the pope did not have the forces necessary to prevent him from taking the rest, if he wanted it. In return, the pope had extracted a promise from Charles VIII that he would profess his obedience to the pope in public.

This was a diplomatic triumph for Alexander VI. A month ear-lier he had been under siege, his city in an uproar, his hold on power tenuous at best; now he had fully reestablished his authority. The terms of the agreement were formally read out and written up, "in French for His Majesty and in Latin for the Pope."

~ Chapter 7 ~

The Conquest
of Naples

"THEY RAPED THE WOMEN, THEN ROBBED THEM"

OVER THE NEXT FEW DAYS, Charles VIII was seen to adhere
to his side of the bargain. On January 19, 1495, Burchard noted,
"the Sala Regia in the Vatican was prepared in the traditional way
for the public consistory in which the King of France would take his
solemn oath of obedience." When everything was ready, the pope
asked Burchard to inform the king, "whom we found beside the
fire in his room, wearing his doublet and his boots still not laced."
On being told that his presence was requested, the king, wiser than
before, replied that he still "had to dress, and when he had done so,
he intended to hear mass in St. Peter's, and then to dine and that
after this he would come to His Holiness." When the cardinals,
who were to escort Charles VIII to the Sala Regia, arrived at his
rooms, they found him still at table and were forced to wait, seated
on the window seats. He further delayed by insisting that Burchard

repeat again and again the order of the ceremony, and it was some two hours before the royal party finally arrived.

In the magnificent setting of the Sala Regia, designed specifically for the reception of kings and emperors, or their ambassadors, Charles VIII addressed the pope: "Most Holy Father," he intoned, "I have come to render homage and reverence to Your Holiness in the same way as my predecessors the Kings of France have done." On January 28, when Charles VIII took leave of Alexander VI, they parted in sincere amity or, as Cardinal Giuliano della Rovere thought, in abject surrender on the part of the king. The master of ceremonies described their parting:

> King and Pope remained closeted together for a short time, and were then joined by Cesare Borgia for a further quarter of an hour after which His Majesty was escorted by the Pope and his cardinals as far as the passage leading to the upper apartments of the palace. There the King knelt down, bareheaded, and the Pope, removing his own cap, kissed him, but refused quite firmly to allow the King to smother his feet with kisses, which His Majesty seemed to want to do. The King then departed.

Leaving with Charles VIII, to accompany the king to Naples in the guise of a papal legate, though in reality a hostage for Alexander VI's good behaviour, was Cesare. He kept the king waiting while he returned briefly to his apartments: "At last Cesare appeared, wearing his cardinal's hat, and, with His Holiness's permission, mounted his horse beside the King. To His Majesty he presented six exceedingly beautiful horses, which stood ready at

hand with bridles but no saddles, and then both the King and Ce-
sare departed."

That evening a courier arrived with news for Alexander VI that
King Alfonso II had fled from Naples—"out of sheer cowardice,"
commented the contemporary French chronicler Philippe de
Commynes—loading four galleys with treasure in order, so the let-
ter reported, to sail to Sicily and then to Spain, to recruit forces
against the French.

The following evening, January 29, came the news that, in fact,
Alfonso II, who had only been crowned by the pope's nephew the
cardinal of Monreale just nine months before, had now abdicated
in favour of his son, Ferrante II, who had, on his father's orders,
contracted marriage to Isabella of Aragon, his father's sister, "that
he had ridden through Naples where he had received oaths of hom-
age from all," and that he had set free all those nobles imprisoned
by Ferrante I and Alfonso II, except for those known to be associ-
ated with the French, and these he had executed.

On January 30 couriers arrived with even more dramatic news
from Naples, this time concerning Cesare. As Burchard recorded:

On Friday 30 January the Pope was informed that the Cardi-
nal of Valence, disguised as a royal footman, had escaped from
the French King's court at Velletri. It was indeed true. The
Cardinal had spent the night in the house of Antonio Florès,
auditor of the Rota, where he had gone immediately on his
arrival in Rome. When he had left the city in the company of
the King he had taken nineteen pack animals with him, all
richly caparisoned and so it seemed, laden with objects of

value, but only two of these horses, in fact, carried plate and other costly items. On the first day of their journey, while the King and the Cardinal were riding towards Marino, these two horses lagged behind the rest and that evening returned to Rome. The Cardinal's servants had declared to the French court officials that the animals had been captured and stripped of their loads. The other seventeen arrived at the court and after the Cardinal's flight, the chests had been opened and were found to be empty. Well, at least that is what I was told, but I think it was not true.

When he learned of Cesare's disappearance, Charles VIII was furious. "All Italians are filthy dogs," he was quoted as having said, "and the Holy Father is as bad as the worst of them." The king suspected that Alexander VI knew very well where his son was and that he had been told beforehand of Cesare's attempt to escape as soon as opportunity offered. The pope did, however, send his secretary to Charles VIII with his sincere apologies for his son's behaviour.

By the middle of February, Charles VIII had entered Capua, where, so it was said, strange portents had appeared. "One night as he slept in his chamber," reported Burchard, "he was woken twice by a dreadful voice; he opened a chest which was in his room to find a banner standing erect and, in his terror, made a vow that he would not return to France without having taken the Holy Land and reconquered the tomb of Christ in Jerusalem; he also promised to build and endow a chapel in Naples in honour of the Holy Ghost."

Charles VIII entered Naples on February 22, slipping quietly into the city to lodge in the Castel Capuano, because the three other royal castles, including Castel Nuovo, remained in the hands of troops loyal to Ferrante II. As a French chronicler observed: "On Sunday, after he had enjoyed an excellent dinner, [the king] put on his robes of state and, with joy not rancour entered the city in pomp, thus displaying his power there, although he did not have a proper entry on that day." Guicciardini reported the view of the populace: "The reputation of the last two kings was so odious among all the people and almost all the nobles, and there was much eagerness for the French regime."

Charles VIII was intent upon enjoying himself in Naples. The city was, he declared, "an earthly paradise." He was certainly, "as one of the most lascivious men in France," finding plenty of opportunity to indulge his "fondness for copulation" and of "changing his dishes" so that "once he had had a woman, he cared no more about her, taking his pleasure with fresh ones." His soldiers were equally lascivious, and having made themselves hated in Rome, they now became detested in Naples, despite the welcome they had first received. As Guicciardini commented:

> The natural arrogance of the French, exacerbated by the ease of their victory, as a result of which they had a highly esteemed opinion of themselves and no respect whatever for any Italian. They seized lodgings in Naples and in other parts of the kingdom with insolence and violence and wherever their troops were quartered they were hated; everywhere they treated their hosts so badly that the friendly welcome with which they had been received was now changed into burning hatred.

The French were "stupid, dirty and dissolute people," another Italian observer decided, and he added:

> They were constantly after women. . . . Their table manners were disgusting. . . . Whenever one of them entered the house of a Neapolitan, they always took the best rooms and sent the master of the house to sleep in the worst. They stole wine and grain and sold them at the market. They raped the women, then robbed them, pulling the rings from their fingers, and, if any woman resisted, they would cut off her fingers to get at the rings. . . . Even so, they spend much time in church praying.

The arrival of the French, moreover, coincided with the first dramatic epidemic of syphilis, which was known as the "*morbo gallico*" or "*mal francese*" by the Italians, and as "*le mal de Napoli*" by the French. This foul venereal disease—"so horrible that it ought to be mentioned as one of the gravest calamities," wrote Guicciardini—arrived in Europe in 1494, probably brought to Europe from the West Indies or America by Christopher Columbus's sailors. It soon spread, and the doctors, confronting the disease for the first time, were perplexed; indeed, as Guicciardini noted, "they often applied inappropriate remedies, many of which were harmful and frequently inflamed the infection." In Rome it was so virulent that seventeen members of Alexander VI's family and court, including Cesare, had to be treated for it within a period of two months.

For almost two months after he escaped from the French court at Velletri, nothing reliable was heard about Cesare; and then he reappeared once more, as a deus ex machina, in Rome, where, with his customary skill in such matters, he set about organizing an

attack upon the Swiss troops who had been left behind in the city when the French army marched south for Naples. The troops were attacked in the piazza in front of St. Peter's by a large body of Spaniards who killed over twenty of them and wounded several more.

> Some said afterwards that all these violent acts were ordered by Cesare Borgia [commented Burchard] because these Swiss soldiers were in the service of the French and, with violence and without cause, had sacked and plundered the home of his mother, robbing her of 800 ducats and other valuable possessions.

Certainly, Cesare had already acquired a reputation for never forgiving what he took to be a wrong and for savagely punishing anyone who crossed him in any way; and having escaped from Charles VIII's custody, he was now considering ways in which he might harm the French king.

Despite the spread of syphilis, the ill discipline of his troops, and the need to get back to France before an emerging alliance of Italian states, headed by Alexander VI, could march against him, Charles VIII was reluctantly obliged to turn his back on the pleasures of Naples. It was not, however, until the end of the third week in May 1495 that he began the long march north. He arrived in Rome four days later, expecting to be able to have an audience with Alexander VI, who he hoped would give formal recognition of his conquest of Naples and invest him as king, but he found only Cardinal Antoniotto Pallavicini, who had been left in charge of the city.

The wily pope had removed himself, together with nineteen cardinals, over four thousand troops, and the entire papal court, first to Orvieto and then, when the French king threatened to find him there, on to Perugia and out of harm's way.

Meanwhile, the forces of the Holy League were massing in Lombardy to attack the French as they made for the Alpine passes. By the end of June, the returning army had crossed the Apennines, but on July 6 their march was brought to a sudden halt at Fornovo, by the banks of the river Taro, where they encountered the mercenary troops of the Holy League under the command of Francesco Gonzaga, the Marquis of Mantua. The battle was fierce but brief, lasting less than one hour, with little chance for the French to use their invincible artillery; the French lost just two hundred men; the Holy League counted over three thousand dead. "The palm of victory was generally awarded to the French," wrote Guicciardini, "because of the great difference in the number of casualties" and "because they had won free passage to advance, which was the reason that the battle had been fought."

However, since he was left in possession of the field and had captured part of the French baggage train—which included a piece of the Holy Cross, a sacred thorn, a limb of St. Denis, the blessed Virgin's vest, and a book depicting naked women "painted at various times and places . . . with sketches of intercourse and lasciviousness in each city"—the Marquis of Mantua claimed the victory. The poets at his court in Mantua celebrated the success of his venture in epic verse and prose, and the marquis, for his part, began building a votive chapel in the city, commissioning his court painter, Andrea Mantegna, to paint his *Madonna della Vittoria* (now in the

Louvre), with himself in armour kneeling at the feet of the Virgin, flanked on either side by the warrior saints St. Michael the Archangel and St. George.

But the French army, though battered, weary, and ill, was still a powerful force and had not been beaten. Accompanied by mules, one to every two men, loaded with treasure, it moved unimpeded toward the Alps and reached France in safety. The Italians were shocked by the realization that, for all their virtues, talents, wealth, past glory, and experience, they had been unable to withstand the ruthless men from the north, and Alexander VI, so proud of his stamina and prone to comparing his strength to that of the bull on the Borgia coat-of-arms, had been unable to withstand the might of a foreign king.

~ Chapter 8 ~

The Borgia Bull

"MANY ARE ASSISTED BY FORTUNE WITHOUT
BEING ENDOWED WITH THE NECESSARY TALENT"

SOON AFTER HIS ELECTION, Alexander VI began planning a
new set of rooms, seven in all, for his personal use in the Vatican,
and to decorate them in a manner that would suit his ostentatious
and luxurious tastes. The resulting set of apartments, known as the
Appartamento Borgia, has survived, with the exception of one
room that was destroyed, and it is still one of the highlights of the
tour of the papal palace.

With their ornate ceramic-tiled floors, the rooms have a boldly
Spanish appearance—indeed, the tiles were ordered by the pope
specially from Spain—and their lavishly gilded stucco decoration
made a marked contrast to the modestly austere chapel painted for
Nicholas V by the Florentine Fra Angelico.

Despite his taste for lavish surroundings, Alexander VI was no-
toriously frugal at mealtimes, rarely having more than one course,

according to the Ferrarese ambassador Giovanni Boccaccio, who said that cardinals avoided dining with the pope if they possibly could because his table was so parsimonious compared with their own, particularly during Lent and on Fridays, when sardines were commonly served at his table instead of the meat dishes otherwise provided by the papal household's six cooks.

The fashion for gilded stucco was a new one, and it had been inspired by the discovery, near the Colosseum, of the remains of the Golden House of Nero, the palace of legendary opulence built by the emperor, whose Circus had once resounded to the roars of the Roman populace in the place where the Vatican now stood.

Visiting the ruins was no easy matter; armed with tallow candles and lunch boxes packed with ham, bread, apples, and wine, artists and others interested in the remains of antiquity crawled into a narrow opening in the side of the Esquiline Hill and into even smaller passages, filthy and pitch-black, that had been excavated below the vaults of the palace, where they lit their torches to catch a glimpse of the glittering stuccoes and frescoes that dated back to imperial Rome; and, in their excitement, many left their own signatures on the walls.

The painter chosen by Alexander VI to decorate his apartments was one Bernardino di Betto di Biagio, better known as Pinturicchio, the gifted painter from Perugia who had established a reputation in Rome as the leading painter of works in the new "imperial style." He, too, must have crawled through the filthy dark passageways into Nero's palace, although he did not leave his signature among the gilded stucco work.

Giorgio Vasari was less impressed with his talents:

Even as many are assisted by fortune without being endowed with the necessary talent, so, on the contrary, there are infinite numbers of men of ability who suffer from an adverse and hostile Fortune . . . it pleases her to use her favour to raise certain men who would never be known by their own merit, as is the case with Pinturicchio of Perugia.

Pinturicchio's work for the pope, however, much pleased his patron, who rewarded the artist with grants of land in the Papal States. Alexander VI's apartments are a forceful monument to the Borgia family. Borgia symbols, most emphatically the Borgia bulls—in one depiction mounted by a cupid—strike the eye, as do the symbols of the House of Aragon from which the pope chose to trace his ancestry. More bizarrely, on the ceiling of the so-called Sala dei Santi were images of the ancient Egyptian deities Isis and Osiris, from whom, according to one of the pope's secretaries, Alexander VI could also trace his descent.

The rooms had other family connections. Lucrezia was portrayed as St. Catherine of Alexandria, defeating the pagan emperor by the force of her argument; Jofrè and Sancia appear as a young couple in the crowd behind her, while Juan, Duke of Gandía, can be seen, superbly dressed as he always was in life, astride a white charger, and Cesare glares out of the picture from behind the throne of the disputing emperor.

Alexander VI himself appears in the fresco of the *Resurrection,* witnessing this dramatic moment in an attitude of prayer, gorgeously attired in an embroidered and bejewelled chasuble, with a skullcap over his balding head, his hands clasped in prayer, his tiara

on the ground before him. Over the door of one room, Pinturicchio painted another portrait of Alexander VI, this time adoring a beautiful Virgin, to whom, according to Vasari, he gave the face of Giulia Farnese.

While Pinturicchio and his assistants were at work in the Vatican Palace, painters, sculptors, and builders were also busy elsewhere in Rome at Alexander VI's behest. At St. Peter's they finished the grand fountain in the piazza, which had been started by Innocent VIII, and adorned it liberally with the Borgia bulls. They also added a second storey to the Benediction loggia at the end of the piazza, where, a few years later, the pope would narrowly avoid being hit by an iron torch-holder that fell down while he was watching a bullfight; and they built a new road from Castel Sant'Angelo to the Vatican, which the pope named Via Alessandrina (now Borgo Nuovo).

Alexander VI also commissioned repairs to several churches in Rome, including San Giacomo degli Spagnuoli, the church favoured by the Spanish colony in the city; as a cardinal he had spent a considerable sum on an elaborate marble relief of the Virgin and child for the high altar in Santa Maria del Popolo, with the Borgia bulls prominently on display on shields held by putti (now in the sacristy of the church). Most memorably, he also paid for a magnificent gilded ceiling for the Basilica of Santa Maria Maggiore, his financial contribution marked, once again, by liberal quantities of Borgia bulls; the gold, it was said, was the first to have come from the mines of Peru and had been presented to the pope by Ferdinand and Isabella of Spain.

The most famous work of art from Alexander VI's pontificate, however, was the *Pietà* by Michelangelo Buonarotti, commissioned

not by him but by the ambassador of the king of France. Michelangelo had arrived in Rome from Florence on June 25, 1496, to work under the patronage of Cardinal Raffaello Riario, who had spent 200 ducats on a life-size sleeping cupid by the sculptor under the impression that it was a work by one of the famous sculptors of antiquity.

Soon after his arrival in the city, "a broad field in which a man may demonstrate his worth," as he described it, Michelangelo called upon Cardinal Riario in his grand palace, built, it was rumoured, with the money he had made gambling with Franceschetto Cibò, the son of Innocent VIII. The cardinal asked the sculptor if he could produce some "beautiful work" for his collection: "I replied that I might be able to make such splendid works as he possessed in his palace," Michelangelo recorded, "but we would see what I could do; so we have bought a piece of marble for a life-size figure, and I shall start work on it next Monday."

The result of this commission was the plump and drunken Bacchus that can now be seen in the Bargello in Florence. The subject and the treatment evidently did not please the cardinal, who, it seems, rejected it, and it was later to be seen among the antique pieces in the garden of Jacopo Galli, Michelangelo's banker.

Michelangelo, however, soon found another patron in the French Cardinal Jean Bilhères de Lagraulas, who commissioned the *Pietà* for his tomb in the French royal chapel in St. Peter's, dedicated to St. Petronilla, and provided him with a letter of recommendation to the officials of the small republican city-state of Lucca, through which the sculptor would have to pass on his way to the white marble quarries of Carrara: "We have recently agreed with master Michelangelo di Ludovico, Florentine sculptor and

bearer of this letter, that he make for us a marble tombstone, namely a clothed Virgin Mary with the dead Christ naked in her arms, to place in a certain altar which we intend to found in St. Peter's in Rome," ran the letter, explaining that Michelangelo "was presently repairing to those parts to excavate and transport here the marbles necessary for such a work and we beg your lordships . . . to extend to him every help and favour in this matter."

The finished *Pietà,* described as "the most important artistic commission of the age," and now to be seen in St. Peter's, was being admired by a group of visitors from Lombardy, so the story goes, when Michelangelo happened to be passing by. He heard one of the group explain to the others proudly that the fine work was by "our Gobbo of Milan." Michelangelo said nothing, but later he returned to St. Peter's in the middle of the night and, by the light of a lamp, carved his name on the band that runs diagonally between the Virgin's breasts.

Proud as he was of this work, Michelangelo, the *"statuario fiorentino,"* was not happy in the Rome of Pope Alexander VI, which he described as violent and materialistic, and was relieved when the time came for him to return to Florence. "Here they made helmets and swords out of chalices," he wrote of Rome at this time.

> They sell the blood of Christ by bucketfuls
> And cross and thorns are lances and shields
> And even Christ all patience loses
> But let him come no more to these city streets
> For here his blood would flow up to the very stars
> Now that in Rome they sell his skin
> And they have closed the roads to all goodness.

Alexander VI's most expensive projects, on which he expended huge sums, were the fortifications that he commissioned in defence of the papal territories. In the Papal States he built and maintained numerous castles and other defences, as well as financing a small fleet of galleys, which were needed to protect the coasts from pirates, and taking the necessary measures to ensure that the roads throughout his territories were kept as clear as possible from brigands. Large sums were also spent on military equipment, particularly on artillery, while many thousands of ducats were expended on crusading funds and subsidies to Venice for fleets deployed against the Turks.

He also spent huge sums of money in the reconstruction of the papal fortress in Rome, Castel Sant'Angelo, giving it a far more imposing external appearance. Originally constructed as a mausoleum for the Emperor Hadrian, it had fallen into disrepair and eventual ruin after the collapse of the Roman Empire, and in the twelfth century, it became a fortress of the Colonna family. Later in the Middle Ages, it had provided builders with a quarry of valuable travertine stone.

The story went that some time in its history the archangel Michael had appeared on top of this vast edifice and was seen to return his sword to its sheath as a sign that an outbreak of the plague in Rome was now over. A statue of the archangel was accordingly erected on the summit of the building where once an immense statue of Hadrian had stood. And when the builders were digging the foundations for the new works, they found a colossal bust of the emperor, which Alexander VI removed to his collection.

This huge castle, the principal defence of the Vatican and St. Peter's, was considered to be impregnable; and soon after he

became pope, Alexander VI approached Antonio da Sangallo, the Florentine architect, with a commission to transform the interior of the building into a luxurious residence, to which he might retreat in times of trouble. It was only a quarter of a mile or so from the Vatican, and it could be approached in safety from there by a walkway raised above the roofs of the intervening houses.

Pinturicchio decorated the interior as lavishly as he had the Borgia apartments in the Vatican, and this time the Borgia bulls were accompanied by scenes from the life of the pope himself, his achievements, and, of course, his family. One room contained scenes of Alexander VI's diplomatic triumph over the naive Charles VIII, most of which showed the king submitting in subservient fashion to papal authority, notably his oath of obedience sworn so publicly in the Sala Regia.

So that the pope could hold out in the castle if necessary, Sangallo was instructed to provide it with large storehouses for grain and oil as well as with dungeons for the incarceration of enemies and prisoners. It was in one of these that the sculptor Benvenuto Cellini was to be imprisoned, along with, so he claimed, "spiders and many venomous worms."

They flung me a wretched mattress of coarse hemp [Cellini later wrote], gave me no supper and locked four doors upon me. In three days that rotten mattress soaked up water like a sponge.... For one hour and a half each day I got a little glimmering of light which penetrated that miserable cavern through a very narrow aperture. Only for so short a space of time could I read; for the rest of the day and night I lived in darkness.

Far above these miserable cells, Sangallo and Pinturicchio created apartments in which Alexander VI could live comfortably and work undisturbed; and above these, on the roof of the castle overlooking the Tiber, there was, for a time, a garden; and here the pope could occasionally be seen taking the air, walking with his secretaries, or playing with his children.

~ Chapter 9 ~

Father and Children

"MOTIVATED BY HIS UNBOUNDED GREED TO EXALT HIS CHILDREN"

"EVEN MORE THAN BY anger or by any other emotion, the Pope was motivated by his unbounded greed to exalt his children, whom he loved passionately," wrote Guicciardini; unlike his predecessors on the throne of St. Peter's "who often concealed their infamous behaviour by declaring their children to be nephews, he was the first pope to announce and display them to the whole world as his own offspring."

At the time of the French invasion, Cesare was the only one of Alexander VI's children with him in Rome. His brother Juan had sailed for Spain in August 1493, to marry Maria Enriquez, cousin of the Spanish king, while Lucrezia had left for Pesaro nine months later to join her husband, Giovanni Sforza, Lord of Pesaro. Jofrè and his wife, Sancia, had been in Naples when Charles VIII invaded and they escaped to the island of Ischia. With the threat of war over

for the present, they all came back home and by the autumn of 1496 Alexander VI was once again surrounded by his family.

Cesare, by now twenty-one years old, was widely recognized as the most powerful cardinal in the college and as the most un-scrupulous. His interests and ambitions, however, were far from priestly, and his clothes were the doublets and hose of a secular prince, not a man in holy orders. He lived in splendour in an apart-ment on the second floor of the Vatican Palace, later the site of the Raphael Stanze, in rooms that were immediately above those of his father, the two suites connected by a private winding staircase. He was frequently seen in the company of the pope, who came more and more to rely upon him, and his influence in Rome grew daily, especially among those who considered their interests would be best served for the moment by being on good terms with the Borgias.

Lucrezia was deeply attached to her brother Cesare, who loved her perhaps more devotedly than he could bring himself to love anyone else. She was, however, like almost everyone else, wary of her brother and his sadistic streak; once, it was said, he invited her to stand beside him on a balcony at the Vatican while he shot at a group of criminals drawn up as target practice in the courtyard below.

Lucrezia had been in Pesaro when the French invaded but had returned to Rome at the end of June the previous year, days before the Battle of Fornovo. By now a happy, lively, attractive young woman aged sixteen, she was thankful to be back at her father's lively court after the provincial dullness of Pesaro. She was soon joined by her husband and the couple took up residence at the palace at Santa Maria in Portico, close by the entrance to the Vatican.

In May 1496 Jofrè also returned to Rome, bringing with him his wife, Sancia. The arrival of his son and daughter-in-law gave Alexander VI an opportunity to indulge in one of those pageants he so much enjoyed. The couple entered the city through the gate of San Giovanni in Laterano, which the master of ceremonies described:

The captain of the militia went to meet them with some 200 of his men-at-arms and the households and servants of all the cardinals, except for those of the prelates of the Pope, were also there to receive them. All the cardinals had been invited that morning, by the couriers of the Pope acting in the name of the Cardinal of Valence, to send their chaplains and squires, but not their prelates, to receive his brother Jofrè on his entry into the city. All acceded to this request. Lucrezia Sforza, daughter of His Holiness and wife of the illustrious Giovanni Sforza, Lord of Pesaro, also went to the said gate to meet Don Jofrè, her brother. She was accompanied by some twenty ladies and preceded by two pages on horseback wearing capes. One of the horses was covered in a magnificent cloth-of-gold caparison; the other in a caparison of red velvet. Lucrezia received Don Jofrè and his wife with affection.

Almost thirty mules trailed behind them, loaded with their luggage, conspicuously displaying Jofrè's coat-of-arms. The huge procession wound its way past the Colosseum, through the Campo dei Fiori, across the bridge at Castel Sant'Angelo, and up Alexander VI's new road, the Via Alessandrina, to the Vatican, where the pope

received them formally but no doubt with warmth from his throne in the Sala dei Pontefici.

Gian Carlo Scalona, the Mantuan ambassador, was not so impressed with Sancia, after all the reports from Naples extolling her charms and her beauty. "Indeed, the Lady of Pesaro," as Lucrezia was known, "surpassed her by far." He commented, however, that the twenty-two-year-old bride had "glancing eyes, an aquiline nose and is very well made up." He did not make direct mention of Sancia's reputation for extremely louche behaviour, though he did report to his master that the Romans had judged her ladies-in-waiting to be "a fine crop." In Naples reports of a succession of young men who had been seen entering her bedchamber had reached the stage where her staff had been obliged to insist that only one male servant, "a reliable and elderly man, over 60 years old," had access to the room.

Scalona's opinion of the much-younger Jofrè was far from being favourable; he was "lascivious-looking," but small, "and dark-skinned, 14 or 15 years old with long reddish hair." His immaturity may well explain why, as the Venetian diarist Marin Sanudo reported, Jofrè had still not consummated his marriage. It was not long after the couple arrived in Rome that rumours began to circulate to the effect that Sancia, frustrated by Jofrè's impotence, had succumbed to Cesare's charms and had become his mistress.

Whether Lucrezia knew about Sancia's relationship with Cesare or not, the two girls soon developed a close friendship. Indeed, they got on together extremely well and were often to be seen romping about just like high-spirited schoolgirls. Two days after Sancia's arrival, they attended Mass in St. Peter's to celebrate the Feast of

Pentecost, with a sermon given by a Spanish chaplain that even the dutiful Burchard described as "too long and boring, which displeased the Pope." The girls were seen, much to Burchard's disapproval, to leave their seats during the tedious service to go up together to the choir reserved for their ladies, and to chatter and laugh together, oblivious to the boring sermon.

In August 1496 Juan, Duke of Gandía, returned to Rome, on the summons of his father, leaving his son and his pregnant wife in Spain, to be welcomed to the city by an even-larger gaggle of cardinals, ambassadors, soldiers, and officials than had greeted Jofrè and Sancia. The twenty-year-old Juan cut a far finer figure than Jofrè. Magnificently clothed in a long mantle of gold brocade and a jewel-encrusted doublet of brown velvet, he wore a scarlet hat hung with pearls and rode a bay horse adorned with tinkling silver bells. He was accompanied not only by his squires but also by an unruly crowd of dwarfs and buffoons.

It was soon apparent to the Romans that Cesare and Juan detested each other. Juan was jealous of Cesare, who seemed now to be widely recognized as their father's right-hand man, while Cesare, the elder of the two, burned with resentment at the indulgence shown to his self-regarding and far less talented brother, who was clearly their father's favourite. Other than Alexander VI, very few cared for Juan, who was described by the Aragonese chronicler Geronimo Zurita as having been a "spoilt boy" and as being now "a very mean young man, full of ideas of grandeur . . . haughty, cruel and unreasonable." He could be seen swaggering about Rome in his gorgeous attire, excessively proud of his figure. Like his father, he had considerable sex appeal—it was widely rumoured that San-

cia gave her favours to both her husband's brothers, further aggra-
vating Cesare's animosity.

Cesare's dislike of his brother was increased when Juan, although
quite unsuited to such a position, was chosen by Alexander VI to
be second-in-command to Guidobaldo da Montefeltro, Duke of
Urbino and captain general of the papal armies, which the pope
intended to throw against the Orsini, a troublesome family who
had sided with the French in their recent campaign in Italy and
now controlled much of the Roman Campagna north and south of
the city.

On October 26, 1496, the two dukes, dressed in full armour, re-
ceived their banners of office from the pope in St. Peter's, and the
following day they marched north against the Orsini castles. No
fewer than ten of these were captured within a matter of weeks.
But at Bracciano, where the formidable Bartolomeo d'Alviano was
in command, the campaign faltered. Guidobaldo da Montefeltro
was wounded, not seriously but badly enough for the incompetent
Juan to be obliged to take over command. The Orsini ridiculed
him by sending a donkey into his camp with a placard tied around
its neck declaring: "I am the ambassador of the Duke of Gandía,"
and another insulting message screwed up and inserted into the
animal's anus.

Two assaults on the castle had failed when a report reached Juan
that a relieving force commanded by Carlo Orsini was marching
on Bracciano, and he unwisely decided to raise the siege and go out
to confront Orsini in the open field. On January 24, 1497, the papal
forces were routed at Soriano. The army was, in the words of Bur-
chard, "heavily defeated in great dishonour." Moreover, "the Duke

of Urbino was captured," he continued, and "some five hundred of our soldiers were killed and many more wounded, while the Orsini captured all our cannon and utterly scattered our forces."

Juan, who was slightly wounded in the face, rode back to Rome. A week or so later, Alexander VI, who had been so ill with worry that he had not been to Mass on Christmas Day, was forced to make peace with the Orsini on their terms. He had to give up all the captured castles on payment of an indemnity of 50,000 ducats, which the Orsini hoped to raise by demanding a ransom of that amount for the release of Guidobaldo da Montefeltro.

Despite his failure at Soriano, Juan was soon afterward sent in command of another papal army, this time to besiege the fortress of Ostia, southeast of Rome, where a French garrison still remained in control. This time Alexander VI turned for help to the Spanish monarchs, Ferdinand and Isabella, who sent their highly experienced and successful commander Gonsalvo di Córdoba to his aid, as well as a corps of trustworthy Spanish troops from Naples. Ostia surrendered on March 9, and the papal troops marched in triumph back to Rome, where Juan enraged Gonsalvo di Córdoba by claiming equal credit for the success at Ostia. Gonsalvo was rewarded with a papal order of chivalry while, much to the Spaniard's annoyance, Juan was given the duchy of Benevento to add to his list of titles. Cesare was also angered by the favouritism being shown to his brother, but he was careful not to show his furious jealousy.

The Dominican Friar

"YOUR HOLINESS IS WELL ADVISED
TO MAKE IMMEDIATE PROVISIONS
FOR YOUR OWN SALVATION"

IN 1481 GIROLAMO SAVONAROLA—a small, spare, ugly man aged twenty-nine, with thick red lips and an immense hooked nose—had arrived in Florence to become preacher at the church and priory of San Marco. He gradually acquired so terrible a power of oratory that congregations sat horrified and spellbound by his vivid images, his warnings of the horrors to be faced by those in his audience who did not repent of their sins.

"Behold the sword has descended," he had declaimed when King Charles VIII's armies had marched on Naples. "The scourge has fallen. The prophecies are being fulfilled. Behold it is the Lord God who is leading on these armies. . . . He will unleash a great flood over the earth. . . . It is God who foretold it. Now it is coming!"

The people had listened to his words in silent fear, waiting for the fall of the sword of the Lord that hung so threateningly over

them. "A Dominican friar has so terrified all the Florentines that they are wholly given up to piety," the Mantuan envoy had reported sardonically. "Three days a week they fast on bread and water, and two more on wine and bread. All the girls and many of the wives have taken refuge in convents, so that only old women are now to be seen on the streets."

His claim that Florence had "no other King but Christ" appealed in particular to those citizens disgusted by the corrupt Medici regime and who yearned for a return to the city's earlier republican values. When Charles VIII invaded Italy, it was not just Naples that suffered. When Piero de' Medici surrendered the Florentine fortresses to the king without permission from the government, the Signoria, Florence revolted and expelled the Medici, setting up a new government with a new Christian constitution.

God had called upon Savonarola to reform the Church, and he, with crucifix in hand, called upon the Signoria to support him in his mission. He commanded the citizens to fast, to cast aside their showy clothes and ornaments, to sell their jewels and give the money to the poor, to remove silver candlesticks and lavish illuminated books from monasteries and churches. He called upon "blessed bands" of children to march through the streets, their hair cut short, bearing crosses and olive branches, singing hymns and collecting alms for the poor, to enter houses and search out objects of vanity and luxury, to urge their parents to abandon their evil ways and follow the paths of virtue, to report to the authorities all instances of scandalous vice.

The Florentines listened and many obeyed. Courtesans stayed indoors; gamblers concealed their cards and their dice boxes; fash-

ionable ladies walked the streets dressed in quiet sober colours; balladeers closed their books of ribald songs.

In Rome Alexander VI was growing increasingly concerned about the activities and influence of Savonarola; and once the French had withdrawn from Italy after the Battle of Fornovo, he summoned the troublesome priest, now prior of San Marco, to Rome. Savonarola replied that it was not God's will that he should go. The pope, slowly abandoning hope that the prior's wild enthusiasm would sooner or later wear itself out, forbade him to preach anymore. But Savonarola, after instructing one of his disciples to preach in his stead, soon resumed his sermons in the cathedral in Florence.

Alexander VI was patient. "We are worried about the disturbed state of affairs in Florence, the more so in that it owes its origins to your preaching," he wrote to the fiery Dominican.

For you predict the future and publicly declare that you do so by the inspiration of the Holy Spirit when you should be reprehending vice and praising virtue. Such prophecies may easily lure the simple-minded away from the path of salvation and the obedience due to the Holy Roman Church. Prophecies like these should not be made when your charge is to forward peace and concord. Moreover, these are not the times for such teachings, which are calculated to produce discord even in times of peace, let alone in times of trouble.

The pope went on to say that he had resolved to call the friar to Rome again, either to purge himself of the charges or suffer punishment for his behaviour.

Since, however, we have been most happy to learn from certain cardinals and from your letter that you are ready to submit yourself to the reproofs of the Church, as becomes a Christian and a religious, we are beginning to think that what you have done has not been done with an evil motive, but from a certain simple-mindedness and a zeal, however misguided, for the Lord's vineyard. Our duty, however, prescribes that we order you, under holy obedience, to cease from public and private preaching until you are able to come to our presence, not under armed escort as is your present habit, but safely, quietly and modestly, as becomes a religious, or until we make different arrangements.

Alexander VI then decreed that the Tuscan Dominicans, who had been granted their independence, should now revert to papal control as a preliminary step toward sending the "pestilential heretic" to another monastery far away from Florence. The prior of San Marco declared that the pope had no authority in the matter. Alexander VI had no alternative but to excommunicate Savonarola for this attack on his supreme authority as pope.

When news of the excommunication arrived in Florence in June 1497, Savonarola remained silent for several months, praying for guidance. Then he announced that God's word had been vouchsafed to him, and on Christmas Day he celebrated High Mass in the cathedral.

"I can no longer place any faith in Your Holiness," Savonarola replied to a threat to place the whole city under an interdict, unless the Signoria either sent the prior to Rome or had him thrown into prison in Florence. "You have not listened to me," he continued. "I

must trust myself wholly to Him who chooses the weak things of this world to confound the strong. Your Holiness is well advised to make immediate provisions for your own salvation."

The Signoria, treated with equal high-handedness, had by now come to believe that the quarrel was getting out of hand. Savonarola's opponents were becoming more outspoken every month; and the clergy were becoming concerned about his constant insistence that his was the voice of God. The Franciscans, in particular, long antagonized by the Dominicans' claim to a special relationship with the Almighty, were demanding that the prior of San Marco should offer some proof of God's exceptional favour.

Savonarola continued to preach. Soon after delivering several dramatic sermons during Lent in 1498, he was arrested by a guard and taken to a cramped cell in the Palazzo della Signoria, known with grim humour as the Alberghettino, "the little inn." From there he was taken to be tortured by the city's rack-master.

Ambiguously he confessed all that was required of him while suffering the dreadful agonies of the *strappado,* but as soon as the straps had been released, he retracted his confession. He was tortured again and recanted again. In the end he was found guilty of heresy and condemned to death, together with two of his most devoted disciples. Messengers were sent to Rome for permission to carry out the sentence. Alexander VI in return sent commissioners to Florence to review the case. The commissioners, in their turn, ordered that the accused should be tortured once more to extract further admissions. The sentence was then confirmed and orders were given for Savonarola and his two fellow friars to be hanged in chains and burned.

An immense pile of brushwood was prepared; a gallows was erected in its centre; and a high platform was built from the door of the Palazzo della Signoria to the gallows' ladder, so that all who had been disappointed by the cancellation of the ordeal might be compensated by a view of the three Dominicans being conducted to their deaths. "They were robed in all their vestments," Luca Landucci entered in his diary under the heading of May 22, 1498:

These were taken off one by one with the appropriate words for the degradation. . . . Then their faces and hands were shaved as is customary in this ceremony. . . . When all three had been hanged a fire was made on the platform upon which gunpowder was put and set alight, so that the said fire burst out with a noise of rockets and cracking. In a few hours they were burnt, their legs and arms gradually dropping off. Part of their bodies remaining hanging to the chains, a quantity of stones were thrown to make them fall, as there was a fear of the people getting hold of them.

Murder

"His Holiness . . . thinks of nothing but
the way in which he may safely
lay hands on the guilty men"

"On Wednesday 14 June 1497," so Johannes Burchard care-
fully recorded,

Cardinal Cesare Borgia and Don Juan Borgia, Duke of
Gandía, both dear sons of His Holiness, had supper with
Donna Vannozza, their mother, and some other guests, in her
villa near the church of San Pietro in Vincoli. After the meal,
and since night was coming on, the Cardinal suggested to his
brother the Duke that they should return to the Vatican; and
so they mounted their horses and left with only one or two
servants to accompany them. They rode together almost to
Cardinal Ascanio Sforza's palace, which had been built by His
Holiness when he was vice-chancellor. At this point the Duke

told his brother that he wanted to go out in pursuit of further pleasure before going back to the palace.

Juan, therefore, left his brother, dismissed the few servants he had with him, except for a footman and a mysterious man in a mask who had joined Juan during the supper party at his mother's and who, moreover, had been to see Juan at the Vatican almost every day for the past month.

Juan made room for this masked man to ride behind him on his mule, and they rode off together to the Piazza degli Ebrei, where Juan told the footman to wait there an hour and then, if he had not returned, to go back to the Vatican. Soon afterward the footman was attacked and badly wounded. Discovered in a pool of blood, he was dragged into a nearby house, whose owner was so frightened that he refused to report what had happened until the next morning, by which time the man was dead.

By now Juan's disappearance was causing consternation at the Vatican Palace. Alexander VI hoped that perhaps he had spent the night with a woman and had not wanted to be seen leaving her house in daylight. But the longer Alexander VI waited for his son's return, the more anxious he became.

He made urgent enquiries in the area where Juan was known to have been the night before. One of those questioned was a timber merchant whose practice it was to have his wood unloaded from boats in the Tiber not far from the hospital of San Girolamo degli Schiavoni. This man said that he had been keeping a watch on a delivery of timber when, close to midnight, he saw two men walk down to the riverbank, where they looked about them, presumably

to see if the coast was clear. Shortly afterward two other men stealthily approached the water, where they were joined by a man on a white horse, which appeared to have a corpse slung across its back. He and the four other men then moved silently along the riverbank, halting just past a place where sewage and rubbish were customarily thrown into the water.

Here the dead body was pulled from the horse and hurled into the Tiber. The rider who had brought it then asked the others if it had sunk. He was assured that it had; but, noticing the corpse's cloak still floating on the surface, he threw stones at it until it had disappeared from view. The five men then left the river together and were soon lost to sight.

All this the timber merchant related when questioned. Asked why he had not reported these events earlier, he replied that he must have seen at least a hundred bodies thrown into the river at that point and had never thought much about it.

Fishermen and boatmen were now called up and ordered to drag the riverbed. They soon found Juan's body. It was fully dressed, with a purse tucked into a belt, which still contained 30 ducats. He had been stabbed repeatedly in his body, legs, and head.

The corpse was then taken to Castel Sant'Angelo, where it was stripped, washed, and dressed in military uniform before being taken to the Church of Santa Maria del Popolo in a procession led by over one hundred torchbearers, ecclesiastics, and members of the dead man's household, all, so Burchard related, "marching along, weeping and wailing and in considerable disorder."

Alexander VI was distraught, "shutting himself away in a room in grief and anguish of heart, weeping most bitterly. . . . From the

Wednesday evening until the following Saturday morning, he ate and drank nothing, whilst from Thursday morning to Sunday, he was quiet for no minute of any hour."

On the Monday, June 19, the pope made a solemn announcement at a special consistory called for that morning:

> The Duke of Gandía is dead. A greater calamity could not have befallen us for we bore him unbounded affection. Life has lost all interest for us. It must be that God punishes us for our sins, for the Duke has done nothing to deserve so terrible a fate.

WHEN HE HAD RECOVERED from the first pangs of grief, the pope determined to reform the Curia, the papal government. "We are resolved without delay to think of the Church first and foremost, and not of ourselves nor of our privileges," he announced, adding that "we must begin by reforming ourselves." For years the Curia had been allowed to become lax and corrupt, manned by officials who were steadily enriching themselves at the Church's expense. He established a reform commission that produced a highly critical report. His enthusiasm soon evaporated, however; and having ordered the arrest of one of his more self-serving officials, Bartolomeo Flores, the archbishop of Cosenza, Alexander VI quickly abandoned his proposed programme of reform and helped himself to much of the fortune that the archbishop had managed to accumulate.

Flores, deprived of his see, was taken from his dungeon to a cell in Castel Sant'Angelo, where he was required "to wear a gown of

coarse white cloth and a heavy white cap, to sleep on a straw mattress, to be content with one cask of water and three loaves of bread a day, one jug of oil and a lamp, a breviary, a Bible and a copy of the Epistle of St. Peter." He died in his damp cell soon after his incarceration there, and his body was taken to the Church of Santa Maria in Transpontina, and there buried "without any torches, mourners, church ceremony or service."

Meanwhile, several men had been questioned about Juan's murder. Alexander VI had sorely missed his favourite son while Juan had been in Spain and had called him back to Rome, appointed him to command the papal armies, unsuited though he was to such a challenge, and had given him what was considered the undemanding task of turning the troublesome Orsini family out of the castle at Bracciano.

Juan's failure at Bracciano and his seduction of Sancia, Cesare's mistress, had infuriated Cesare, fuelling his jealous dislike of Juan as the obvious favourite, though unworthy and conceited second son. Jofrè also had cause to feel affronted at Juan's behaviour. Nor were the two brothers the only men suspected of Juan's murder, for this was a man with many enemies, particularly among the Orsini and their allies.

A few weeks after the murder, on July 1, the Florentine envoy in Rome reported that since Alexander VI no longer showed much interest "as to the man guilty of the murder," it was "held to be certain beyond any doubt that His Holiness has now discovered the truth, and that he thinks of nothing but the way in which he may safely lay hands on the guilty men." And later that year, Manfredo Manfredi, the Mantuan ambassador, told the Duke of Ferrara: "It seems that, more than ever, the Pope gives signs of blaming the

Orsini for the murder of his son; and it is believed that he is disposed to avenge it." At the same time, it was reported from Venice: "His Holiness intends to ruin the Orsini because they certainly caused the death of his son, the Duke of Gandía."

Soon after these suspicions were voiced, it became generally accepted in Venice that Cesare, rather than the Orsini, was responsible for the murder. Sancia of Aragon seems to have suspected Cesare, and this was also common gossip in Spain, where both Queen Isabella and Maria Enriquez, Juan's widow, were inclined to believe that the circulating stories of Cesare's guilt were probably true.

As for Alexander VI's opinion of the identity of the murderer of his son, the pope did not commit himself, but he did exculpate, for one reason or another, most of those upon whom suspicion had fallen. Among these were Giovanni Sforza and his uncle Ascanio Sforza, who was known to have quarrelled recently with the Duke of Gandía, and Guidobaldo da Montefeltro, the Duke of Urbino, who had fought with Juan against the Orsini but, after being taken prisoner, had been left to languish in prison until ransom was paid by his loyal subjects.

Another Husband
for Lucrezia

"She was prepared to . . . submit herself
to the examination of midwives"

Lucrezia received the news of her brother's horrific murder in her rooms in the Dominican convent of San Sisto, a tranquil place situated on the Via Appia, opposite the Baths of Caracalla, surrounded by orchards and vineyards, and some distance from the centre of Rome. She had taken refuge here on June 4, ten days earlier; when, shortly after she arrived, papal guards came to conduct her to the Vatican, the abbess assured them that Lucrezia was staying in the convent at her own request and persuaded them to leave her in peace.

Her desire had been to escape the stories that were spreading like wildfire through the city to explain why she had been abandoned by her husband, Giovanni Sforza. One report mentioned that she had "left the palace and gone to a convent," adding ominously, "Some say she will turn nun, while others say many other

things which one cannot entrust to a letter." Rumours of her in-
cestuous relationships with her brothers and even her father, the
pope, abounded; within days of the murder, Giovanni was sus-
pected of committing the crime "because the Duke of Gandía had
had commerce with his wife."

At the time of Juan's murder, however, Giovanni was not in
Rome. The alliance between the Borgias and Milan, which had
seemed such an excellent idea three years before, had now lost its
appeal, and the pope was determined to end it. Threatened and
taunted by the Borgia brothers, fearful for his very life, and worried
that he might be obliged to repay the 31,000 ducats he had received
as Lucrezia's dowry, the lacklustre Giovanni had fled Rome on
Good Friday, March 24, for Pesaro. His fears had grown when,
after begging Lucrezia to join him, she—encouraged by both Ce-
sare and the pope—had refused to do so. These fears had been re-
alized at the end of May, a fortnight before Juan's brutal murder,
when Alexander VI's lawyer had arrived in Pesaro to serve him
with a writ for divorce.

At first it had been thought that since Lucrezia's first betrothal
to Gasparo di Procida, the Count of Aversa, had not been formally
dissolved at the time of her marriage to Sforza, it would be pos-
sible to use these grounds to claim that the marriage was invalid.
But this weak excuse proved unacceptable to the wily lawyers in-
volved in the case. So it was decided instead to argue that the mar-
riage, which had taken place in 1493 when Lucrezia was just
thirteen years old, had never been consummated, thus leaving her
a virgin and free to take another husband more to her father's po-
litical taste.

Lucrezia duly signed a declaration to the effect that "after three years of marriage . . . without sexual relations or carnal knowledge, she was prepared to swear on oath to this and to submit herself to the examination of midwives." Alexander VI now insisted that Giovanni make a public declaration that he was impotent, a humiliating prospect and a cruel one.

The unfortunate Giovanni was understandably furious, dismissing the allegation as absurd. He was far from impotent, he protested; he had, he insisted, made love to his wife on countless occasions. Moreover, he pointed out that his first wife had died in the course of giving birth to their child. Finally he approached his uncle Ludovico Sforza for help, but the duke did not take him seriously. He suggested Giovanni should prove his virility with Lucrezia, somewhere outside Rome, with witnesses who could observe the event; or a public demonstration could be arranged with some complaisant lady in Milan, with the papal legate, the cardinal of Monreale, who was one of Alexander VI's nephews, as a witness.

Giovanni now declared that the pope wanted to get him out of the way so that he could enjoy his daughter's body more conveniently himself. Moreover, he hinted that while he had not been allowed to share a bed with Lucrezia, now aged seventeen, both her father and her brother Cesare had done so. The rumours of incest, a sin as offensive then as it is now, spread like wildfire through Rome and all of Italy. Born out of Giovanni's desire for revenge on the family who were taunting him so unfairly, the story stuck.

Many who saw Lucrezia in public, smiling in the company of her adored and adoring family, found the sensational rumours easy to believe, as they did when the pope left her in charge of papal affairs

while he was absent from Rome. Yet it was unusual for a daughter to be given this responsibility, though not because she was a lady— the rulers of Italy's courts regularly left their wives in charge of their affairs while they were fighting, earning their livings as mercenary soldiers, and the pope was doing no more than leaving the reins of power in the hands of the person upon whose loyalty he could rely utterly. And those who saw her in the circle of her household found the persistent talk of incest difficult to credit. She seemed too de-mure, too innocent.

Cesare, meanwhile, had official duties to perform. A week before Juan's assassination, the pope had nominated his son, still a few months short of his twenty-second birthday, to the prestigious po-sition of papal legate "to anoint and crown the most serene Fed-erigo of Aragon" as king of Naples. He arrived in Capua, where the coronation was to take place, in good time for the event, which was planned for August 6, 1497, entering the city with an imposing cav-alcade that included seven hundred horses as well as numerous ser-vants, guards, prelates, and a straggling crowd of camp followers. Unfortunately he was suddenly taken ill soon after his arrival, and the coronation had to be postponed. He recovered quickly, how-ever, from this illness, which was rumoured to be some sort of vene-real complaint, and on August 11, gorgeously attired in red velvet and cloth-of-gold, he was carried in one of his father's papal chairs to the cathedral, where he played his part in the delayed ceremony with dignified composure.

Cesare obviously enjoyed his stay in Capua and Naples, where he walked about the city in his splendid clothes, clearly relishing the attentions of an admiring and envious populace; and, so it was said, casting lascivious eyes on the daughter of the Conte d'Aliffe, on

whom he spent the enormous sum of 200,000 ducats with a careless extravagance that had by now become customary. He fell ill again, soon after his return to Rome, and this time the gossips were quick to identify his complaint as syphilis, the French disease, so Isabella d'Este was informed by her agent, Donato de' Preti, who wrote to her from Rome to say that "Monsignor of Valencia has returned from Naples after crowning King Federigo and he is now sick with the *morbo gallico.*" Cesare's personal physician, Gaspar Torella, would gain enough experience of the disease to write a treatise on it, which he dedicated to his patient.

Cesare had returned to Rome on September 5 and had ridden directly to the Vatican, where he and his father spent several hours closeted in private discussion. While in Naples, Cesare had persuaded King Federigo to make an offer of a new bridegroom for Lucrezia, in the shape of Alfonso of Aragon, the Duke of Bisceglie. This amiable and handsome eighteen-year-old youth was Sancia's brother, and though he was, like her, illegitimate, this offer to reinforce the links between Rome and the royal house of Naples, not to mention Spain, was greeted by the pope with enthusiasm.

More complicated, however, was the issue of Cesare's own future. With Juan dead and the fifteen-year-old Jofrè showing no signs of fathering an heir, it was up to him to secure the future of the Borgia dynasty, something he could not do while still a cardinal. Moreover, although his father was hale and hearty, he was now approaching his sixty-seventh birthday, and time was not on their side. Cesare himself was eager to concentrate upon "warlike undertakings" and to take over Juan's position as commander of the papal armies, but the pope advised caution and the need to find him an appropriate wife before making any rash decisions.

The choice of a wife for Cesare, indeed, had quickly become the talk of Rome. One rumour had it that Sancia was prepared to overlook her suspicions of Cesare's involvement in his brother's murder and marry him, while her young husband, Jofrè, would be appointed a cardinal in his place. It was soon clear, however, that both the pope and Cesare had more ambitious plans, and that while he was in Naples, Cesare had approached King Federigo about the possibility of arranging a marriage between himself and the king's daughter, Carlotta of Aragon, who was currently living in France at the court of the French queen Anne of Brittany.

King Federigo might have been prepared to offer the illegitimate Alfonso as bridegroom for Lucrezia, but he fought shy of agreeing to a marriage between his own legitimate daughter and the licentious, power-hungry Cesare, who clearly had an eye on the Neapolitan throne. Anxious not to offend the pope, Federigo temporized: "It seems to me," he was reported by the Venetian ambassador to have said, "that the son of a pope, who is also a cardinal, is not the ideal person to marry my daughter. If the Pope can make it possible for a cardinal to marry and keep his hat, I'll think about giving him my daughter." Nor was his daughter happy with the proposed match; not only was Carlotta in love with a Breton nobleman, but she was also determined not to marry "a priest who was the son of a priest."

With the issue of a wife for Cesare temporarily in abeyance, the pope now concentrated his efforts on finalizing the annulment of his daughter's marriage. Under pressure from his uncles Duke Ludovico and Cardinal Ascanio, Giovanni Sforza finally gave way. "If His Holiness wants to create his own kind of justice," he declared, "there is nothing I can do about it; let the Pope do what he likes, but

God watches over all things." On November 18 he reluctantly put his signature to the humiliating declaration: "I never knew her."

A month later the marriage was dissolved. The demure Lucrezia was present at the ceremony in the Vatican on December 22 that formally declared her to be *virgo intacta* and, as such, legally able to contract another marriage. She gave a short speech of thanks in Latin, which the Milanese ambassador praised for its elegance: "If she had been Cicero himself," he mused, "she could not have spoken with more grace." But most of Rome, still buzzing with the rumours of her incestuous relationships with her father and brother, agreed with the Perugian chronicler Francesco Matarazzo, who thought the declaration that Lucrezia was a virgin to be a proposition so outlandish that it "set all Italy laughing," since it was, he explained with characteristic hyperbole, "common knowledge that she had been and still was the greatest whore there had ever been in Rome." She was, in fact, by this time, six months pregnant, though her ladies-in-waiting had dressed her carefully, to ensure that there were no visible signs of her condition.

In the convent of San Sisto, while her husband was being pressed to sign the required admission of his impotence, Lucrezia had received regular visits from a good-looking young Spaniard, a valet in her father's service, one Pedro Calderon, to whom she seems to have become passionately attached; and on March 15, 1498, according to the reports of the Ferrarese ambassador in Venice, she gave birth to a boy.

When Cesare heard of Calderon's guilt, so it was rumoured, he was determined to punish the valet for what he took to be his intolerable presumption. Finding him one day near Lucrezia's room in the Vatican, after her return from the convent, he rushed at the

man, brandishing his sword. Calderon ran away, seeking to escape the violent Cesare by throwing himself into the arms of Alexander VI, who threw his papal robe about the young man. But Cesare slashed at him with his sword, splashing his father's robes with blood. A month before the boy was born, the body of Calderon was fished out of the Tiber, together with that of Lucrezia's maid, Pantiselia. As the papal master of ceremonies Johannes Burchard recorded, he "fell, not of his own free will, into the Tiber and was fished up today in that river."

Lucrezia's baby seems to have been stillborn or to have died soon after birth, in what would become a sad and familiar end to her pregnancies. At about this time, confusingly, another Borgia child appeared in the Vatican and was christened Juan, in memory of the murdered Duke of Gandía. Endeavouring to explain Juan's existence, the pope issued two bulls, one of them secret. The official bull declared that the child, delicately described therein as "the Roman infant" (*infans Romanus*), was the son of Cesare Borgia by an unnamed spinster; the secret bull, on the other hand, maintained that the child was that of Alexander VI himself by the same unnamed spinster. The child was undoubtedly his, conceived while he was pope, but it was the identity of the spinster that caught the imagination of the Roman gossips; given the widely believed rumours that incest was rampant among the Borgias, it was perhaps inevitable that she was quickly identified as the pope's own daughter (though Lucrezia herself would always consider Juan as her half-brother, as would later historians).

Meanwhile, arrangements for Lucrezia's Neapolitan marriage went ahead, and Alexander VI agreed to provide the sum of 40,000 ducats for his daughter's dowry, a third more than he had

paid for her marriage to Giovanni Sforza. On July 21, 1498, Lucrezia and Alfonso, Duke of Bisceglie, were formally pronounced man and wife in a private ceremony, held "without pomp," according to Burchard, in Lucrezia's palace at Santa Maria in Portico, where, in the presence of various ecclesiastics including several bishops and three cardinals, a sword was held over the heads of the bride and bridegroom.

The couple—he a good-looking, lively young man, she still a pretty, high-spirited girl—consummated their marriage and spent the next few days feasting and dancing. A fight between Cesare's servants with those of Sancia marred the decorum of the wedding festivities but did not altogether spoil them. Cesare himself, still a cardinal, caused considerable surprise and, no doubt, ironical amusement by appearing with his brothers and courtiers in a masque dressed in the guise of a unicorn, the horned emblem of female chastity.

However, even while the Neapolitan alliance was being celebrated in Rome, the storm clouds were gathering on the Italian horizon. On April 7, 1498, the young King Charles VIII had died, very suddenly, after striking his head on a door lintel at the château of Amboise. He was just over a month short of his twenty-eighth birthday and had been married for over six years; his wife, Anne of Brittany, had borne him four children but none had survived infancy, and so the crown passed to his cousin, the thirty-six-year-old Louis, Duke of Orléans.

Eight days before he died, Charles VIII had seen a great serpent in his dreams, and when asked what this meant, his astrologers had replied that it was a sign that he would return to Italy. But after his death, reported the Venetian diarist Marin Sanudo, "the said

astrologers changed their minds, saying that the serpent meant that he would be succeeded by the Duke of Orléans, as has happened, because the Duke carries this emblem on his coat-of-arms." The serpent on his shield was the Visconti viper: Louis was the legitimate heir of the old regime that had ruled Milan before the Sforzas had seized power, and he intended to enforce his claim.

~ Chapter 13 ~

The Unwanted Cardinal's Hat

"HIS MIND AND HIS DESIRE
AND HIS INCLINATION WERE STILL
FOR THE SECULAR LIFE"

TALL IN STATURE, with a long face and a grave countenance, the new French king, Louis XII, was certainly more regal in appearance than his ugly predecessor; after a misspent youth, he had settled into middle age, devoting his time to hunting and falconry. At his unexpected succession to the French throne, he had several reasons for negotiating an early alliance with the Borgia pope.

Louis XII needed Alexander VI's support to enforce his claim to the duchy of Milan; as the legitimate grandson of Valentina Visconti, daughter of the great Duke Gian Galeazzo, he had a better right to the title than the current duke, Ludovico Sforza, brother of Cardinal Ascanio, whose ancestors had been born on the wrong side of the blanket (Ludovico had inherited the title in 1494 at the death of his nephew, Gian Galeazzo, which, so it was said, had been "provoked by an immoderate coitus"). Louis XII also intended to

revive the French claim to Naples, which Charles VIII had failed to retain after his conquest of the kingdom three years earlier. More pressing, however, was the king's need for a divorce from his hunchbacked and barren wife, and for a papal dispensation that would allow him to marry Charles VIII's widow, Anne of Brittany, not only to retain that troublesome region for the French realm but also to produce an heir.

In return for the dissolution of his marriage, as well as a cardinal's hat for his trusted friend and councillor Georges d'Amboise, the archbishop of Rouen, Louis XII devised an offer that neither Alexander VI nor the ambitious Cesare could refuse. In addition to a handsome sum of money, the king proposed to give Cesare the duchy of Valence and to bestow upon him the coveted collar of the French royal chivalric Order of St. Michael. He also offered to use his influence to arrange Cesare's marriage to Carlotta of Aragon, daughter of the king of Naples and lady-in-waiting to Anne of Brittany. Moreover, providing Cesare agreed to fight with the French army during his forthcoming campaign to oust the Sforzas from Milan, Louis XII promised to give him the command of a large body of armed French lancers, which would be maintained at the king's expense but would serve under Cesare's command, wherever, significantly, the new duke wished.

The offer was accepted, just as the king had hoped. And so, on July 29, 1498, Alexander VI duly issued a papal brief listing eight reasons why the royal marriage was invalid and set up a commission of cardinals and prelates in France to examine Louis XII's case for divorce. It was now time for Cesare to "put off the purple . . . with the least possible scandal . . . and with the most decorous pretext." Three weeks later, on August 17, as Burchard recorded:

There was a secret consistory in which Cardinal Cesare Borgia declared that from his early years he was always, with all his spirit, inclined to the secular condition; but that the Holy Father had wished absolutely that he should give himself to the ecclesiastical state, and he had not believed he should oppose his will. But since his mind and his desire and his inclination were still for the secular life, he besought His Holiness Our Lord, that he should condescend, with special clemency, to give him a dispensation, so that, having put off the robe and the ecclesiastical dignity, he might be permitted to return to the secular estate and contract matrimony; and that he now prayed the Most Reverend Lord cardinals to give their consent willingly to such a dispensation.

That same day, Louis de Villeneuve, Baron de Trans, arrived at the gates of Rome, bringing with him Louis XII's letter appointing Cesare as Duke of Valence and an invitation for this new French aristocrat to visit his court. "He came in the name of the King of France," reported Burchard, "to escort the most reverend Cardinal of Valencia to that country." To the pedantic master of ceremonies, Cesare was still a cardinal, despite having announced his resignation, because his decision had not, that day, been ratified by the college.

Rather than agree to this most unusual arrangement, several cardinals had avoided voting by absenting themselves from the consistory on August 17, making the excuse that cases of plague in Rome rendered it prudent for them to leave the city for the healthier air of the countryside. But the pope called another consistory six days later, writing to all the cardinals who were in the neighbourhood,

so the Venetian envoy reported, "telling them that they must come to Rome because matters concerning the welfare of the Church and Christianity were to be discussed. So the dissident cardinals yielded," clearly with some reluctance, "and Cesare Borgia could now take off his [cardinal's] hat and make himself a soldier and get himself a wife." The twenty-three-year-old cardinal of Valencia had become the Duke of Valence, from which he derived his nickname, il Valentino. He was now free to marry and profess himself openly as a soldier.

Cesare's behaviour had long been inappropriate for a prince of the church. He rarely wore his plain clerical garb, preferring instead the elaborate outfits of a courtier or even, on occasion, fancy dress. "Monsignor of Valencia exercises the practice of arms every day," wrote Cristoforo Poggio to Mantua on January 19, 1498, observing that he "seems resolved to be a gallant soldier." Nor were his religious observances such as those expected of a member of the sacred college: "Cardinal Valentino attended the solemn mass in the papal chapel," wrote Burchard on April 21, the Saturday after Easter, lamenting his conspicuous absence during the ceremonies held during Holy Week, "but he has not previously been seen there since Passion Sunday."

Now that he was a duke rather than a cardinal, Cesare took pleasure in demonstrating his skills, martial and equestrian, before astonished spectators. The day after announcing his resignation from the sacred college, so the Mantuan ambassador Gian Lucido Cattaneo reported, he did so in Cardinal Ascanio's hunting park before an audience that included Lucrezia and Sancia: "Armed as a janissary, with another fourteen men, he gave many proofs of strength

in killing eight bulls," and, added Cattaneo, "in a few days I hope to see him fully armed on the piazza."

Indeed, Cesare needed to hone his athletic skills to impress the French court, where he would soon be a guest, and spent much of his time practising "the exercise of arms, horses and leaping." He sometimes overreached himself; one day in the Belvedere, for instance, when practising leaps across the backs of horses and mules, he tried, in one bound, "to mount a mule rather taller than the rest," Cattaneo reported, "and when he was in the air the mule took fright and kicked him in the ribs and on the back of the head, and he lay unconscious for more than an hour."

Cattaneo was, however, not so impressed with the new duke's appearance. "He is well enough in countenance at present," he reported, somewhat grudgingly, "but his face is blotched beneath the skin as is usual with the great pox." These marks were the customary signs of secondary syphilis, and Cattaneo believed that Cesare was apprehensive about going to France to marry the Neapolitan princess Carlotta of Aragon, lest that scarred face of his, "spoiled by the French disease," would induce his intended bride to refuse him.

This was not Cesare's only concern; there were reports that the king of Spain was "extremely displeased" about the Borgia alliance with France. Cattaneo reported that the pope had assured one cardinal that Louis XII was most anxious to have Cesare in his service and the cardinal had replied that "it is true Valence is a dexterous man," but he warned the pope, "Beware, Holy Father, that you do not aim so high that if you or he fall, you will break too many bones." Many Italians also feared this alliance between the pope and a king who openly professed his claim to both Milan and

Naples; it promised another invasion of the ruthless men of the north and, as Cattaneo dramatically put it, "the ruin of Italy."

Such warnings did not deter Alexander VI, who was determined to do all that he could to further his son's career. He raised 200,000 ducats to cover the expenses of Cesare's trip to France to ensure that his appearance at the French court was as dramatically imposing as possible. This huge sum came partly, so it was believed, from impositions on the Jews in Rome and partly from the sale of goods confiscated by the pope from his Spanish majordomo, a converted Jew who had been appointed as bishop of Calahorra and had been charged by Alexander VI with heresy.

Cesare spent most of this money on "jewels, stuffs, cloth-of-gold and cloth-of-silver, silks and other luxurious goods, much of them imported at considerable expense from Venice." For his use on the journey to France, he commissioned a commode for his personal use, "covered with gold brocade outside and scarlet inside, with silver vessels within the silver urinals." It was said that even the shoes of Cesare's horses were inlaid with silver and loosened so that they fell off to be picked up by the most nimble-footed among the cheering crowds.

So it was that, on October 1, 1498, Cesare left Rome for Civitavecchia, where two French galleys were waiting to take him to Marseilles. "We are sending you our heart," Alexander VI had written to Louis XII in a letter that Cesare was taking with him to France, "that is to say our beloved son." The pope watched the departure of his "beloved son," standing at the window of the Vatican until the cavalcade was out of sight.

Cesare was, as usual, gorgeously dressed, wearing a black velvet mantle over his shoulder, a white brocade tunic, a black velvet cap,

sparkling with rubies, and boots sewn with gold chains and pearl droplets. Riding a bay horse caparisoned in red and gold, the French royal colours, he was accompanied by the French envoy Baron de Trans and by an ostentatiously large retinue: the members of his household, not forgetting his diligent physician, Gaspar Torella; a richly dressed crowd of young noblemen, Spanish and Roman; scores of pages, grooms, and guards; fifty mules and twelve carts piled high with baggage. Carefully secreted in his luggage was the cardinal's hat for Georges d'Amboise, the archbishop of Rouen, and the dispensation, signed by the pope, that would allow Louis XII to remarry, providing, of course, the divorce commission pronounced in the king's favour. The new duke was finally on his way to find his own bride.

~ Chapter 14 ~

Cesare's French Bride

"The most contented man in the world"

Cesare's reception at Marseilles was suitably boisterous. Welcomed by the roar of cannons, the royal guests were met by four hundred archers who marched forward to escort the visitors to the quarters reserved for them. They spent almost a week in the city, enjoying the entertainments on offer, feasting at several banquets, and being shown such sights as the place had to offer.

Leaving Marseilles at the end of October, Cesare and his entourage started the long journey north to the French court, which was currently in residence in Chinon, some twenty-five miles southwest of Tours, where the divorce commission was still deliberating Louis XII's divorce. At Avignon they were the guests of the papal legate—this was none other than Cardinal Giuliano della Rovere, who would, as Pope Julius II, later cause such terrible trouble for Cesare. For now, outwardly at least, they were on amicable

terms, particularly since Alexander VI was relying on the cardinal to assist with negotiations at the French court in return for the pope's help in restoring the della Rovere family to their former position of influence in Rome.

As a demonstration of this alliance, uneasy though it was, between Alexander VI and Giuliano, the legate had ridden two miles out of Avignon to meet Cesare and escort him into the city. "Avignon never witnessed such an enthusiastic welcome," wrote a witness of the scene. "Nor in the city had there ever been a more splendid procession." He was greeted with fountains gushing wine, presented with valuable pieces of silver plate, and "fêted by ladies and beautiful girls in whom the said Cesare takes much pleasure, knowing well how to dance and entertain them, the dances being morrisses, mummeries and other frivolities."

Unfortunately, Cesare was in no mood to enjoy the festivities. Once again he was suffering from a recurrence of his venereal disease. So, indeed, was Giuliano: "Della Rovere has fallen sick again of that illness of his," one informant told Ludovico Sforza. "Now the flowers [as the syphilitic rashes were euphemistically known] are starting to bloom again; if God does not help him, he will never be quite healthy. Also they say publicly of Cesare that he too has the malady of St. Lazarus in his face and, moreover, he is in a discontented frame of mind."

From Avignon Cesare travelled up the Rhône valley to Valence, the capital of his duchy, and then on to Lyons, where he arrived on November 7. From Lyons he dawdled, taking every opportunity to delay his arrival at the French court until the divorce commission had declared its verdict. Crowds gathered in every town to watch him pass by; as the son of a pope, he was an object of considerable

curiosity. His entourage was led by a parade of sumpter mules, each bearing the Borgia crest and followed by two more mules carrying huge chests, the contents of which became a lively subject of debate among the crowds of onlookers. After these came the gentlemen of Cesare's household, their horses caparisoned with immense cockades and silver bridles, followed by twenty pages dressed in red velvet and cloth-of-gold, by young noblemen of Rome and Spain, and by his personal bodyguard of Spanish mercenaries. Cesare himself rode past imperiously, pearls and precious stones decorating his black velvet costume, his hat, and even his boots.

He did not create a good impression on his route north to Chinon. He was said to be aloof and arrogant, all too ready to take offence and to give it. To the French, his ostentatious retinue appeared absurdly pretentious for a twenty-three-year-old youth who was not only illegitimate but was also unable to claim one drop of royal blood. His impassive manner was viewed as haughty; on occasion he was even insolent, as when, at a reception at Valence, Louis XII's representative came forward with the collar of the Order of St. Michael and would have placed it around his neck, but Cesare pushed it away, saying that it was for the king himself to bestow.

Finally, on December 17, the cardinal of Luxembourg announced that the divorce commission had found in Louis XII's favour, freeing him from what he himself described as this "cripple, afflicted with scrofula, repellent in person and mind." The divorced wife, by her own admission not a beauty, had remained dignified throughout the proceedings; she retired to a convent, founded her own order of nuns, and was canonized in 1950.

The following day Cesare made his formal entry into Chinon, crossing the bridge over the Vienne with the great medieval castle, stronghold of the Plantagenet kingdom in France, looming mightily over the town. He was accompanied by Georges d'Amboise, whose red hat was in the duke's baggage, along with the papal dispensation that would allow Louis XII to marry Anne of Brittany. A man who was there gave a description of the occasion:

The Duke of Valence entered thus on Wednesday, the eighteenth day of December 1498 . . . preceded by twenty-four handsome mules carrying trunks, coffers and chests, covered with cloths bearing the Duke's arms, then again come another twenty-four mules with their trappings halved in red and yellow. . . . Then twelve mules with coverings of yellow striped satin. Then came six mules with trappings of cloth-of-gold. . . . And after came sixteen beautiful great chargers, led by grooms, covered in cloth-of-gold, crimson and yellow . . . after these came eighteen pages, each one on a fine charger, of whom sixteen were dressed in crimson velvet, the two others in cloth-of-gold. . . . Then came six fine mules richly equipped with saddles, bridles and trappings in crimson velvet, accompanied by grooms dressed in the same. Then two mules carrying coffers and all covered in cloth-of-gold. . . . Then after came thirty noblemen clad in cloth-of-gold and silver, followed by three musicians, two tambours and one rebec, dressed in cloth-of-gold according to the style of their country, and their rebecs had strings of gold. They marched between the gentlemen and the Duke of Valence, playing all

the while. Then came four musicians with trumpets and clar-
ions of silver, richly dressed, playing their instruments with-
out ceasing. There were also twenty-four lackeys all clad in
crimson velvet halved with yellow silk, and they were all
around the Duke; beside him rode [Georges d'Amboise], con-
versing with him.

As to the Duke, he was mounted on a great tall horse very
richly harnessed, with a covering of red satin, halved with
cloth-of-gold and embroidered with very rich gems and large
pearls. In his cap were two double rows of five or six rubies, as
large as a big bean, which gave out a great light. On the brim
of his cap there were also a great quantity of jewels, even to his
boots, which were all adorned with chains of gold and edged
with pearls.

Cesare rode through the town of Chinon, glittering with jewels
and the finest clothes. From the castle windows high above, the
king and his courtiers watched the procession and were exceed-
ingly entertained by what they considered the "vanity and ridicu-
lous pomposity of this duke." On entering the château, Cesare
made "a profound reverence to the ground to His Majesty," re-
ported the Venetian ambassador, "then, half way across the great
hall, he made another reverence, and then, coming up to the King,
he made as if to kiss his foot, but the King prevented this, so he
kissed his hand instead, as did the gentlemen of his suite." And after
dinner Cesare was escorted to the royal apartments, where he re-
mained with the king "to the fourth hour of the night," and the fol-
lowing day Louis XII entertained Cesare in the company of several
fashionable ladies. Indeed, despite his earlier ridicule, the king was

clearly deeply impressed with this extraordinary young man, who could be so agreeable when he chose to be so, especially when flattered by royalty.

On December 21, in a magnificent ceremony in the Church of St.-Mexme at Chinon, in the presence of King Louis and Cesare, Cardinal Giuliano della Rovere solemnly invested Georges d'Amboise with his cardinal's hat. "On the journey from the royal court to the church," reported Burchard, who was not there but was informed of the event, "the illustrious Cesare, Duke of Valence, formerly cardinal, carrying the hat for all to see, walked behind the other princes and immediately in front of the King, as if he were the royal equerry."

Cardinal Giuliano sent news to Rome of Cesare's success at the French court. "I cannot refrain from informing Your Holiness that the most illustrious Duke is so endowed with prudence, ability and every virtue of mind and body, that he has conquered everybody," he wrote to the pope on January 18, 1499. "He has found so much favour with the King, and all the princes of this court," he added, "that everyone holds him in esteem and honour of which fact I willingly and gladly give testimony."

Louis XII and Anne of Brittany were married in the castle at Nantes on January 6, 1499. Cesare's marital prospects, however, were not looking so positive. He had hoped that by now Carlotta of Aragon might have changed her mind about marrying him; but the Neapolitan princess was more stubborn than ever in her refusal to do so, "unless," so Cardinal della Rovere reported, "her father insists on it." King Federigo would only agree to the marriage if his rightful position as king of Naples was confirmed by both Alexander VI and Louis XII; Louis XII had his own ideas about who was

the rightful king of Naples. For his own part, he did try to force Carlotta to consent to the marriage, and faced by what he saw as her "feminine perversity," even went so far as to threaten to exile her from the French court. It was all to no avail, and in due course she married the Breton with whom she had fallen in love.

Cesare, whose principal reason for going to France was to get married, was furious, blaming the French king for not doing more to help him and threatening to return to Rome to complain of his treatment to his father, who was as angry as his son. "All Europe," Alexander VI declared, "was very well aware that, but for the definite promise of the King of France to find a wife for him, Cesare would have remained in Italy."

In Rome, meanwhile, the issue of the alliance with France was causing violent rifts in the college. "Yesterday in consistory," the Venetian ambassador had reported in December 1498, "Cardinal Ascanio [Sforza] told the Pope that sending his son to France would be the ruin of Italy. The Pope shouted in reply that it had been Ascanio's brother who had first brought the French into Italy." Alexander VI had a point—it was Ludovico who had encouraged the adventurous Charles VIII to invade Italy and assert his claim to the kingdom of Naples, a policy that, in hindsight, appeared rash in the extreme, particularly now his successor to the throne of France had a better claim to Milan than did Ludovico and his brother. The quarrel ended with the pope threatening to hurl Ascanio into the Tiber.

Yet, despite all the difficulties, Cesare was persuaded to stay on in France. There were hopes that all had been resolved when it was reported that King Louis and Cesare had had dinner alone to-

gether. In late February Burchard reported the rumour that "the Pope's son, Cesare, lately the Cardinal of Valence, has contracted matrimony with the daughter of the King of Naples, who is living in France," adding that "the marriage has been consummated." Less than a week later, this was flatly contradicted in a letter from Cardinal Giuliano della Rovere: "The marriage of Duke Valentino with the daughter of the King," he wrote, "is now definitely excluded."

Rumours of a possible French bride were now rife in Rome and causing such concern and confusion that the pope not only had to receive deputations of protest from several European powers, even from Portugal, but felt obliged to appear in public with an armed guard. The pope declared to the Venetian ambassador, who came to see him about some other matter, that at the moment he cared little about other problems; he was waiting for news from France. "He is very anxious to hear what is happening there and is kept in suspense."

Finally, after anxious weeks of waiting on the part of the pope, and increasing impatience on the part of Cesare, Louis XII proposed that since a marriage to Carlotta of Aragon could not be arranged, Cesare should marry—instead of an Italian bride—a French one. The king's choice was the sixteen-year-old Charlotte d'Albret, a quiet, religious, good-looking, and good-tempered girl who had excellent royal connections; her father was the Duke of Guienne, her mother was related to the new queen, and her brother was the king of Navarre.

The news that Cesare was to marry Charlotte d'Albret arrived in Rome in late March. The pope disapproved of the match, knowing the inevitable trouble it would make for the papacy in Italy, and

would have prevented it had he been able to do so; but in view of his son's determination, he felt constrained to give way, even agreeing to give a cardinal's hat to the girl's brother, Amanieu d'Albret.

The marriage contract was signed on May 10, and two days later the wedding took place in the queen's apartments at the château of Blois. This family ceremony was followed by a grand wedding breakfast served in huge marquees put up in the grounds below the château walls; and after the meal, the marriage was consummated while Charlotte's giggling young ladies took turns in watching the activities of the couple through the keyhole. The pleasure of the bride and groom was evidently spoiled, however, in a manner described by Robert de la Marck, the Lord of Fleurange:

> To tell you of the Duke of Valence's wedding night: he asked the apothecary for some pills to pleasure his lady. But he received a bad turn for, instead of giving him what he asked for, the apothecary gave him laxative pills which had such an effect that he never ceased going to the privy the whole night.

The next day Cesare sent a trusty Spanish messenger to his father in Rome. On arrival the courier was immediately summoned to the Vatican and kept there for several hours, so anxious was the pope to hear every detail of the marriage, its preliminaries and its aftermath. He was pleased and amused to hear that his son had "broken the lance" eight times on the wedding night—even the pedantic Burchard recorded this piece of information in his diary. And the French king wrote to the pope with the information that it had been a better performance than he himself had been able to manage; he,

too, had "consummated the matrimony eight times," but these eight times consisted of two before supper and six at night.

Over the next few weeks, more couriers arrived from France, each with letters reporting further details of Cesare's success. The pope was delighted with the news that Louis XII had given Cesare the right to use the armorial bearings of the French royal house; the duke's coat-of-arms would henceforth show the Borgia bull quartered with the lilies of France. He was also delighted to hear of Cesare's new command in the French army, with an elite corps of one hundred lancers, of his collar of the royal chivalric Order of St. Michael, which King Louis XII bestowed on him a week after the wedding, and of the estate in France that had been bought with the money that Charlotte had inherited from her mother. Cesare himself wrote to his father to say that he was "the most contented man in the world."

Even Charlotte wrote to her father to say that she was very well satisfied with her husband; and she hoped to be able to go to Rome one day soon to see her father-in-law. She was also satisfied with the presents showered upon her by her enthusiastic bridegroom, many of which had been bought by Cesare for Carlotta of Aragon, and well she might have been, for they included numerous precious stones, pearls and diamonds, brocades and silks, gold chains, silver-gilt dinner services, vessels and vases, miniature silver bell towers and citadels, and mother-of-pearl models of warships.

On May 23, the day the news of the wedding arrived in Rome, the pope declared an evening of celebrations. That night Rome was *en fête.* Fireworks exploded in the sky; torches burned throughout the night; "bonfires were lit as a sign of joy in the city," recorded

Burchard, who reported that even Lucrezia had lit her own fire, despite the fact that the French alliance spelled imminent disaster for her husband, Alfonso of Aragon, and for her sister-in-law Sancia. For Burchard, too, the marriage did not bode well: "It was in reality a great dishonour, a source of great shame for His Holiness and for the Holy See."

The pope, however, was hugely relieved. He admitted to one foreign envoy that he had entertained real doubts as to the marriage ever taking place, but now that it had done so he was delighted, and, whereas he used to speak ill of France, he was "now all French because of the love the King of France had shown towards his Duke." So anxious and impatient of late, he was contented once more and raised no objection when asked to pay the 30,000 ducats required in France toward the cost of accommodating and entertaining his son during his stay there. The benefits that he was expecting from this alliance with France would bring him, and particularly his son, advantages that would far outweigh this sum of money.

~ Chapter 15 ~

Conquests

"Aut Caesar aut nihil"

It was in the middle of July 1499 that news reached Rome that the king of France was gathering his troops in Lyons ready for the invasion of Italy and the military campaign to enforce his claims to Milan and Naples. Knowing what was in store for his family, Cardinal Ascanio Sforza fled the city to join his brother, Duke Ludovico. The pope's son-in-law, Alfonso of Aragon, left on August 2, riding toward Naples, much to the misery of Lucrezia; the young man, according to the Venetian ambassador, had "deserted his wife who has been with child for six months and she cries constantly." A few days later, Alexander VI sent his reluctant daughter-in-law Sancia off to join her brother in Naples and, on August 8, dispatched their spouses, Lucrezia and Jofrè, north to Spoleto, a town in the Apennines, to which he now appointed the nineteen-year-old

Lucrezia as governor, an unusual appointment but one that confirmed the respect the pope had for his daughter's abilities and the trust he placed in her loyalty—it was an appointment that would have been conventional for a son. Out of respect for her delicate condition, he equipped her with a litter, which was decorated inside with white and crimson satin, to ease what would be an extremely uncomfortable journey up into the hills in the harsh summer heat.

Cesare, meanwhile, had taken leave of his new bride in early July, just two months after his wedding, and ridden south from Blois to join the French troops massing at Lyons. With an army of six thousand cavalry, one company of which was under Cesare's command, and seventeen thousand infantry, Louis XII was optimistic about his chances of conquering the prosperous duchy of Milan. He declined, however, to lead the troops himself, preferring instead to follow the old French tradition whereby a king without a direct male heir should remain in France.

By the end of the month, the French army had crossed the Alps, negotiating the passes with ease in the midsummer heat, and were now encamped on the Po plain. Alessandria capitulated after a short siege, and several other towns, mindful of the price they would pay for resistance, chose to surrender peacefully. On September 2 Duke Ludovico Sforza, who was not popular in Milan and was suspected by many of having poisoned his nephew to acquire his title, fled the city. The Milanese, unwilling to suffer as Alessandria had done, opened their gates to the French invaders. A month later, on Sunday, October 6, Louis XII made his formal entry into the city, hailed as "King of the Franks, Duke of Milan."

Leading the cavalcade was an armed guard of six hundred sol-

diers, followed by Louis XII's general carrying the gilded baton. The French king rode a bay charger caparisoned in gold and clattered triumphantly through the city streets, which had been hung with white awnings emblazoned with the French fleur-de-lis. Also taking part in the procession were Cesare Borgia and Cardinal Giuliano della Rovere, as well as the ambassadors of Venice, Spain, Genoa, Florence, Ferrara, and Mantua. The cavalcade, however, was not greeted with as much enthusiasm as Louis XII had hoped; one Venetian eyewitness reported that he heard only a few shouting, "France! France!"

The once-proud Sforza dynasty had collapsed into ruins. When Louis XII opened the treasure chests in the Castello Sforzesco, Ludovico's massive fortress, he found them empty—Ludovico had managed to escape with a fortune in gold and jewels. Leonardo's famous fresco of *The Last Supper* in the convent of Santa Maria delle Grazie, to which the king made a special visit, accompanied by Cesare, had already begun to flake off the walls of the refectory, and, saddest of all, Leonardo's clay model of a horse, intended by Ludovico Sforza for a bronze equestrian statue of his father, Francesco, had symbolically crumbled under the shots of the French soldiers who had used it for target practice.

With the French conquest of Milan accomplished, Cesare had fulfilled his part of the bargain that his father, the pope, had reached with the king of France, and it was time for Louis XII to honour the promise he had made to Cesare, to provide him with a contingent of French troops to fight under the duke's orders. The arrival of the French army in Italy provided Alexander VI and his son with the pretext they needed to establish a state for Cesare in northern Italy, using the thinly disguised excuse of the need to reassert

control of the Papal States to counter the strong French presence in the area.

The Papal States covered a large area in northern and central Italy, stretching down the Adriatic coast from Bologna and Ravenna to Ancona and across the Apennines into the Tiber valley to include Lazio and the countryside around Rome. It was a mosaic of small states, each belonging to the church, bordered to the north by the duchy of Ferrara and to the south by that of Urbino, both papal fiefs, and to the west by the independent Republic of Florence. Some of these states were administered directly from Rome, like Spoleto, where Lucrezia was governor; others were ruled by quasi-autonomous lords, known as vicars.

As Niccolò Machiavelli observed without excessive exaggeration, these lands were "a nursery of all the worst crimes, of outbreaks of rapine and murder, resulting from the wickedness of local lords and not, as these lords maintained, from the disposition of their subjects. For these lords were poor, yet endeavouring to live as though they were rich, they resorted to innumerable cruelties . . . and passed laws prohibiting certain acts only to give occasion for breaking them . . . and punishing offenders by imposing heavy fines which they collected." The area might have been intermittently lawless, but much of it was highly fertile, especially in the north, where agriculture flourished on the alluvial soils of the Po plain. It was also of enormous strategic importance, offering the possibility, once firmly unified, of a state as considerable as those of Naples, Venice, or Florence. It was this area that Alexander VI intended, with the help of the French, to unite into a duchy for his son.

In October, shortly after Louis XII's triumphant entry into Milan, Alexander VI announced that "the vicars of Rimini, Pesaro,

Imola, Forlì, Camerino and Faenza, as well as the Duke of Urbino, feudatories of the Church in Rome, have failed to pay their annual census to the Apostolic Chamber," according to Burchard's report, "and so [the pope] has removed their titles and declared them forfeit." Burchard added that the city of Milan—by which he meant the new French government—had loaned 45,000 ducats to the pope to raise troops to retake these territories: "The Duke of Valence," he reported, "captain of these troops, has received this sum in the name of the Church."

On November 18 Cesare returned to Rome for a brief visit, entering the city late that afternoon through one of the smaller gates to avoid detection. He spent the next two days at the Vatican, much of the time in private discussion with his father, though he did find the opportunity to visit his beloved Lucrezia, who had given birth to a baby boy during the night of November 1. The boy had been christened Rodrigo, after his grandfather, in a splendid ceremony in St. Peter's, attended by all those cardinals who were in Rome.

Cesare left Rome again on November 21, and rode north with all possible speed, accompanied by 1,500 soldiers of the papal army, toward the northern borders of the Papal States, where his French troops—4,000 infantry and 1,800 cavalry under the command of Yves d'Alègre—were waiting for him. He was now ready to embark on the first stage of his campaign to establish the rule of the Borgia over the Romagna in the name of the church with an attack on Imola and Forlì, two towns on the great Roman road, the Via Emilia, which were held in the name of the Riario family by Girolamo Riario's widow, Caterina Sforza-Riario.

Alexander VI, meanwhile, dispatched the fifty-two-year-old cardinal of Monreale, the pope's nephew and another victim of the

mal francese, to Venice in order to reassure the government of that city that Venetian interests in the Romagna were not under threat, a gesture that acquired greater force when backed openly by Louis XII. The French king personally reassured the Bentivoglio family, the rulers of Bologna, that he would safeguard their state. But he made it clear that the Borgia campaign had his backing: "At the request of our Holy Father," he wrote, "and wishing to help him recover those lands, signories and domains [of the Papal States] and especially the castles and lands of Imola and Forlì, we have appointed our dear and well-beloved cousin, the Duke of Valence, as our lieutenant."

With the self-confidence he now always chose to display, Cesare announced that the "recovery of the lands and lordships of Imola and Forlì" would now be achieved without undue delay. The Riario family, he insisted, had become so disliked by their subjects that they could not depend upon the resistance of the inhabitants, who were more than likely to open their gates to their liberators. This confident estimate, however, did not take into account the resolution of Girolamo Riario's widow, Caterina Sforza-Riario.

Imola proved no obstacle, and the fortress surrendered to Cesare's armies on December 11, after a brief, almost token resistance by Caterina Sforza-Riario's castellan, and six days later Alexander VI's great-nephew Cardinal Juan Borgia received the oath of obedience from the civic authorities on behalf of the pope. Forlì, however, was to prove a greater obstacle; the city itself fell without a struggle but the fortress, to which Caterina had retreated, was one of the strongest in Italy. While she held out inside the castle, Cesare entered Forlì with his lance at rest in silent acknowledgement

of his victory. French and Swiss mercenaries, followed by hundreds of rapacious camp followers, poured in through the gates, plundering the captured towns and violating their women.

Cesare made little effort to stem the violence: when the citizens appealed to him to curb his soldiers, he used the spurious excuse that the troops were answerable to the king of France and he could not control them. He did, however, succeed in placating the responsible citizens of both Imola and Forlì by assuring them that if he survived to keep his promise, he would make it up to them and ensure that when peace was fully restored, they would be reappointed to any offices they might have undeservedly lost.

Caterina was a remarkable woman. The illegitimate daughter of Duke Galeazzo Maria Sforza, she was now thirty-six years old. Tall and beautiful, brave and unscrupulous, she was given to outbursts of fury, real or assumed, and was "much feared by her men," who knew her among themselves as the Virago. On occasion she wore full armour, adapted to conform to her full figure, and was immediately recognized by the falcon perched on her arm. She had been married three times, had had several lovers, and had borne nine children.

After the assassination of her husband, Girolamo Riario, in 1488, she had run for shelter to the castle in Forlì, leaving her children to the mercy of his murderers, who had threatened to kill them too. She had responded in a characteristic manner, standing on the battlements of the castle, her skirt raised in her arms and shouting: "Fools! Can't you see that I can make more?"

She was also alleged to be a witch with an arcane knowledge of magical potions, the recipes for which she kept in a safely guarded

book and that were, in fact, potions, salves, bleaches, and all kinds of cosmetics that she used to preserve and enhance her undoubted beauty.

Her first reaction upon hearing that the pope had confiscated her state was to plan his murder. On the evening of the day that Cesare had left Rome, Burchard reported, "a certain Tomasino da Forlì, a musician of the Pope, and one of his colleagues were arrested and taken to Castel Sant'Angelo." It emerged that Tomasino had just arrived in Rome carrying letters that purported to be an offer of peace from Caterina and that he had intended, after bribing one of the Vatican guards to gain entry to the palace, to present to the pope in person.

"If the Pope had opened them," continued Burchard, "he would have been poisoned and would have been dead a few hours or days later." Tomasino confessed that "it had been his firm belief that, once the Pope was dead, the cities of Imola and Forlì would have been liberated from the siege imposed by the Duke of Valence." What exactly had been in the package no one knew for sure, but it was widely rumoured that Caterina had wrapped the letters in the grave cloth of the corpse of a man who had recently died of the plague. Her nephew Cardinal Raffaello Riario fled Rome a few days later, taking with him a small group of servants and sticking to minor roads to evade any pursuers.

Despite the failure of her devious plot, the formidable Caterina still refused to give up, and she now waited in her citadel above the town at Forlì, determined to hold out as long as she could against the Borgia advance. Standing defiantly on the ramparts, she rebuffed Cesare when he came up twice to the edge of the moat to demand her surrender, and on one of these occasions, so it was re-

ported, she almost captured him by inducing him to come onto the drawbridge to discuss the terms and then giving orders for the drawbridge to be raised.

By the last week of the year 1499, Cesare's French troops had put their artillery in position and the attack on the castle began in earnest. Whenever the guns fell silent for a time, Caterina could be seen scrambling over fallen masonry, sometimes in armour and with her sword in hand, at others dressed as though for some grand fête, always apparently undaunted.

The outcome, however, was never in doubt. After two weeks of heavy bombardment, with Cesare's gunners battering the citadel by night as well as by day, the keep collapsed and then a large part of the outer wall fell into the moat. A storming party crossed the moat on rafts, clambering up the tumbled stones and through the breach in the walls, pouring into the fortress to hack and stab at the defenders. On January 14 the defence collapsed, four hundred of Caterina's soldiers were dead, and Caterina herself was taken prisoner. The slaughter was total: Burchard, who reported that news of the victory at Forlì reached Rome that night, wrote that "the magnificent Countess, widow of Count Girolamo Riario, has been captured; all the others have been killed." And the papal legate, the cardinal of Monreale, who was ill with a fever in Urbino, rashly left his sickbed to ride to Forlì to congratulate his cousin on his victory, but he only got as far as Fossombrone, where he collapsed and died.

It was said afterward that Cesare and Yves d'Alègre quarrelled over who should take charge of Caterina—d'Alègre had been her captor; Cesare was in command. In the end Cesare won the argument and dragged the struggling woman to his quarters, where he

was alleged to have commented that she had defended her castle more vigorously than she had her ultimately willing body. The Venetian diarist Marin Sanudo reported that the relationship between Cesare and Caterina was far from being merely that of captor and prisoner: Duke Valentino, he wrote, "is keeping the lady of Forlì . . . who is a most beautiful woman, daughter of Duke Galeazzo Sforza of Milan, day and night in his room. And, in the opinion of all, he is taking his pleasure." Louis XII's general, the Milanese condottiere Gian Jacopo Trivulzio, put it more bluntly: "Oh, good Madonna, now you will not lack for fucking."

From Forlì, Cesare intended to march south to attack Pesaro, the state of his ex-brother-in-law, Giovanni Sforza, but before he could do so, a courier brought the startling news that Ludovico Sforza had managed to raise a large force of eighty-five hundred mercenaries and was about to march on Milan to reclaim his duchy. Louis XII now requested that the French soldiers serving under Cesare were to be withdrawn, temporarily, from his command and recalled to Lombardy. The first stage of Cesare's campaign was now at an end, and he decided to return to Rome, leaving some of his troops to garrison his new possessions and bringing his famous prisoner with him for incarceration in the dungeons of Castel Sant'Angelo.

The pope prepared a tumultuous welcome in Rome for his son, and the entry, which was to take place during Carnival, would add impressively to the customary events staged during that season. "On Wednesday 26 February, all the cardinals, on the order of His Holiness," reported Burchard, "received notification that they were to arrange for their households to be outside the gate of Santa Maria del Popolo" at midday to welcome Cesare on his return. Bur-

chard also announced that all ambassadors, government represen-
tatives, and officials of the Curia were to be there "in person," as
were the cardinals themselves. They had a long, cold wait; it was
not until after three o'clock that the crowds at the gate finally heard
the distant sounds of trumpets and pipes that heralded Cesare's
arrival.

His entry was recorded in detail by Burchard, who had arranged
the whole event and was evidently displeased that not all of the par-
ticipants shared his own desire for order:

> The cardinals, learning that Don Cesare was approaching,
> mounted their mules and waited in customary fashion out-
> side the gate. They doffed their hats to welcome him, and he
> in turn took off his own cap and graciously thanked them. The
> procession made its way to the Vatican, Don Cesare riding
> between Cardinals Pallavicini and Orsini, passing along the
> Via Lata to the church of Santa Maria sopra Minerva . . . and
> the Campo dei Fiori.
>
> About a hundred packhorses in new black trappings led the
> cavalcade, walking in good order, and behind, rather more
> haphazardly strung out, were fifty more. I was unable to
> arrange the households in any sort of order since there were
> in the procession about a thousand infantry soldiers, Swiss
> and Gascons, who marched along in ranks of five each under
> their own separate standards, all blazoned with Don Cesare's
> arms, and were not interested in our arrangements at all.
> When the Pope's infantry approached, carrying their own
> banner, the Swiss, on meeting them, demanded that they
> should lower this standard. They absolutely refused to march

along with it, and this led to a considerable argument, but Don
Cesare quickly settled it. Don Cesare had around him a hun-
dred grooms, each one dressed in a cloak of black velvet reach-
ing to his knees, with a collar of simple and severe design.
There were a number of trumpeters in the procession, all
wearing Don Cesare's arms, and two of his own heralds,
but both trumpeters and other musicians remained silent
throughout the journey.

The Duke of Bisceglie [Alfonso of Aragon] and Don Jofrè
Borgia followed next in the procession, and then Don Cesare
Borgia between two cardinals, with the bishops and ambassa-
dors behind them riding two abreast. There was a wrangle
over precedence between two ambassadors . . . [who] refused
to take any further part in the ceremonies. The ambassadors
for Venice, Florence, Savoy and other states were, however,
present. Behind them came Vitellozzo Vitelli [the condot-
tiere] in charge of the men-at-arms, who marched along in
such disorder that the ecclesiastics could not take their places
and consequently for the most part also withdrew.

To welcome Don Cesare at the Vatican, the Pope came to
the room over the loggia of the entrance to the palace. When
Don Cesare reached the Sala dei Paramenti, the Pope climbed
to the Sala del Pappagallo, where he took his seat and had five
brocaded cushions arranged, so that one was on the throne,
one under his feet, and the other three on the floor in front of
him. The door of the Pappagallo was then opened, and Don
Cesare entered . . . kneeling before His Holiness, he made a
brief speech in Spanish to thank him for being thought wor-
thy of such an honour, and to this the Pope replied also in

Spanish. For this reason, I did not understand what he said. Don Cesare next kissed both feet and the right hand of the Pope, and following this ceremony, those lords who also so desired also kissed His Holiness's foot.

The Castel Sant'Angelo was most elaborately decorated on this occasion. Two banners were set up on the lower round tower overlooking the Ponte Sant'Angelo, whilst on the higher tower, where trumpeters played, there were displayed four or five more banners, all with the papal arms. Above the walls, and between each turret facing the bridge, there stood three men armed from head to foot and holding halberds in their hands, whilst above the walls of the round tower were fifteen soldiers and as many again where the trumpeters were blowing. Some two hundred or more explosions in turn shook the area with a great deal of noise . . . with reverberations that brought down several windows and shutters. . . . I had never seen such a splendid nor triumphant display.

So delighted was the pope to welcome his son home to Rome as Lord of Imola and Forlì that he was reported as being unable to decide whether to laugh or cry and so did both alternately. Cesare had, indeed, achieved much and had done so at little cost to either his father's purse or to the troops under his command. And, strikingly, in this moment of real triumph, he had chosen deliberately to dress both himself and his household more modestly than he had in the past. He and his bodyguard made their entry into the city all clothed in black, Cesare proudly wearing his golden collar of the Order of St. Michael; and in black again, he appeared before his father in the Vatican to make his report.

The following day, February 27, Rome witnessed one of the highlights of the Carnival season, the cavalcade of elaborately dec-orated carts in the Piazza Navona, and it was watched eagerly by the crowds who had lined the streets to see the parade as it made its way from the piazza to the Vatican Palace. The theme that year was the Triumphs of Caesar and the tableaux depicted on the wag-ons celebrated the military successes of Julius Caesar, the victori-ous general of ancient Rome, who appeared on the final wagon, crowned with his victor's wreath of laurels.

With his usual relish for such occasions, Cesare accompanied the cavalcade astride his magnificent charger. The pope, who was watching the display in the piazza of St. Peter's from a balcony in the Vatican Palace, was so impressed that he asked for an encore, and his son duly turned the procession around to allow it to pass once more beneath his father's window.

The programme for the Carnival pageant, drawn up by human-ists employed by the pope and executed by artists working on papal projects in the Vatican, was clearly designed to draw parallels be-tween Caesar and Cesare. And the message would not have been missed by those onlookers who had watched Cesare's triumphal entry into the city the day before, where they had seen the victori-ous soldier carrying his own sword, which was engraved with the letters CESAR, and the same letters embroidered on the clothes of his personal bodyguard. Cesare was soon to adopt as his motto *"aut Caesar aut nihil"*—Caesar or nothing—a very ambitious declaration of intent.

~ Chapter 16 ~

Jubilee

"The Pope intends to make the Duke Valentino a great man and King of Italy if he can"

"On the morning of the fourth Sunday of Lent, 29 March," Burchard recorded just a month after Cesare's triumphant return to Rome as Lord of Imola and Forlì, "the cardinals assembled at the accustomed hour in the Sala del Pappagallo and were thence summoned more privately to meet His Holiness in his small audience chamber, where, having taken their advice," as the master of ceremonies euphemistically described the process whereby the pope informed the college of his intentions, "he decided to bestow the Golden Rose on the illustrious Cesare Borgia, his much-loved son, and to create him Captain-General and Gonfalonier [standard-bearer] of the Holy Roman Church."

The ceremony had, of course, been planned well in advance. Directly after the meeting, the pope was carried on his throne into St. Peter's, with the Golden Rose in his left hand, followed by Cesare,

dressed in a coat of brocade, the cardinals, and other members of the papal court, to join the ambassadors, prelates, and officials assembled in the basilica. Inside Cesare was formally enrobed with the insignia of his new office: the great mantle and the gilded helmet with its ermine plumes crowned by the figure of a dove that glistened with pearls. Kneeling before his father, he made his solemn vows:

I, Cesare Borgia of France, Duke of Valence, Gonfalonier and standard-bearer, Captain-General of the Holy Roman Church, do solemnly swear from this day forwards that I will faithfully submit to St. Peter, to the Holy Roman Church and to you, my most holy lord, Pope Alexander VI, and to your canonical successors. Never will I intend, plan or undertake to deprive you of life or limb, to take possession of your person in a wicked fashion, to lay my hands violently on you or your successors, whatever is done against me, whatever wrongs are propagated against me and under whatever pretext, and I will reveal to no one the plans that you or your successors confide in me.

"Receive these standards," Alexander VI responded, giving his son the banners of the church, "which have been sanctified by the blessing of Heaven, and will be terrible to the enemies of Christendom." He then handed to his son the baton of command and finally the Golden Rose. At the end of the ceremony, the banners were hoisted by two men-at-arms, and the congregation followed them out of the basilica and into the piazza: the ambassadors, eight flautists, four drummers, three heralds, soldiers, cardinals, and fi-

nally the duke himself, followed by the footmen and prelates and by Cesare's men, "who marched," to Burchard's obvious distress, "in inevitable disorder."

The proud Cesare could now add the pontifical keys of St. Peter to the Borgia bull and the lilies of France on his coat-of-arms, but his ambitions to enlarge his modest state in the Romagna, which depended heavily on the support of Louis XII, had, for the moment, stalled. After the euphoria, which was noticed in his behaviour at this time, he fell into one of those moods of deep gloom, symptoms of the manic-depressive. "I know that in my twenty-sixth year," he was quoted as having said, "I stand in danger of ending my life in arms and by arms." He also asked the German humanist Lorenz Behaim to cast his horoscope; and it seems that the result was not encouraging.

Ludovico Sforza's campaign to seize his duchy back from the French had met with surprising success. He had succeeded in re-conquering Milan, although the great Sforza castle remained in French hands, and on February 6 he had made his triumphant return, welcomed by his subjects with much joy. The French army had withdrawn to Novara, awaiting their chance to retake the city, Yves d'Alègre and his gunners, which Cesare needed for his Romagna campaign, among them. There was, however, much that the pope and his son could do to plan the next stage of their campaign, and much money to be raised to finance it.

The year 1500 was a Jubilee year in Rome, when thousands of pilgrims were expected to flock to the city, where, by visiting certain churches, fasting, praying, attending confession and Communion, and giving alms, they would receive pardon for all their sins. The tradition of the Christian Jubilee year was not an ancient

one; founded by Pope Boniface XIII in 1300, as a means of raising funds to fill the papal coffers, it had initially been intended as a celebration for the beginning of each century, though Paul II had decreed in 1470 that it should be held every twenty-five years.

Burchard gives a lengthy account of the preparations made in the city for the Jubilee; provision for housing the pilgrims, sweepers to clear the litter from church floors, special patrols to prevent tramps loitering around the porches, and "large strong casks," added Burchard, "were to be provided for freewill offerings next to the Chapel of St. Andrew in St. Peter's, and they were to be protected with three different locks and keys, one key to be kept by the Datary, a second by one of the confessors and the third in another official's hand."

In an attempt to attract more pilgrims than usual, Alexander VI announced that for the 1500 Jubilee, the Holy Door of St. Peter's would be reopened. This door, which had long been walled up, was by tradition the Golden Gate of Jerusalem, through which Christ himself had entered the city on Palm Sunday. It had reputedly been brought to Rome by Emperor Vespasian after the Roman conquest of the Jewish capital in 70 A.D., and it was widely believed that any sinner who walked through it, even a murderer, would have his sins forgiven.

Accordingly, on December 24, 1499, huge crowds assembled in the piazza in front of St. Peter's to watch the ceremonial opening of the Holy Door. The pope arrived amid much fanfare and celebration, and, according to Burchard, he was "handed an ordinary workman's hammer" by one of the builders, who had spent several days chiselling away at the Holy Door from inside the basilica to weaken it. The pope "gave three or more blows" to the wall, thus

creating a small opening, before retiring to his papal chair a few yards away to watch the workmen demolishing the rest. "On this task they spent half an hour, during which time our choir sang continually," the master of ceremonies reported.

Alexander VI, dressed in full pontifical robes and wearing the triple tiara, led the ceremonial procession through the Holy Door into St. Peter's, holding a candle in his left hand and Burchard's colleague supporting his right elbow, followed by the cardinals and the papal court (the builders themselves had been forbidden, "under penalty of losing their heads," to go through the doorway while they were demolishing it).

The expected influx of pilgrims did indeed materialize, and so did their offerings. The Florentine diarist Luca Landucci reported large numbers of northerners, many from across the Alps, passing through the city on their way south to the Jubilee. From their lodgings in one of Rome's many inns and taverns or, more cheaply, in the hospices that all Christian nations maintained in the city, the pilgrims thronged the streets of the capital of their faith as they walked from church to church, seeing and believing in the sights and sites of Christian legend.

At Santa Maria Maggiore they worshipped at the manger that had once been Christ's own crib in the stable at Bethlehem; at San Giovanni in Laterano they marvelled at the swaddling clothes that had wrapped the baby Jesus and the table where he and his apostles had eaten their Last Supper; here, too, they could climb the stairs of Pontius Pilate's house in Jerusalem, following, on their knees, in the footsteps of Christ himself. At St. Peter's they could see the lance that had pierced Christ's body during the Crucifixion, a much-treasured relic that the basilica had acquired as

recently as 1492, though Burchard recorded that several cardinals had noted that the same lance could also be seen in both Paris and Nuremberg.

Rome was, indubitably, the city where St. Peter and St. Paul had preached and died for their faith; the great basilicas of St. Peter's and San Paolo fuori le Mura marked their graves. And the heads of these great leaders of the early Church could be seen by the pilgrims, at certain hours, in a chapel in San Giovanni in Laterano; as one pilgrim noted with awe, they "still have their flesh, colour and beards as if they were still alive."

The faithful, however, also provided easy pickings for the pickpockets and cutpurses who roamed the city streets. Burchard reported that on April 10, 1500, six men were hung on the gallows for the crime of robbing pilgrims. On May 27, the eve of the Feast of the Ascension, eighteen more were hung on the Ponte Sant'Angelo, where they would have been hideously visible to all those crossing the Tiber on their way to St. Peter's to walk through the Holy Door before saying their prayers in the venerated basilica and leaving their offerings in the casks provided. The first to be hung was a doctor from the hospital at San Giovanni in Laterano, who had been in the habit of leaving his wards each morning, armed with a crossbow, to kill and rob anyone he found; among the others were a band of highwaymen who had attacked a group of travellers in the hills outside Viterbo.

During the spring, news arrived in Rome that must have done much to lift the spirits of the pope and his son. On April 10 Louis XII had celebrated a great victory over Ludovico Sforza at Novara, after the Swiss mercenaries fighting for Ludovico refused to use their arms against the French. Landucci reported that twelve thou-

sand were dead. Ludovico himself had been captured and taken to France; the fate of Cardinal Ascanio Sforza remained obscure, but early on the morning of Maundy Thursday, April 16, a courier arrived in Rome with the news that he had been found in a castle near Piacenza, where he had fled with six hundred horsemen and valuables worth 200,000 ducats. He, too, was now a prisoner, and the pope, according to Burchard, was so pleased with the news that he tipped the courier 100 ducats.

Far from offering help, or even support, to his erstwhile friend in this hour of need, Alexander VI took the opportunity to seize Ascanio's valuable collection of artworks and jewels, including a set of twelve silver-gilt statues of the apostles; it took four hours for the carts, operating in secret under the cover of darkness, to transport the goods from the cardinal's palace to the Vatican.

Meanwhile, Cesare was beginning to enjoy his enforced rest from the battlefield; and while his wife Charlotte d'Albret, who had given birth to his daughter, remained in France, Cesare spent much of his time with his mistress, an extremely pretty and entertaining young woman, Fiammetta de' Michelis, whose accomplishments and complaisance as a *cortigiana* had enabled her to buy three houses in Rome as well as a country house outside the city walls. Cultivated as well as desirable, she spoke Latin, knew pages of Ovid and Petrarch by heart, sang well, and played the lyre; her handsome lover was often to be seen on his way to and from her house near the Piazza Navona.

Lucrezia, however, was less happy, her enjoyment of the warmth of early summer marred by increasing friction between her husband, Alfonso of Aragon, and her father and brother, whose alliance with France was proving a problem for both Alfonso and his

sister Sancia. When the news spread around Rome that a Burgundian had challenged a Frenchman to a duel, to settle an argument over a banner, Cesare tried, unsuccessfully, to bribe the Burgundian to withdraw: "He would prefer," so the rumour went, "to have lost 20,000 ducats rather than see a Frenchman beaten." Sancia, on the other hand, made a point of dressing her own squires in the Burgundian colours, to show where her loyalties lay.

Cesare was careful not to publicly display any sign of the growing friction between himself and his brother-in-law. When the two men were seen together, they appeared to be on perfectly amicable terms, riding about the city in evident amity. Yet there was noticed in Cesare's manner a more than usual impatience, "as though he were anxious for important actions to unfold."

Cesare also appeared in public during this summer of 1500 honing his skills as a bullfighter. On June 24, the Feast of St. John the Baptist, he demonstrated his prowess with the sword in the piazza of St. Peter's, which had been cordoned off to prevent the bulls from escaping. On another occasion, so the Venetian envoy Paolo Capello reported, he killed "seven bulls, fighting on horseback in the Spanish style and cutting off the head of one of them with his first stroke, a feat which seemed great to all Rome."

On June 29, shortly before sunset, the pope himself was lucky to escape with his life thanks to an act not of man, but of God. During an exceptionally violent storm, with "hailstones the size of broad beans and an extremely violent wind," reported Burchard, a chimney in the Vatican collapsed, breaking two beams in an upper chamber that brought down the ceiling of the room below, where Alexander VI was in discussion with a cardinal and one of his private secretaries. The two men were just closing the windows, as the

pope had asked them to do, when they heard the thunderous crash and turned immediately to find the papal throne hidden under a pile of rubble: "They cried to the guards, 'The Pope is dead! The Pope is dead!' and the news quickly spread throughout the city." Alexander VI, however, was only unconscious; when they removed the plaster and bricks, they found him seated on his throne, with two small cuts to the head, two larger ones on his right hand, and another on his right arm, miraculously still alive. As one chronicler observed, this lucky escape "was seen as a great sign and omen for the Pope."

Some two weeks later, on the evening of July 15, 1500, Alfonso of Aragon went to the Vatican to dine with the pope; after what seems to have been a pleasant evening, he took his leave of his fellow guests to walk the short distance home to the palace of Santa Maria in Portico just across the piazza of St. Peter's, accompanied by a gentleman of his household, Tomaso Albanese, and a groom. As they passed by the basilica, a number of men, apparently sleeping on the flight of great ceremonial steps, roused from their "slumbers," rose to their feet, and suddenly fell upon Alfonso, stabbing him with their daggers. They would have carried him off to their tethered horses had not his companions rushed to his aid and dragged him away to the safety of the Vatican.

Inside the palace, Lucrezia fainted at the sight of her wounded husband. By the light of the tapers and candles, it was soon clear to all that Alfonso's injuries were serious; he had deep gashes to his head and his shoulder, "either one of which could prove mortal," as the Florentine ambassador reported. The Pope had him taken to one of his own rooms in the Borgia apartments, where his wounds were dressed. He recovered slowly, under the watchful eye of a

doctor sent to him by the king of Naples and the careful nursing of Lucrezia and Sancia, his room guarded by soldiers and his food prepared by his loving wife, fearful of another attempt on his life.

It was generally supposed that the instigator of the attack was Cesare Borgia. The pope was inclined to agree: at least, he told the Venetian ambassador that if Cesare had, indeed, been responsible for the attack, Alfonso thoroughly deserved it. Alfonso himself clearly had no doubts as to who was responsible, and he was only too ready to avenge this vicious attack on his person. When he caught sight of Cesare one day in the gardens below his bedroom window, he picked up a crossbow and shot a bolt that only narrowly missed its target.

On August 18 Alfonso, still in bed but much recovered, together with his wife and his sister, was enjoying the company of his uncle and the Neapolitan ambassador, when a party of armed men, led by Miguel de Corella, Cesare's trusted Spanish lieutenant and known by some as his "executioner," rushed into the room, claiming that they had orders to arrest the visitors. There had been a plot, Corella announced: Cesare Borgia's life had been threatened. Lucrezia and Sancia protested—they themselves had not been warned of any such plot; the officer must have written authority before they could allow any member of their patient's household to be taken away.

Possibly he had mistaken his orders, Corella replied; and he suggested that the two ladies should go to the pope and ask him to confirm that the envoy was to be arrested. So the two young women left for the pope's apartments; and when they returned, they found the door of Alfonso's room locked against them. There had been an accident, they were told; the duke had tripped and fallen; his

wounds had reopened; regrettably he was dead. Burchard reported, succinctly, that he had been "strangled in his bed."

Alfonso was buried that night in the Church of Santa Maria della Febbre; and it was given out that he had been the victim of a dreadful plot, details of which would be published later. Naturally, they never were. Though, within a short time, according to Ferdinand Gregorovius, the murder was no longer a mystery since Cesare, Duke of Valence, had openly declared that he had killed his brother-in-law because his own life had been threatened by Alfonso.

Lucrezia left Rome a few days later, accompanied by just six riders, bound for her castle at Nepi. This castle had been a favourite residence of Alexander VI while he was a cardinal, and it was he who had given the town its forbidding aspect when he built a new circuit of walls to fortify this strategic stronghold on the Via Cassia, some twenty-five miles north of Rome, that guarded one of the main approaches to the city. Once pope, he had given the town to Cardinal Ascanio Sforza in gratitude for Sforza's support in the conclave, but after the cardinal's flight from Rome the previous summer, he had rescinded the gift, bestowing it instead on his daughter. In February 1500 the fond and indulgent father had also spent 24,000 ducats on the town of Sermoneta, with its castles and land to the south of Rome, for his beloved Lucrezia to add to her ownership of Spoleto and Nepi.

Lucrezia spent four quiet months secluded at Nepi with her baby boy, Rodrigo. "The reason for this journey," explained Burchard, "was to find some consolation or distraction from the anguish and shock she has felt since the death of her husband, Alfonso." Her misery was evident at the bottom of the letters she wrote to her

household in Rome, where she signed herself "La Infelicissima" (most unhappy woman) and she spent large sums of money arranging for prayers to be said for the soul of her murdered husband and to assuage her own grief.

She had had cause to feel isolated in Rome. Her former friends were wary and, in the words of the Mantuan envoy, "neither her brother nor her father could forgive her for the love she had borne her husband." According to the fanciful account of the Venetian ambassador in Rome, Lucrezia had "drunk so deeply at the spring of sorrow" upon the murder of her husband, that "in a single night she had become more like a woman three times her age, and it was clear that she would never recover her youthful beauty."

One day in late August, shortly after Alfonso's assassination, Baron de Trans arrived in Rome, once again acting as envoy for Louis XII with a message for Cesare. He stopped at an inn just outside the city walls and soon afterward, according to Burchard, "there came a certain horseman, masked and riding fast, who dismounted at the inn and, keeping on his mask, which he did not lower, embraced Monsieur de Trans and spoke with him. After a short while the masked man returned to the city. They say it was Duke Valentino."

Now that Louis XII was secure in his possession of Milan, his attention had turned to his next objective—the capture of Naples—for which he needed the help of both Alexander VI and his son. De Trans had brought with him to Rome a letter from the French king asking the pope for political support for the planned conquest of Naples, unhindered passage for his armies through the Papal States, and recognition as the rightful king; from Cesare he required the duke's undoubted military skills in the campaign. In re-

turn, Cesare was to be offered a large force of infantry and lancers, under the command once again of Yves d'Alègre, for the next stage of his conquest of the Romagna.

As the Mantuan envoy reported ominously, "The Pope intends to make the Duke Valentino a great man and King of Italy if he can." "I am not dreaming," he added, "my brains are not disordered, I will say no more." Cesare had already enlisted the help of various condottieri and was running out of money to pay them. His father had done what he could to help him, going so far as to divert not only some of the funds he had accumulated to finance a crusade against the Turks, but also much of the money received from pilgrims in Rome for the Jubilee. It was to augment these funds that Alexander VI decided to create a large number of cardinals, imposing a fee for each nomination.

Accordingly, on September 18, after the cardinals had returned from their summer retreat in their villas in the hills outside Rome, Alexander VI summoned them to a secret consistory to discuss the distribution of the new red hats. But not enough members of the sacred college turned up at the Vatican that morning; the cardinal of Lisbon wrote to apologize but he was ill; the cardinal of Siena also apologized but he was bedridden with gout. A week later the pope tried again; this time the consistory took place, but such was the opposition to his plan that no decision could be taken.

Meanwhile, the Turkish threat to Venice had provided Alexander VI with the lever he needed to enlist the aid of that city's government to Cesare's campaign in the Romagna. With Venetian colonies on the Dalmatian coast falling like ninepins to the mighty Turkish navy, two envoys had been dispatched to Rome in September to seek the pope's help.

Alexander VI received them graciously and proceeded to admonish them for their past behaviour. "The government of Venice has until now acted ungratefully towards His Holiness," he said, according to the Florentine ambassador's report of the conversation, and "if they wish to please His Holiness they must act differently in [the] future. They answered that they wished to do anything for His Holiness, and to embrace the Duke Valentino and consider him their good son, and to give him a *condotta* on the most generous terms and, as for Rimini and Faenza, they would be perfectly willing for him to carry out his intentions in those places. The Pope answered that he wanted no more of their fine words— he had had quite enough of these already—now he wanted deeds."

Alexander VI was given his wish; the government of Venice created Cesare an hereditary *gentiluomo* of the city and presented him with a palace there in order to maintain this signal honour. On September 26, 1500, the day after the second consistory had failed to agree on the promotion of the new cardinals, the Venetian ambassador felt able to report that "the order has now been given that Duke Valentino will leave two or three days after the cardinals have received their hats," more specifically "according to what the astrologer concludes will be a favourable moment."

Two days later Alexander VI tried a third time to persuade the college to agree to the creation of the new red hats; on this occasion fifteen cardinals arrived at the Vatican and did, finally, agree formally to the promotion of thirteen new colleagues. Guicciardini was to remark, some years later, that these cardinals were "selected not amongst the most worthy but amongst those who offered him [the pope] the highest price." Burchard listed their names and the

fees that had been levied upon the value of their benefices, which amounted to the enormous sum of 160,000 ducats.

When the names were made public, it was clear to all that most had close links to Cesare and his father: Amanieu d'Albret was Cesare's brother-in-law and his hat had been promised as part of the contract for his marriage to Charlotte; Pedro Luis Borgia was his cousin; Francisco Borgia and Jaime Serra, who had been tutor to his brother, the murdered Juan, were more distant relations; Juan Vera was Cesare's own tutor; Pedro Isvalies was the governor of Rome; Ludovico Podocatharo was Alexander VI's personal physician; Gianbattista Ferrari was datary to the pope; and so on.

Just six of the new cardinals were in Rome when the consistory agreed to their promotion, and they were summoned immediately to the Vatican to await the end of the meeting. "There, once the doors were open, they kissed the Pope's foot, then his hand and his mouth," announced Burchard, and the cardinals "escorted them to the Duke of Valence's rooms, which are above the Sala del Pappagallo." As the Venetian ambassador reported, "They went to the Duke, offering themselves to him, they dined with him, settled their accounts and swore their loyalty to him."

It was with unusual haste, just four days later on October 2, that these six men attended a ceremony in St. Peter's during which the pope solemnly gave each one his cardinal's hat, with its distinctive hanging tassels. Later that day Cesare left Rome to join his army marching north up the Via Flaminia toward the Romagna.

Duke of the Romagna

"FROM ALL PARTS COME REPORTS
OF THE ILL INTENTIONS
OF THE POPE AND THE DUKE"

CESARE RODE OUT OF ROME on October 2, 1500, with an entourage of young Roman nobles, papal bureaucrats to man the administration of his new state, and members of his household, including his secretary, his treasurer, and his doctor, the ever-present Gaspar Torella. After a brief detour to visit the grieving Lucrezia at Nepi, he joined his formidable army of over ten thousand men, who had now reached the foothills of the Apennines.

Marching under Cesare's command were some of the finest condottieri captains available; or, as Machiavelli put it, "nearly all the professional soldiers in Italy." In addition to the Frenchman Yves d'Alègre and his three hundred lancers, and the Spaniard Miguel de Corella, Cesare's "executioner," were Gianpaolo Baglioni, Lord of Perugia; Paolo Orsini, once a captain in Florence's armies; and

Vitellozzo Vitelli, the famous artillery expert whose family ruled the papal fief of Città di Castello.

Among the troops was the Florentine artist Pietro Torrigiano, famous for having broken the nose of his fellow student Michelangelo: "Money being offered in the service of Duke Valentino," as Giorgio Vasari recorded, he "changed himself in a moment from a sculptor to a soldier," though he was later to return to stone-cutting and travelled to England, where he created the tomb of King Henry VII in Westminster Abbey, which has been rightly described as England's greatest memorial of the Italian Renaissance.

Cesare's objective, before winter closed in and the fighting season ended, was to consolidate his control of the Via Emilia by taking Faenza, a strongly fortified city between Forlì and Imola, and to extend the state south to the Adriatic coast with Rimini and Pesaro, two towns south of Cesena. The going was slow on the long march north from Rome, the mud thick on the road; but Cesare was in no hurry to commit himself to expensive military action, hoping that the agents he had infiltrated into these towns would persuade the excommunicated vicars to surrender without a fight.

In Rimini the despised Pandolfo Malatesta, arrogant grandson of the famous condottiere Sigismondo Malatesta, made little trouble. He handed over the keys of his city to Cesare's representative, the bishop of Isernia, before taking a boat to Venice, much to the relief of his subjects, who had failed in their attempt to remove him just two years previously. It proved almost as easy to convince Giovanni Sforza to leave Pesaro. On hearing that his erstwhile brother-in-law's troops were crossing the Apennines and approaching the city, Giovanni, who had already been humiliated

by the Borgias once before, fled and, just a few days after accepting the keys of Rimini, the bishop of Isernia did the same in Pesaro.

Cesare entered the city of Pesaro on October 27, his men-at-arms clad in his personal livery, which had been embroidered with a new emblem, the seven-headed Hydra, the mythical beast that when one head was cut off could grow another—an appropriate metaphor for Cesare's military ambitions.

The conquest of Rimini and Pesaro achieved with so little trouble and expense, Cesare was in an accommodating mood, exercising the ingratiating charm that he could summon at will when required. He apologized to the Duke of Ferrara's ambassador with "much amiability" for not having seen him the day before when the envoy had called at his headquarters. But he had had so much to do; also he had been troubled by a painful ulcer in his groin.

"The Duke's daily life is as follows," the ambassador continued. "He goes to bed between three and five o'clock in the morning and consequently midday is his dawn." Despite his unusual hours, however, it was clear that Cesare worked hard and had earned the respect of his captains. "He is considered brave and strong and generous and sets great store by straightforward men; but he is hard in revenge as I have often been told," added the envoy. "He is thirsting for fame and seems more eager to seize states than to administer them."

Having made a quick survey of Pesaro and instructing one of the artists in his entourage to make a painting of the citadel to send to his father in Rome, Cesare set out along the coast for the twenty-mile ride to Rimini, where he made his ceremonial entry on October 30.

Cesare now moved north along the Via Emilia toward Faenza, which, as he had informed the Ferrarese ambassador a few days earlier, he feared would not prove so straightforward as either Rimini or Pesaro; and he was right. Here, unlike so many of the other fiefs in the Romagna, the dynastic lords, the Manfredi, were well liked and respected by the people. A conspiracy to deliver the place over to Cesare was discovered and the plotters arrested: Cesare was forced to conclude that he faced a long siege.

After a heavy bombardment of the town, an assault was attempted but failed. A Ferrarese chronicler reported the news of this unprecedented defeat with ill-concealed jubilation. "On Saturday 28 November news arrived in Ferrara that the men of Duke Valentino, bastard son of the Pope, had come to Faenza with artillery and many Frenchmen in order to evict the Lord of Faenza but the men of that land killed many of the Duke's men, and wounded many more, which was a marvel," particularly, as the chronicler explained, "because he had already acquired the lordships of Rimini, Pesaro, Cesena, Forlì and Imola by tricks and treachery and driven out those unfortunate rulers."

Cesare's hopes of a quick surrender had been met with brave defiance. Toward the end of November, with snow already lying heavy on the ground, his stores almost exhausted, and his irregularly paid mercenaries deserting one by one as the fighting season came to an end, Cesare decided to withdraw his men to Forlì, leaving a small force outside Faenza to continue the blockade of the town.

He spent Christmas that year at Cesena, establishing the administration of his new state and ordering the strengthening of the fortifications of the conquered territories. He also gained the

support of the people of the Romagna by such gestures as contributing generously to the peasants in the countryside so as to compensate them for the damage done to their fields and woods during the recent campaigns.

At first he was in such seclusion that he was rarely seen outside the palace in which he had established his headquarters, issuing the orders calculated to gain him the good opinion of the people, hanging looters and men who stole or refused to pay a fair price for provisions. He then gained a reputation as a prankster, going about masked, sword in hand, spattering pedestrians with mud or demonstrating his strength in wrestling contests, his ability to outpace all comers in running races, or his skill at the *quintana,* a jousting game in which horsemen galloped at a figure of a Turk, gaining points depending upon the part of the dummy they struck. He also excelled at the *giostra all'anello* (the ring game), in which riders armed with lances charged at a ring stuck on a pole in an attempt to remove it.

In the middle of February 1501, Cesare indulged in another of his pleasures, the pursuit and conquest of a beautiful young lady, the pleasure no doubt heightened by the considerable risks involved. The lady in question was Dorotea Malatesta, the twenty-three-year-old sister of Pandolfo Malatesta and bride of Giambattista Caracciolo, a captain in the Venetian army. She was on her way from Urbino to Venice, where she was to join her husband, and Cesare had been asked by the Venetian government to provide an escort for her party while it was travelling up the Via Emilia. Soon after the escort had seen her safely into Venetian territory, she was waylaid, late in the afternoon, by a gang of ten horsemen armed with crossbows, who carried her off, after wounding

several of the men in her entourage. The mayor of Ravenna, who had been told to keep an eye on Dorotea, gave a colourful account of what happened to her and her female companion after they were carried off.

The two women, "protesting and lamenting greatly, their hair dishevelled," were taken back across the border to a village near Cesena, where the men ordered Dorotea to dismount and led her into a cottage, where they "demanded the fire to be lit and the supper prepared." When Dorotea asked where she was being taken, they answered, "Do not seek to know; you are in good hands and you will be going to better ones, where you are awaited with high desire." When she tried to find out the identity of her kidnapper, they replied: "Enough, my lady, do not seek to know more." The mayor continued: "And they set her, weeping and groaning, down to eat. She did not want food, so they threatened her, and she was forced to take an egg; then she was put to sleep with her companion and the peasant's wife, and she was not molested that night." Her destination, according to the mayor, was Forlì.

Cesare was immediately suspected of the kidnapping. The Venetian authorities protested loudly to the papal legate and to the French ambassador in Venice about the duke's supposed involvement in the affair; the abduction of "one of the most beautiful and notable ladies in Italy" was a horrible crime, to be "abominated and detested."

The government also sent a representative to Cesare to complain of the crime and to demand Dorotea's release. Cesare denied all knowledge of the abduction, and when the Venetian agent—who had been instructed to make no salutation to him—was received by Cesare, he was arrogantly rebuffed. Cesare assured the

man that he had "no lack of women" and did not need to abduct them. He declared, moreover, that the crime had been committed by one of his Spanish officers, Diego Ramires, and that it was he and Dorotea who had been lovers. Indeed, claimed Cesare, Diego Ramires had shown him some shirts that Dorotea had given him.

The Venetian government was not alone in protesting at Cesare's guilt. The king of France also complained; so did Francesco Gonzaga, the Marquis of Mantua, on behalf of his sister, the Duchess of Urbino, in whose care Dorotea had been before her marriage. But Cesare brushed aside all such protests, and as the days and weeks passed, while there were rumours that Dorotea was being kept in captivity against her will, perhaps in the castle of Forlì, nothing reliable was heard of her for the moment. She reappeared, however, in February 1504, at Faenza after a long sojourn in a convent.

It was certainly the case that Ramires was suspected by many in Italy of being guilty of the crime. Indeed, one contemporary chronicler, Giuliano Fantaguzzi, wrote unequivocally that Dorotea was "attacked and abducted by Messer Diego Ramiro, soldier of Duke Valentino and formerly courtier of the Duke of Urbino."

Others, however, were certain Cesare was guilty. Even the pope believed that his son might well have committed the "horrid and detestable crime." He informed the Venetian ambassador in Rome: "I do not know what punishment whoever did it deserves," adding that "if the Duke has done it, he has lost his mind." He showed the envoy a letter written to Cesare demanding that the culprit be severely punished; and he maintained that when the abduction took place, his son had been in Imola, not Forlì. Despite his "bold words," however, the pope showed how deeply the affair "had upset him."

Meanwhile, Faenza was holding out against the siege of Cesare's armies, "supplied," as the Ferrarese chronicler explained, "with victuals thanks to the covert assistance of Florence, Bologna and other Italian powers." Cesare had resumed his attack on the city at the end of January: "Yves d'Alègre with 1,000 horses," reported the chronicler, "passed through Reggio Emilia to help Duke Valentino who has decided to take Faenza by force." The chronicler also noted large quantities, "10,000 they say" of French cavalry, foot soldiers, lancers, and artillery moving through the duchy of Ferrara in March and early April.

Cesare finally took Faenza during the week following Easter, which fell on April 11 that year. As many as two thousand were killed; many more were wounded. Cesare lost seven hundred of his own men and several of his captains, on the first day of the battle. In Rome Alexander VI failed to attend Mass in the Sistine Chapel on Easter Saturday—"it was said," reported Burchard, "that the Pope had not come because of a rumour that many of the Duke's soldiers have been killed outside Faenza." But a few days later, his worries eased when news arrived that the city had finally fallen, that Astorre Manfredi, the young Lord of Faenza, had surrendered, and that Faenza had paid 40,000 ducats to Cesare to avoid being sacked.

The news, which had arrived in Rome on April 26, was greeted with great excitement. While the cannons of Castel Sant'Angelo roared from eight o'clock that evening until light dawned the next day, Jofrè rode through the streets celebrating his brother's victory, accompanied by Carlo Orsini and a large group of revellers, shouting, "The Duke! The Duke! Orsini! Orsini!"

Cesare, meanwhile, had wasted little time on celebrations. Just days after his victory at Faenza, he had seized the opportunity to

consolidate his hold on the area by marching some ten miles up the Via Emilia to take Castel Bolognese. This strategic outpost belonged to Bologna, and Cesare's move had caught Giovanni Bentivoglio, the ruler of the city, by surprise. In order to avoid a direct attack, he was forced into an alliance with Cesare, recognizing his possession of Castel Bolognese and agreeing to provide him with a hundred soldiers, which were to be maintained at Bologna's expense, in return for the guarantee of his security.

As Lord of Imola, Castel Bolognese, Faenza, Forlì, Cesena, Rimini, and Pesaro, Cesare was now the ruler of a substantial state that stretched seventy-five miles down the Via Emilia from Bologna to the Adriatic coast. And in May his father, the pope, invested him with the title of Lord of the Romagna. He had achieved his stated goal as captain-general of the church of returning the fiefs that had belonged to the excommunicated vicars to papal rule, and slightly exceeded his mandate with the capture of Castel Bolognese.

Alexander VI now ordered his son to return to Rome. It was soon clear, however, that Cesare had assumed a new importance in his own eyes. Acting independently of the pope, and in a way that was directly contrary to his father's wishes, Cesare now turned his attention to Florence. He was aware of the need for speed: Yves d'Alègre and the other French troops would soon be obliged to leave him to join the French army that was massing at Parma for Louis XII's campaign against Naples.

Florence's republican government was seriously alarmed. "From all parts come reports of the ill intentions of the Pope and the Duke, who intend to attack us and change our constitution," the Florentine representative in France, Machiavelli, was told. The Florentines were only too aware that Cesare would have "such confi-

dence in his fortune that every undertaking, even the most diffi-cult, seems easy to him." And they worried about the motives of several of Cesare's captains, whom they described as "most inimi-cal to our city." Paolo Orsini, for example, had close links with the exiled and detested Medici family; or Vitellozzo Vitelli, who had sworn publicly to take revenge on the Florentines for executing his brother Paolo.

In the city itself, fear of Cesare had caused "the greatest dis-order," so Biagio Buonaccorsi said; many citizens had fled their homes, he added, and "appeals were made to the King [of France] who was too far away to be of any help in so urgent a matter; the King did write letters to the Duke, but none of them was obeyed and everything was in suspense and great tumult."

By May 2, five days after seizing Castel Bolognese, Cesare's troops had crossed the Apennines and set up camp at Firenzuola, just thirty miles from Florence. His army approached the city slowly, taking every opportunity to destroy crops, burn barns, steal animals and food stores, even to cut the grain ripening in the fields. On May 13 the Florentine envoys met Cesare at Campi and, much to the relief of the city, negotiated a treaty of alliance with the bold invader, paying Cesare 36,000 ducats a year for the privilege. Buonaccorsi claimed that the Florentines had signed "merely to get Cesare off their backs," but the threat had been very real.

"This lord is very proud," Machiavelli was to write later of Ce-sare, "and, as a soldier, he is so enterprising that nothing is so great that it does not seem trivial to him. And, for the sake of glory and of acquiring lands, he does not rest, and acknowledges no fatigue or danger. He arrives at one place before he is known to have left the other; he endears himself to his soldiers; he has got hold of the best

men in Italy, and these factors, together with continual good fortune, make him victorious and dangerous."

Cesare now withdrew his men to the Tuscan coast, allowing them to plunder indiscriminately on their way to their camp near Piombino, opposite the island of Elba, from where he was now in a position to threaten both Pisa and Siena. Cesare himself, however, had other obligations, not least his promise to assist in the French campaign to conquer Naples, and so, on June 27, he finally acceded to his father's request and returned to Rome. He had reason to feel satisfied with himself and his achievements. At the age of twenty-five, the new Lord of the Romagna had become a force to command fear and respect in Italian affairs.

The Naples Campaign

"THEY KILLED WITHOUT PITY"

CESARE RETURNED TO ROME late in the evening of June 17, 1501, stealing in quietly through one of the smaller gates in his characteristically mysterious way, unobserved in the gathering dusk and in the general commotion caused by the vanguard of the French army, who had set up camp outside the city walls the day before.

The soldiers had left a trail of destruction behind them as they had marched through central Italy. The Florentine diarist Luca Landucci reported as many as thirty thousand troops "doing many wicked things: they cut crops for their horses wherever they went, plundered all the wine cellars, flogging anyone in their way; they respected neither the commissioners nor the people; they killed the peasants who tried to stop them from taking their hens and in one fight they killed twenty men." On hearing the news that the French

had arrived in Rome, Landucci exclaimed with compassion, "Just think what it is like in Rome."

The French army of fourteen thousand men had been provided with meat, bread, and wine, and a camp had been established for them outside the walls of Rome. They had, additionally, so Burchard said, been provided with the services of the very inadequate number of sixteen prostitutes. Burchard also said that the Florentine merchants in Rome had bribed the city governor with a generous sum of ducats to avoid having senior French officers billeted in their houses; the French were billeted on them anyway, and the governor kept the money.

Their commander, Robert Stuart, Lord d'Aubigny, a Scot by birth, arrived in Rome on June 23 and was received at the gate of Santa Maria del Popolo by Jofrè, who escorted the Frenchman to the Vatican. The pope greeted his guest, and, so the French chronicler Jean d'Auton observed, "dissimulated his feelings with a joyous countenance." Alexander VI, "despite the fact that he was Spanish and no friend of the French," continued the chronicler, "received the captains of the French army, and talked merrily with them on various subjects." He handed out lavish presents to all; d'Aubigny received a great grey charger, "with harness so splendid that everyone was amazed by it."

That evening Cardinal Sanseverino, the brother of the commander of the Italian troops, entertained the French officers at "a magnificent banquet," which was held in the gardens of Cardinal Ascanio Sforza's villa, "in which there were groves of orange and lemon trees and pomegranates as well as other fruit trees and flowers of all kinds and scents, and singers, jugglers, tragedians and comedians all exercised their art in turn."

The French army left Rome on June 28, after marching past Castel Sant'Angelo. From his position high on the balcony, Alexander VI watched the parade of 12,000 infantry, 2,000 cavalry, and 26 carriages laden with artillery, observing, so it was said, "the departure of these soldiers with great joy." Also in the parade was Cesare, seen in public for the first time since his secret return ten days earlier.

The following day Lord d'Aubigny went to the Vatican, where he was closeted for some time with the pope, who told his visitor the news that, in a secret consistory held a few days earlier, he had formally dispossessed Federigo of Aragon of the kingdom of Naples and bestowed it instead on the king of France. After their private talks, d'Aubigny went to the Sala del Pappagallo, where, Burchard reported, "all the cardinals permitted him the honour of kissing them on the mouth," before taking his leave and rejoining his troops on the road south to Naples.

Despite taking part in the parade, Cesare himself did not leave Rome immediately, delaying his departure for several reasons. The formidable Caterina Sforza, weakened after spending nearly a year imprisoned in the dungeons of Castel Sant'Angelo, was finally persuaded to abandon her rights to Imola and Forlì, and she was released from gaol to spend the rest of her years in exile in Florence. More importantly, Cesare was waiting impatiently for his captain Vitellozzo Vitelli and his soldiers, who were on their way south from Tuscany, having taken the strategically important port of Piombino. Finally Cesare and his four hundred troops were ready to join the French army marching to Naples under the command of d'Aubigny.

Little serious resistance was offered to the French troops and their allies in Aversa, Nola, and other towns in the kingdom of

Naples. Only Capua, twenty miles north of the capital, put up a fight, and by the middle of July, Cesare was absorbed in a violent and bloody campaign to seize the city for Louis XII. "The taking of Capua was due to the treason of an inhabitant of that city, who secretly let in the Duke's troops and they then killed him," reported Burchard. "They killed without pity priests, monks and nuns, in churches and convents, and all the women they found: the young girls were seized and cruelly abused; the number of people killed amounted to around 6,000." According to an improbable account by Guicciardini, Cesare had the women of the town locked up in a tower and selected the most desirable for himself. What was certain was that this orgy of rape, murder, and looting ended in the entire population of Capua being killed.

On August 4 d'Aubigny entered Naples in triumph, while the ex-king Federigo, who had been crowned by Cesare's hand just four years before, fled to the island of Ischia. Louis XII was now Duke of Milan and king of Naples, and the dominant power in Italy, thanks to the support of the pope and his son. When Cesare arrived in Naples, d'Aubigny offered him grateful thanks in the name of the French king and a reward of 40,000 ducats for his services as well as the title of Prince of Andria.

Alexander VI, meanwhile, had taken advantage of the French presence in the peninsula to consolidate his own control over the lands and castles that had once belonged to the powerful Colonna family, and on July 27, the day after Capua had been cruelly sacked, set out on a tour of inspection of his new territories. Riding with him were fifty horsemen, as many as one hundred on foot, his household, and many of the cardinals, each accompanied by their own retinue of servants and courtiers. After lunch at Castel Gan-

dolfo, the pope was rowed around Lake Albano, listening to the crowds gathered at the lakeside shouting, "Borgia! Borgia!" and letting off volleys of gunfire.

During his absence, Alexander VI had entrusted the care of the Vatican, and the church, to the capable hands of his daughter, who moved into the papal apartments. "The Pope gave her authorization to open letters addressed to himself," reported Burchard, and "told her that if there were any difficulties she was to take advice from the Cardinal of Lisbon and the other cardinals, whom she was empowered to summon." On one occasion, he continued in an unusual display of ribaldry, she did seek the cardinal of Lisbon's advice: "Seeing that the affair was of no importance, the Cardinal said to her, 'When the Pope discusses an issue in consistory, the vice-chancellor or, in his absence, another cardinal, writes a record of the solutions proposed and of the cardinals' votes, so we should have someone here to take notes of our discourse.' Lucrezia replied that she was quite capable of writing herself. The Cardinal then asked, 'But where is your pen?' Lucrezia understood the joke [pen was a popular term for penis] and she smiled."

The Duke
and the Borgia Girl

"IF I COULD OVERCOME MY DISTASTE
FOR THESE BORGIA UPSTARTS"

LUCREZIA HAD RETURNED to Rome from her self-imposed exile at Nepi in time for Christmas in 1500 and to the news that Alexander VI had started to consider whom she should marry next. She did not want to marry again, she told her father, according to a report sent by the Venetian ambassador, adding that she said "my husbands have been very unlucky" and "she left in a rage." She was, however, to have little say in the matter.

The pope carefully considered the merits of alliances with various Italian families before deciding on Alfonso d'Este, the eldest son of Ercole I, Duke of Ferrara. The twenty-four-year-old prince was a widower, his wife having died in childbirth three years earlier. The lineage of the Este family was honourable, their possessions enviable. One of the oldest noble dynasties in Italy and undisputed masters of Ferrara and its surrounding territory since 1240, their

state was not so large as either Venice or Milan, but it benefited from the lush soils of the Po plain, was well and profitably administered, and Ferrara itself was a lively centre of the arts. It was, moreover, just to the north of Cesare's duchy of the Romagna, and the alliance, so the pope thought, would benefit both of his beloved children.

The proposal, however, was not at all welcome in Ferrara, where the Borgias were considered socially inferior and morally corrupt. The Este family may have had many skeletons in their own cupboard, and Alfonso was far from being a model of propriety himself. He was said to have but two interests in life; one was the casting of cannons in his own foundry; the other was walking the streets of Ferrara at night, a drawn sword in one hand, his erect penis in the other. His dead wife had also been the subject of scandalous talk; neglected by her husband, she had shared her bed with a young Negro girl with whom she took male parts in the theatricals for which the Ferrarese court was renowned.

Nevertheless, when the offer was made in the spring of 1501, Duke Ercole and his family were horrified, not least at the prospect of an alliance between themselves and the man currently under suspicion of abducting and raping the pretty young bride Dorotea Malatesta. That Cesare was guilty of the crime, despite his protestations of innocence, no one in Ferrara doubted. And Alfonso's sister, Isabella d'Este, wife of the Marquis of Mantua, had a special interest in the case; the unfortunate Dorotea had been a protégée of her sister-in-law the Duchess of Urbino.

Moreover, Duke Ercole I was currently pursuing the prospect of royal connections, hoping for the niece of Louis XII as a bride for his son. When the pope's envoy Cardinal Gianbattista Ferrari

proposed a union between the Borgias and the Estes, he was haughtily informed by the duke that it would be "impossible to countermand the plans already in process of settlement with His Majesty of France: one does not snatch from the consideration of a king plans which it pleases him to consider, as a wilful child might tease a cat by hiding its bowl of milk."

Undeterred, indeed provoked, by this rebuff, the pope hinted at the consequences that might ensue upon Duke Ercole's continued refusal of a Borgia marriage, going so far as to suggest through his envoy that the "advantage" of such a marriage would be that Duke Cesare would "no longer be a threat to the south of his Excellency's dominions" and that Lucrezia would bring to Ferrara a dowry of no less than 200,000 ducats: "I strongly urge you," the pope's envoy was instructed to say, "to make a bond with His Holiness." Alexander VI also made direct overtures to Louis XII, who responded by informing him that nothing would induce him to "unravel the skeins of love" that linked his niece with Alfonso d'Este, who would soon become her husband.

The king, however, needed the help of the Borgias to further his own ambitions in Italy and, somewhat reluctantly, agreed to call a halt to the negotiations for the proposed marriage between Alfonso and his niece, and to press Duke Ercole instead to accept Lucrezia as his new daughter-in-law. And so it was to be.

In a letter to his son-in-law Francesco Gonzaga, the Marquis of Mantua, Duke Ercole explained his change of plan:

We have recently decided, owing to practical considerations, to consent to an alliance between our house and that of his Holiness—in short to the marriage of our eldest son, Alfonso,

and the illustrious lady Lucrezia, sister of the illustrious Duke of Romagna and Valence, mainly because we were urged to do so by his Most Christian Majesty [the king of France] and on condition that His Holiness would agree to everything stipulated in the marriage contract. Subsequently His Holiness and ourselves came to an agreement and the Most Christian King persistently urged us to approve the contract.

The duke, however, declined to give way without a struggle; he demanded an increase in the dowry with another 20,000 ducats worth of precious stones; he demanded that the 4,500 ducats he was obliged to pay each year to the Vatican be rescinded. He also demanded, without much hope of being granted them, the territories of Cento, Pieve, and Cesenatico, as well as various benefices for his younger son, Ippolito, who had been made a cardinal by Alexander VI in 1493. Unwilling to commit himself to the proposed marriage of his son into a family he considered upstarts, he had raised objection after objection, stipulated condition after condition, asked for guarantees that the dowry would be paid, until Alexander VI had complained that the man was behaving "like a shopkeeper."

Ercole I had also heard the distasteful rumours claiming that Lucrezia had indulged in incestuous relationships with both her father and brother—indeed there were few in Italy who had not heard them—and before agreeing to the match, he sent two diplomatic officials to Rome to make enquiries about the Borgia girl and her suitability for admittance into the distinguished House of Este.

When the envoys arrived in Rome, they were admitted immediately to Lucrezia's presence. Later that day they reported to their

"most illustrious and excellent prince" that "we entered the palace where the illustrious Lucrezia lives, and where, tired with riding and thinking we were going to rest, we were immediately conducted into the said Lucrezia's presence, where we were graciously received. We expressed the infinite pleasure and contentment of your Excellency, and the great love which your Excellency bears her," emphasizing, as they had been ordered to do, "how perfectly disposed your Excellency is to treat her well." The two envoys did their work conscientiously, taking almost four months over it and finally deciding that Lucrezia was an acceptable bride.

There were several problems concerning Lucrezia's past that needed careful consideration. Her son Rodrigo was one such issue. He was living with his mother in Rome; but it was decided that it would not do for him to accompany her to Ferrara. The Ferrarese ambassador in Rome went to see Lucrezia about this to ask her "what was to be done with him; she replied, 'He will remain in Rome and will have an allowance of 15,000 ducats.'" The fact that Lucrezia had already borne a son was, of course, an advantage to a duke in need of grandsons to secure his family line.

There was also the issue of Lucrezia's divorced husband, Giovanni Sforza, who was living in Ferrara, to be settled. The pope wrote about this to the two envoys who had been sent by Ercole I to make enquiries concerning Lucrezia. They, in turn, passed his request on to the duke; the pope "has asked us to write to Your Excellency to request that you see to it that the Lord Giovanni of Pesaro shall not be in Ferrara at the time of the marriage celebrations, for, although his divorce from the illustrious lady was absolutely legal," they insisted, "himself fully consenting to it, he may, nevertheless still feel some resentment."

Meanwhile, negotiations about the dowry had reached their con-
clusion, and it was clear that Ercole I had extracted a high price. It
was agreed that Lucrezia should bring 100,000 ducats and that she
should also take to Ferrara jewellery, carpets, linen, tapestries, fur-
niture, silver, and *objets d'art* and *de vertu* worth a further 75,000
ducats. The duke would receive the castles and lands of Cento and
Pieve—though not the port of Cesenatico, which properly be-
longed to the duchy of Romagna—as well as a reduction in the an-
nual census payable to the Vatican from 4,500 ducats to a token
sum of 100 ducats. Cardinal Ippolito d'Este was to be made bishop
of Ferrara and receive other benefices worth 14,000 ducats a year
and a palace by St. Peter's. Ercole I was jubilant; the deal, he
thought, was worth a total of 400,000 ducats to his family. "If I
could overcome my distaste for these Borgia upstarts," Alfonso in-
formed his father, "I might even consider myself fortunate."

At last, on August 26, 1501, the marriage contract was signed,
and Lucrezia, just twenty-one years old, was to be a bride for the
third time. For her own part, having been sent a portrait of her fu-
ture husband and heard reports of his taste for low life and low
company, she decided that, once she had given him children, Al-
fonso would let her go her own way. Moreover, the proposed mar-
riage into the Este family would allow her to escape from Rome, a
place associated with unhappy episodes in her young life.

And the old duke was soon to be grateful to his prospective
daughter-in-law for more than mere money. In 1499 Ercole I had
heard of a nun at the Dominican convent at Viterbo, Sister Lucia
da Narni, who had been developing stigmata on her hands every
Friday. A man much intrigued by such miracles, the duke decided
to bring the nun to Ferrara. The mother superior, however, was

reluctant to part with so potentially valuable an asset, though Sister Lucia herself was quite willing to go. So the duke arranged for her to be spirited out of the convent in a basket and taken to Ferrara, where, unfortunately, she felt dreadfully homesick, missing the nuns whom she had left behind in Viterbo. Very well then, the duke decided, the other nuns should also come to Ferrara, where a new convent would be built for them.

Duke Ercole then sent a trusted courtier, Bartolomeo Bresciano, as his envoy to Viterbo to put this proposal to the prioress of the convent, but she objected in the strongest terms to the duke's suggestion. Bresciano, appalled by her bossiness, called her a woman "more obstinate than the Devil himself" and turned to Lucrezia to ask her to use her influence at the papal court. Lucrezia, whom he described as "a delightful lady with a first-class mind," went out of her way to assist, negotiating in person with the pope and the Dominicans until, at last, the prioress was forced to let nine of her nuns go to Ferrara. Lucrezia "is endowed with such graciousness and goodness," wrote Bresciano to Duke Ercole, "and thinks only of how to serve you."

Now that the contract had been signed, the formal betrothal between Alfonso and Lucrezia could take place. Accordingly, as Burchard recorded, "about the hour of Vespers on Saturday 4 September news came of the marriage contracted and concluded between Alfonso d'Este, elder son of the Duke of Ferrara, and Lucrezia Borgia, formerly the Duchess of Bisceglie and earlier the wife of Giovanni Sforza."

The news of the forthcoming marriage was greeted in Rome with exceptional excitement and with the celebrations that the citizens so much enjoyed on these occasions; a "continual cannonade"

of artillery fired noisily from the ramparts of Castel Sant'Angelo while fireworks flashed and spluttered in the sky. The following day, Sunday, saw Lucrezia, dressed in a robe of gold brocade and accompanied by her ladies and several bishops, riding in the place of honour in a grand procession of three hundred horses from her palace to the Church of Santa Maria del Popolo, while her Spanish dwarfs skipped and jumped through the streets.

That evening, as the great Capitoline bell tolled, bonfires were lit at Castel Sant'Angelo and throughout the city, illuminating the towers of the castle, the Capitol, and other buildings: "The people became wildly excited," which, according to Burchard, "caused some anxiety." On Monday two clowns "paraded through all the principal streets and piazzas," continued Burchard. They went on their way, one on horseback, one on foot, both shouting loudly, "Long live the Duchess of Ferrara! Long live Pope Alexander! Viva! Viva!" Lucrezia had given each of them a dress from her wardrobe; the riding clown had received the new gold brocade robe she had worn the evening before, which was said to be worth as much as 300 ducats.

The pope also celebrated his daughter's betrothal with a succession of parties and banquets at the Vatican. He joined in the festivities with relish, undeterred by a bad cold and a loose tooth, and the fact that he was approaching his seventieth birthday, remarking cheerfully to the Ferrarese ambassador that, although his face was tied up, he would happily invite the bridegroom's father to a wild boar hunt.

Cesare, who had returned from Naples on September 15, was exhausted after the fighting. A few days later he received a visitor—one of the rare occasions when he received them at all—lying down but

fully dressed. "I thought he was ill," the surprised Ferrarese envoy wrote, "but yesterday evening he danced without intermission and will do so again tonight at the Pope's palace where the illustrious Duchess [Lucrezia] is going to supper." Burchard also commented on Cesare's condition: "The Duke has recently been ill again with his old complaint, which returned upon him after the conquest of Naples and has, some of his physicians think, affected his mind as well as his body. Although forcing himself to take part in dances and entertainments, it is seen and reported by his servants that they discover him exhausted and sometimes in pain upon his bed."

Lucrezia, too, was beginning to feel the strain of unremitting parties and dances that the pope was so fond of attending and watching. "Whenever she is at the Pope's palace," the Ferrarese envoy reported, "the entire night, until two or three in the morning, is spent dancing and at play, which fatigues her greatly."

On September 25 the celebrations were halted when the pope and his son left Rome for a week, leaving Lucrezia once again in charge at the Vatican, while they went on a tour of inspection of the papal castles north of Rome, stopping at Nepi and, in particular, the fortress at Civita Castellana, forty miles north of Rome, which was being built under the direction of the military architect Antonio da Sangallo. The two men did the same in October, this time travelling south to view the fortresses recently seized from the Colonna family.

By the end of October, Cesare and his father were back in Rome. Perhaps it was these trips that revitalized Cesare, but he had certainly recovered his spirits by October 31, when he hosted a supper party in his apartments in the Vatican Palace to which he invited his

father, his sister, and many friends, along with fifty courtesans. This particularly colourful party was described in detail by Burchard:

> On Sunday the last day of October 1501 there took place a supper attended also by fifty honest prostitutes, those who are called courtesans. After supper they danced with the servants and others who were there, first clothed, then naked. After supper the lighted candelabra which had been on the table were placed on the floor, and chestnuts thrown among them which the prostitutes had to pick up as they crawled between the candles. The Pope, the Duke and Lucrezia, his sister, were present looking on. At the end they displayed prizes, silk mantles, boots, caps and other objects which were promised to whomsoever should have made love to these prostitutes the greatest number of times. The prizes were distributed to the winners according to the judgement of those present.

Four days later, so the Florentine ambassador Francesco Pepi reported, the pope failed to attend Mass in the papal chapel. It was rumoured that he was ill, no doubt the after-effects of Cesare's party, at which, according to Pepi, the elderly pope had spent "the night until the twelfth hour with the Duke who had brought into the palace that night, singers and courtesans; and all night they spent in pleasure, dancing and laughter." Rather less reliably, the Perugian chronicler Francesco Matarazzo reported that the pope "had all the lights put out, and then all the women who were there, and as many men as well, took off all their clothes, and there was much play and festivity."

Lucrezia was again seen to be enjoying herself when, a few days after the game with the chestnuts and candles, there was a display of animal lubricity inside the Vatican. Burchard described how a farmer had brought some mares through the Viridaria gate by the palace carrying loads of wood for the market and

> when the mares reached the piazza of St. Peter's, some of the palace guard came up and cut through the straps and threw off the pack saddles and the wood in order to lead the mares into the courtyard immediately inside the palace gate. Four stallions were then freed from their reins and harness and let out of the palace stables. They immediately ran to the mares, over whom they proceeded to fight furiously and noisily amongst themselves, biting and kicking in their efforts to mount them and seriously wounding them with their hoofs. The Pope and Lucrezia, laughing with evident satisfaction, watched all that was happening from a window above the palace gate.

Cesare was evidently not present on this occasion; and it appears that there was at this time a growing friction between father and son, the pope becoming increasingly annoyed by his son's "turning day into night and night into day," as one of the Ferrarese envoys put it, and extremely hard to pin down to a meeting to discuss affairs of state.

It seemed as though Cesare, increasingly independent, elusive, and self-assured, and liable to fly off the handle at the least hint of criticism of his actions, no longer valued the advice of his father and certainly rarely sought it. Cesare's arrogant atheism was an-

other bone of contention since, although his father's morals were widely held to be deeply corrupt—indeed, Agostino Vespucci told Machiavelli that it was "known to everyone that His Holiness brought every evening to the Vatican twenty-five women or more . . . so that the palace is manifestly made the brothel of all filth"—the pope was scrupulous in the outward observances of his religious duties and had an apparently sincere devotion to the cult of the Virgin Mary.

When wearing his black mask by day, Cesare naturally became an object of curiosity on the streets of Rome; but men who stared at him soon learned that it was dangerous to do so. Cesare had one man arrested and imprisoned for apparently making a critical re-mark; that night his hand was cut off, his tongue ripped out and at-tached to the little finger of the severed hand, and the whole grisly ensemble was hung out of the prison window for all to see. Yet an-other, guilty of some unknown offence, was "secretly strangled and his body cast into the Tiber." Men naturally grew ever more wary in Cesare's presence.

"He cannot tolerate insults," his father confided in conversation with the Venetian ambassador. "I have often told him that Rome is a free city and that everyone may speak and write as they please. Evil is often spoken of me but I let it pass. The Duke replied to me, 'It may be true that Romans are accustomed to speak and write as they please but I will teach people to take care what they say about me.'" He was as good as his word—more than one man had a hand struck off or his tongue ripped out for writing or speaking mockingly of the Duke of Valence.

Uneasy as relations between the pope and Cesare were from time to time, both remained devoted to Lucrezia. Indeed, the pope

patently adored his daughter, the "apple of his eye," and, useful as her marriage to Alfonso d'Este would be to both of them politically, providing a reliable alliance with Ferrara, both father and brother looked upon it as a sacrifice, one that would bring Lucrezia's inevitable departure from Rome.

Meanwhile, Duke Ercole's ambassadors continued to send favourable reports regarding the behaviour of the girl soon to be his daughter-in-law. "Lucrezia is a highly intelligent, gracious and extremely graceful young lady, modest and lovable," one envoy reported in November 1501. "She is also devout and dutiful as a Christian. Tomorrow she will go to confession and intends to receive communion during Christmas week."

The duke's daughter, Isabella d'Este, however, was suspicious of this attractive twenty-one-year-old woman who was to become her sister-in-law and was to receive so many valuable family jewels and sumptuous clothes in consequence. She dispatched to Rome a man who could be trusted to send her accurate reports of the unwelcome bride, her trousseau, and the ladies of her court. The man, having undertaken "to follow the most excellent lady as a shadow follows a body," sent back to Mantua reports that cannot have pleased Isabella, describing a "charming and very graceful lady":

On Sunday I went to see her in the evening [one of the reports ran] and found her sitting near her bed with ten maids of honour and twenty other ladies wearing handkerchiefs on their heads in the Roman fashion. They soon began to dance and Madonna Lucrezia did so very gracefully. . . . She wore a *camorra* of black velvet with a white chemise . . . a gold-striped veil and a green silk cap with a ruby clasp. . . . Her maids of

honour have not yet got their wedding dresses. Our own ladies are quite equal to them in looks and, indeed, in everything else. . . . The number of horses and people the Pope will place at her disposal will amount to one thousand. There will be two hundred carriages. . . . The escort which will take her to Ferrara will travel in these.

Finally, at the beginning of December 1501, Duke Ercole gave the order for the departure of the grand cavalcade that was to travel to Rome in order to escort his son's bride back to her new home. Three of Alfonso's brothers—Ferrante, Sigismondo, and Cardinal Ippolito—led the party of ducal courtiers, secretaries, councillors, bishops, soldiers, and servants, horses, mules, and wagons. The weather was dreadful, the going exceptionally hard. They struggled for three weeks through the snowbound passes of the Apennines and down to the flooded Tiber plain. Finally, just before Christmas, the long line of horsemen, carriages, and carts drew to a halt outside the walls of Rome at the gate by Santa Maria del Popolo.

~ Chapter 20 ~

Frolics and Festivities

"THE CUSTOMARY FESTIVITIES [FOR CARNIVAL],
INCLUDING THE HORSE RACES,
WILL COMMENCE AFTER CHRISTMAS"

LATE IN THE AFTERNOON of December 23, 1501, the entire papal court assembled, at Alexander VI's orders, at the gate of Santa Maria del Popolo to greet the Este princes and their courtiers, who had come to Rome to escort Lucrezia back to Ferrara. The cardinals waited an uncomfortable hour on their mules before dismounting and retiring to the comparative warmth of the church, where they waited another hour before the visitors finally arrived.

They were received by Cesare, who was accompanied by pages in silk tunics, a band of trumpeters, and four thousand soldiers, all wearing his personal livery. And after the lengthy speeches of welcome had been finished, he escorted the Ferrarese party through the city, across the Ponte Sant'Angelo, to the deafening roar of cannons that thundered from the ramparts of the castle, and on to the

Vatican. His appearance thrilled the crowds that had gathered on the streets to watch the cavalcade pass: Burchard recorded that he "excited great admiration in the minds of all who beheld him, for he was magnificently dressed in a coat of the French fashion, fastened with a gold belt which set off his graceful yet athletic form to advantage, and rode a fine, strong charger which was so magnificently caparisoned that its trappings alone were said to be worth 10,000 ducats."

At the Vatican Alexander VI graciously welcomed his guests, the bridegroom's three brothers, Ferrante, Sigismondo, and Cardinal Ippolito. Cesare then led them across the piazza of St. Peter's to be greeted by his sister, who was looking dramatically radiant in a white dress, her long fair hair partially concealed by a green gossamer net, secured by a gold band and two rows of fine pearls encircling her forehead.

The preparations in Rome for the reception of the Ferrarese visitors could scarcely have been more impressive. Cesare, in his extravagant way, was determined to make everything as splendid as possible: "The things that are ordered here for these festivities are unheard of," wrote the Florentine ambassador Francesco Pepi, shocked at the extravagance, adding, "The shoes of the Duke's footmen are made of gold brocade, and so are the shoes of the Pope's grooms while he and the Duke vie with each other in wearing the most magnificent, the most fashionable and the most expensive things."

Magnificent as he himself chose to appear, Cesare wisely decided not to try to take precedence over the Este brothers, who were, after all, his guests. This tactful behaviour was "considered as highly complimentary to the embassy," Burchard commented, "as it was

known that ever since his marriage to Charlotte d'Albret, sister of
the King of Navarre, his pride had so much increased that he al-
lowed neither ambassadors from kings nor any of the princes of
Germany, nor even cardinals, to take precedence over him in any
way, making an exception only in favour of the blood royal of
France."

In order to entertain his guests as splendidly as possible, the
pope had issued a decree announcing that Carnival would be cele-
brated early: "The customary festivities," wrote Burchard, "includ-
ing the horse races, will commence after Christmas." Accordingly,
on December 26 the streets filled with revellers; the masked fig-
ures of Cesare and the Este princes were also to be seen joining in
the bawdy fun as courtesans ran about dressed as boys and throw-
ing eggshells filled with rosewater at each other and at passersby.

That evening Lucrezia hosted a ball, where, so Isabella d'Este's
secret informant told her, the young bride "danced with extreme
grace and liveliness, wearing a *camorra* of black velvet bordered with
gold," the décolletage chastely obscured beneath a film of gilded
gauze, "with a string of pearls around her neck, and a green net with
a chain of rubies on her head," and, he added, "a few of her ladies-
in-waiting are very pretty."

The next morning the Carnival was in full swing. For the fol-
lowing three days, the streets of Rome were filled with crowds
watching, and taking part, in the great races run between Campo
dei Fiori and the piazza in front of St. Peter's. The Jews were the
first to run, but the winner was disqualified because, it was said, he
had broken the rules, and it was announced that the race would be
rerun the next day. There were races for old men and for prosti-
tutes, a particular favourite with the populace. According to Bur-

chard, there was also a race for wild boars, mounted by youths, "who beat them with sticks and kept control of their heads with reins attached to the rings that pierced their snouts, whilst other men guided them along and prevented them from running into side alleys."

When the last race was over, on December 29, those gathered in the piazza of St. Peter's watched as trumpeters and players of other musical instruments assembled on the platform above the steps of the basilica and began to sound the fanfare to announce the arrival of the bride. Burchard recorded the scene:

> From her residence next to St. Peter's, Donna Lucrezia emerged, clothed in a robe of golden brocade, decorated in the Spanish fashion, and with a long train behind her which was borne by a young girl. At her side were the two brothers of her bridegroom, Ferrante on the right and Sigismondo on the left. Fifty Roman ladies, most beautifully attired, came next, followed by Lucrezia's own ladies-in-waiting, walking in pairs.

When the bridal procession had entered the Vatican, the crowds watched as a wooden castle was wheeled into the piazza and two companies of Cesare's soldiers fought a mock battle, with plenty of noise and colour, for possession of the structure.

Meanwhile, inside the palace, Lucrezia was received by her father, accompanied by thirteen cardinals and by her brother Cesare, and the ceremony began. The sermon, which was delivered by the bishop of Adria, a nephew of Duke Ercole, was long and tedious: "His Holiness," reported Burchard, interrupted the bishop several

times, "repeatedly urging him to hurry through more quickly." The bishop, however, was not to be hurried; and it was some considerable time before he came to the conclusion of his address.

When the sermon was finally over, a table was brought out and placed in a suitable position in front of the pope. Ferrante d'Este, acting as proxy for his brother the groom, "brought Donna Lucrezia to His Holiness and, in his brother's name, presented her with a golden ring," and Cardinal Ippolito "brought in four other rings of great value, a diamond, a ruby, an emerald and a turquoise together with a small casket, which was placed on the table and, by the Cardinal's order, opened."

The box contained a glittering collection of the Este family jewels, a veritable trove of treasure: two beautiful caps, one of which was "studded with fourteen diamonds, as many rubies and about 150 pearls," four jewelled collars, one jewelled pendant, several bracelets, "four of which were of very great value," four strings of large pearls, and four jewelled crosses studded with diamonds. The exquisite jewels, valued at 8,000 ducats, were now given to Lucrezia by the cardinal, who promised her more of the same from her new father-in-law. These jewels, however, were evidently not intended as a gift but merely as a loan, so that the duke, as one of his envoys wrote, "need have no anxiety," adding that "the document regarding this marriage simply states that Donna Lucrezia will be given the bridal ring as a present, and nothing has been said of any other present."

The bride "with her ladies and many others all remained in the palace until five o'clock the following morning," and the festivities continued for the next few days. "The following night," reported Burchard, "a number of comedies were recited in the Pope's apart-

ments, and ballets performed, with some singing as well." One play performed in the Sala del Pappagallo had been inspired by the work of the Roman poet Virgil, and it starred two young men playing the parts of Cesare and his new brother-in-law as rulers of the lands of the Po.

On Thursday, December 30, there took place, one after the other, the races of the Barbary horses, of the Spanish jennets, and the fillies. This day of racing was one of the highlights of the Carnival festivities, eagerly anticipated by the Roman crowds, who thronged the streets to watch the spectacle, and by the betting touts who stood to make fortunes from the gullible punters.

This particular year, according to Burchard, "there was a great deal of violence and injustice." The winner of the first race was the Arab horse belonging to the Marquis of Mantua, "but it was not awarded the prize because it had lost its rider, who had clumsily fallen off at the start of the race," leaving as the winner the Arab belonging to Cesare. Burchard did not record whether the unfortunate rider had been unseated deliberately, but there must have been many in Rome that night discussing Cesare's manner of winning the next two races.

One of Cesare's staff had won the race of the Spanish jennets "most unfairly," as Burchard reported. "The horse did not begin in the course with the others on the Campo dei Fiori but ran out of a house beside the vice-chancellor's residence as the others arrived, thus getting a lead on them and winning the prize." The fillies race was equally suspicious. "During the race, when the horses were on the Ponte Sant'Angelo, one of Cesare's grooms crossed the course on his horse, stopped the mare who was in the lead and forced its rider out of his saddle."

On January 1 the usual parade of Carnival carts took place, and the theme this year, not surprisingly, extolled the virtues of the dukes of Valence and Ferrara in the guise of Julius Caesar (Cesare) and Hercules (Ercole), in a series of tableaux that were paraded on wagons not in the usual setting of Piazza Navona but against the much grander backdrop of St. Peter's. The piazza was then barricaded to serve as the stage for a bullfight. Eight bulls and one buffalo were killed—four more bulls and another buffalo were spared for a similar spectacle on the following day.

The day was approaching when Lucrezia would leave Rome forever. On the morning of January 6, 1502, the Feast of the Epiphany, she went to bid farewell to her father. Her dowry had been formally counted the night before and handed over to her new brothers-in-law, Ferrante and Sigismondo d'Este. In the Sala del Pappagallo, Lucrezia, Cesare, and their father spoke quietly together in Spanish. As fond of them as she had always been, she bore the parting as she bore all partings, with her usual equanimity.

Mounting her horse, she rode out of the Vatican, flanked by Cesare and Cardinal Ippolito and escorted by a huge procession; "she was not wearing valuable clothes because it was snowing," reported Burchard. The pope was clearly deeply moved as he watched her leave, hurrying from window to window of the palace to catch a glimpse of the cavalcade until it was finally out of sight. He would never see his daughter again.

~ Chapter 21 ~

The New Bride

"Look at the great lady!"

THE BRIDAL CAVALCADE travelled slowly up the Via Flaminia in the gently falling snow. A few miles north of Rome, Lucrezia bid farewell to Cardinal Ippolito d'Este and her beloved brother Cesare, who returned to the city and the warmth of their own fireplaces, leaving Lucrezia to continue her long journey through the Apennines north to Ferrara with her own retinue, which numbered some seven hundred people, escorted by the five hundred men of the Ferrarese party that had travelled to Rome the previous December.

"There was no bishop, nor protonotary, nor abbot," recorded a shocked Burchard, but Lucrezia was accompanied by her cousin Cardinal Francisco Borgia, whom Alexander VI had appointed legate to the Papal States. And to augment the party of Roman nobles travelling with her, Cesare had provided her not only with

two hundred gentlemen from his own household, but had also ordered a number of musicians and clowns to entertain her on her way. As well as some 10,000 ducats for her expenses on the journey, the pope had provided her with a sedan chair, which she was to share with the Duchess of Urbino, from Gubbio to Ferrara. Lucrezia's retinue was also impressive, including numerous squires and cooks, stable boys and dressmakers, and, of course, her own ladies-in-waiting, among whom, according to the reports Isabella d'Este received from her informant, were several beauties, one with syphilis, and "one Moor, the most beautiful woman I have ever seen."

Providing mounts for all these attendants had proved a problem for the pope, who was temporarily short of funds after the spectacular expenses he had incurred in entertaining the Este party in Rome, and he had obliged all cardinals in the city to loan either two horses or two mules for Lucrezia's journey—"none of these animals was returned," commented Burchard.

The long string of baggage animals winding its way through the snowbound passes of the Apennines was heavily laden. Strapped to the backs of several mules were the heavy padlocked chests containing Lucrezia's dowry. Over one hundred mules were needed to carry her jewels, linen, and clothes; she took with her no fewer than two hundred expensive shifts and almost as many hats, one of which, according to Isabella d'Este's informant, was valued at 10,000 ducats.

Despite being shielded from the worst of the weather behind the curtains of her litter, Lucrezia found the journey exhausting. At Spoleto she insisted on stopping for two nights, much to the exasperation of the Ferrarese party, who were keen to get home. Duke Ercole was also informed that she needed to wash her hair

with tiresome frequency, and he was forewarned that it would be advisable for him to postpone the date of the bride's official reception at Ferrara.

The pope also received regular reports on the progress of his daughter's journey and wrote to her to say that he hoped to hear from her when she reached Ferrara and that he also hoped she was "in good health and spirits and, above all, that her face and body were wrapped up against the tempestuous and snowy weather." She also heard from Cardinal Ippolito d'Este, who wrote to reassure her about her little two-year-old son, Rodrigo, whom she had been so distressed to leave behind in Rome: "Having sent someone this morning to visit the most illustrious lord, Don Rodrigo your son, the messenger reported that His Lordship was sleeping very quietly and contentedly; and thanks be to God he is as handsome and as healthy as anyone could wish."

On January 16, ten days after bidding farewell to her father, the cavalcade turned off the Via Flaminia onto the steep road leading to the hilltop town of Gubbio, where the redoubtable Duchess of Urbino, Elisabetta Gonzaga, sister-in-law to Isabella d'Este, dressed in her habitual black, waited unsmilingly to meet the horsemen and rumbling carriages. The following day Lucrezia, accompanied by the thirty-year-old duchess, continued the journey in the gilded sedan chair, behind the curtains of which the two women conducted an evidently stilted conversation, their friendship hampered not least by the fact that the duchess believed Cesare guilty of abducting her protégée, Dorotea Malatesta, a year earlier.

At Urbino the duke, Guidobaldo da Montefeltro, was awaiting their arrival on the road leading to his capital, the streets of which were decorated with flags and streamers and garlands of dried

flowers. Beneath these the brightly painted and heavily laden carts, drawn by bullocks, rattled and screeched into the courtyard of the ducal palace, where Lucrezia was to stay.

For two nights Lucrezia remained in Urbino, staying in the imposing castle and enjoying not only the comforts of aristocratic life but also its lavish balls, banquets, and theatrical entertainments. She appeared at one ball in a dress of black velvet with a huge diamond on her forehead, while the Spanish dwarfs, who formed an ill-disciplined and noisy addition to her suite, hopped and romped around her, crying, "Look at the great lady!"

Lucrezia was aware that reports about her appearance and behaviour, even details of her personal hygiene, were being sent to the jealous and formidable Isabella d'Este by her secret informant, a man known as Il Prete (the priest) but whose identity remains mysterious. When his inquisitive behaviour came to Lucrezia's notice, she sent for the man, questioned him at length, and managed to elicit more information about her new sister-in-law than he had intended to divulge. "She is a lady of keen intelligence and perspicacity," he afterward reported of Lucrezia; "one had to have one's wits about one when speaking to her."

The luxuries of the ducal palace, however, were not to be enjoyed for long, and once again the slow and exhausting journey was resumed, now toward Pesaro, still in the stilted company of the Duchess of Urbino, who would stay with her until they reached their destination. The two women arrived at Pesaro on January 21, thankful at least that the stony snowy mountains were, at last, behind them.

At Pesaro—the city that had once belonged to her first husband, Giovanni Sforza, and was now the possession of her brother—it

was Cesare's Spanish governor, Ramiro de Lorqua, who was waiting to welcome her and escort her past the expectant populace crowding the streets. When the cavalcade finally halted that evening, Lucrezia pleaded fatigue as an excuse for not joining a ball that had been arranged in her honour but that would be attended by many of her ex-husband's subjects; and she retired with her ladies to the quarters assigned to her, where one of her maids performed what was almost a daily ritual by washing her mistress's long blond hair.

Riding through Cesare's duchy, the journey along the Via Emilia pleasantly smooth after the rough jolting over the hill roads, Lucrezia reached Cesena, her brother's capital, on January 24. Here, however, an unsettling rumour of trouble ahead brought an end to such carefree gaiety; it was said that Dorotea Malatesta's fiancé, the mercenary commander Giambattista Caracciolo, had sworn to take revenge for the kidnapping and was now awaiting to fall upon the Borgia bride somewhere nearby.

The threat, however, did not materialize, and Lucrezia reached Bologna without incident, though her decision to delay her arrival in that city by spending a second night at Imola in order to rest must have irritated Giovanni Bentivoglio and his wife, her hosts in Bologna. After a splendid procession through the city, watched by huge crowds, and another ball, Lucrezia was so tired that she overslept the next morning.

On the last day of January, Lucrezia and the Duchess of Urbino left Bologna for the villa of their hosts at Bentivoglio, near the border of the duchy of Ferrara, and the last stop on her exhaustingly long journey from Rome. Just before sunset an unexpected party of four horsemen were seen dismounting at the door. Lucrezia's

bridegroom, Alfonso d'Este, had impetuously decided to come in person to greet his bride. "This act pleased everyone," wrote Bernardino Zambotti, the Ferrarese diarist, "and especially the bride and her ladies, that his lordship wished to see her," and did much to counter the widespread rumours of Alfonso's opposition to the match.

Alfonso himself was clearly pleased by what he saw; and, so it was reported, he suggested that he and Lucrezia go to bed together there and then. Dissuaded from this impropriety, he returned to Ferrara, where, the next day, standing beside his father, with a company of crossbowmen behind them, he welcomed the ducal barge in which, in staterooms of considerable splendour, Lucrezia had travelled the twenty miles of waterway from Bentivoglio.

At Malalbergo she had been joined by her new sister-in-law, the jealous and hostile Isabella d'Este, who was reluctantly acting, as custom dictated, as hostess for her widowed father, the duke. Her eyes would fill with tears, so Isabella said, when she saw her mother's ruby necklace hanging around Lucrezia's graceful neck.

It was not until she disembarked from the ducal barge outside the walls of Ferrara that Lucrezia met her new father-in-law for the first time. The elderly Duke Ercole, almost seventy years old, seemed greatly struck by her appearance and was much entertained by the jokes and posturings of her clowns. He graciously kissed her hand before escorting her to the house of Alberto d'Este, his illegitimate brother, where she would stay the night in order to prepare for her state entry into Ferrara the following day.

The preparations in Ferrara for the arrival of the heir's bride had been gathering pace over the past weeks: streets were cleaned, horse droppings and mud carted away; inns were fully booked; shops were

stocked with splendid stuffs and mementos; tailors and dressmakers worked day and night to finish the new outfits ordered by the city's courtiers; playwrights and poets were busy writing their dramas, while actors and orators were rehearsing their lines; flags and banners were embroidered with interwoven depictions of the Borgia bull and the Este arms; coats-of-arms of the two families were emblazoned on the gates of the ducal palace. Garlands were hung over shopfronts and tapestries draped from windows above. The army of painters and carpenters had managed to finish a series of elaborate arches erected along the route the procession would take, decorated with mythological scenes to proclaim the union of the two families, the Borgia bull standing solidly beside the black and white eagles of the Este dynasty.

The city seethed with excitement; one Ferrarese diarist spoke for many when he responded to one man who thought the festivities "a gross inconvenience, but in my opinion he was speaking like a fool."

The city's leading families competed with each other for the honour of providing a daughter to join the bride's new household and prepared apartments in their palaces to accommodate the official guests who had been invited. Ambassadors arrived from Lucca, Florence, and Siena; the Venetian embassy numbered 150; around the necks of the French embassy, met by the duke in person, one observer counted eighty-four heavy gold chains, worth, he thought, some 35,000 ducats. There were "so many visitors in Ferrara," he noted, "that it was almost impossible to believe."

Finally, late in the clear, cold afternoon of February 2, the Feast of Candlemas, Lucrezia rode across the bridge over the Po at Castel Tedaldo to enter the city that would be her home for the rest of her life.

Eighty trumpeters led the cavalcade, followed by a hundred mounted crossbowmen, all dressed in the red-and-white Este livery and wearing caps made in the French style, a mark of honour to Louis XII, whose alliance with the pope and Cesare had precipitated the marriage. Next came the heralds wearing black-and-gold tabards and carrying silver trumpets, followed by drummers riding white mules, by armed halberdiers, by mounted pages and nobles and bishops and ambassadors, a gaudy array of gold and silver, red and purple, velvets and silks, and costly fur-lined cloaks—the Spanish courtiers of Cesare's household provided a sober contrast in their customary plain black.

Spontaneous cheers greeted the bridegroom Alfonso, who was splendidly dressed in grey velvet embroidered with gold—the embroidery alone was said to be worth 8,000 ducats—and a cap trimmed with feathers, riding with his squires astride a superb bay charger caparisoned in purple velvet. Then came the bishops, in white copes and jewelled mitres; the ambassadors in their official finery; and then the drummers and jesters, who heralded the arrival of the bride. This was what the crowds had been waiting for, and they roared their approval.

Riding a snow-white horse with gold trappings, Lucrezia entered Ferrara beneath a white silk canopy decorated with gold fringe, which was carried by eight doctors of the university. She wore a jewelled coif on her head, its value estimated at 15,000 ducats, one of the caps that, as Isabella d'Este acidly remarked, "my lord father sent her in Rome," adding, "Around her throat was the necklace which had belonged to my mother." On her feet was a pair of slippers worth 2,000 ducats, and she wore a dress of gold brocade striped with purple satin, ornamented, according to one observer,

"with so many jewels that it was a marvel," with a gold cloak thrown back over one shoulder to display its ermine lining.

Behind her came several open carriages bearing numerous Ferrarese ladies and other guests and, last of all, the long line of pack mules carrying the chests filled with her clothes, jewellery, and other possessions, their loads covered with lengths of deep red satin embroidered with her own device.

Lucrezia's mount, an elegant bay horse, was startled by the sudden deafening roar of artillery from Castel Tedaldo that sounded as she crossed the bridge, and it reared up, throwing her to the ground. Fortunately she was not hurt but picked herself up, laughing merrily, "and this I saw myself because I was right there," wrote one observer of the event. A mule was brought for her to continue, and she made her way through the narrow winding streets, past the entertainments staged for her at every turn, and finally into the great piazza in front of the ducal castle.

The piazza was crowded with people, "so full," remarked one observer, "that if a grain of millet had fallen from the sky it would not have reached the ground." The arrival of the cavalcade was heralded by a tremendous fanfare from the 113 trumpeters and pipers playing on the balcony of the ducal palace, and the dungeons beneath were opened to release a stream of prisoners. Two men then descended down ropes from the top of the high towers in the piazza, their arms outstretched so that "they looked like birds," as one man said, to land at Lucrezia's feet. Zambotti commented that "everyone thought it a great marvel because it happened so quickly and neither of them was hurt."

Lucrezia rode into the courtyard of the palace, where she dismounted and climbed the marble staircase, at the top of which

Isabella d'Este and other female members of the ducal family waited to embrace her before escorting her into the Great Hall, which had been hung with cloth-of-gold "and silks of great value" to mark the occasion. There she was guest of honour at the feast, the highlight of which was a series of life-size sculptures all made in sugar, followed by a ball.

At the end of the evening, the bridal couple made their way to their bedchamber in the apartments that had once belonged to Alfonso's mother. The following day, the bridegroom's father reported to the pope: "Last night our illustrious son, Don Alfonso, went to bed with his wife, and from all accounts, it appears they were quite satisfied with one another." Her husband seemed pleased with her and was attentive for the first few days, even though he did not linger for long of a morning in their bed, but, having slept with her, so the Ferrarese ambassador to Rome told the pope, he "took his pleasure with other women during the day." "Being young," the pope had commented, complacently, "it does him good."

The phlegmatic, silent bridegroom, a man whose interests, so it was said, were limited to sewers and artillery, had regarded his marriage as no more than a painful duty. The two women he had most deeply cared for had both died young; his mother, Eleonora of Aragon, the sister of King Federigo, had died when he was seventeen years old; his younger sister, Beatrice, had died in childbirth four years later. Alfonso's secretary thought it was interesting to speculate on his master's feelings toward the bride in whom he had appeared to show no initial interest. As he came to know Lucrezia better, however, the more interesting and attractive he found her; he actually sought out her company, grateful to have reason to dis-

believe the stories of her debauched past. "Whatever his feelings were before he met her, before long he conceived," so it seemed to the secretary, "a love as ardent as was the aversion he had felt for her when the marriage had first been proposed."

The wedding festivities continued for over a week. There were jousts most days in the great square in front of the palace, followed by banquets and balls every night. A troupe of actors performed the comedies of Plautus each afternoon, which the duke, determined to show off the quality of culture for which Ferrara was justly famous, had insisted were to be better than anything that Lucrezia would have seen in Rome. There were also the customary ceremonial offerings of presents to the bride and groom. The Venetians produced two superb mantles of deep red velvet, worth 300 ducats each. The French ambassador had brought expensive gifts from Louis XII: a rosary for Lucrezia, its beads of perforated gold filled with aromatic musk, and a shield for Alfonso, decorated with the figure of Mary Magdalene, which, the ambassador was at pains to explain, was to show that he had taken a woman of virtue, though all of those present had heard the rumours of incest and many believed that Lucrezia's past, like the Magdalene's, had been far from virtuous.

Lucrezia, it seems, thoroughly enjoyed the parties. Zambotti described her as being "full of life and gaiety." The pope's daughter, so it was agreed, danced "admirably" and dressed "beautifully." Duke Ercole was full of praise for the daughter-in-law he had been so reluctant to accept and seems to have become genuinely fond of Lucrezia, taking her, as a mark of his favour, to visit Sister Lucia da Narni, the nun she had helped to move from Viterbo to Ferrara. "Her virtues and good qualities have so pleased me," the duke wrote

to Alexander VI about Lucrezia, "that she is the dearest thing I have in this world."

Isabella d'Este and Elisabetta Gonzaga were less enthusiastic about their new sister-in-law. No longer in their prime, the Duchess of Urbino was thirty and Isabella just three years younger, while Lucrezia, despite her three husbands, was still only twenty-one years old. The two older women were clearly put out by the bride, who was undeniably younger and prettier than themselves and, moreover, took precedence over them at court.

The malicious Isabella did her utmost to make the unwelcome bride uncomfortable; "yesterday," she wrote grumpily to her husband in Mantua, "we all had to stay in our rooms until five o'clock because Lucrezia chooses to spend hours dressing so that she can put the Duchess of Urbino and myself into the shade in the eyes of the world." The Borgia girl, she complained, spent an unconscionable time dressing, washing her hair, and chattering in her rooms; she also declined to attend such festivities as did not appeal to her; and when a risqué comedy was performed, she was obviously amused by it, while Isabella made it clear that she, like all respectable ladies, found it most objectionable.

With the departure of the guests on February 9, Ash Wednesday and the beginning of Lent, Lucrezia settled down to life at court as wife to Alfonso, the duke's heir. On Maundy Thursday she acted as hostess for her father-in-law at the customary dinner given to 160 poor people, serving their food and assisting in the washing of their feet. The next day, Good Friday, she attended Mass in the cathedral, where the congregation was entertained by a Passion play, a five-hour spectacle with angels descending from the roof to hover over Christ as he prayed in the garden of Gethsemane, his

Crucifixion on a hill specially built in front of the high altar and his Descent into Hell through the head of a huge writhing serpent.

Yet as the days passed, she found life in Ferrara hard, homesick for Rome and her beloved father. She spent mornings in bed; she lay in the scented waters of her bath, accompanied by one of her young ladies, who, when they emerged, would read erotic novels to her. She passed increasingly long periods in the rooms that had been assigned to her with her Spanish attendants to whom she spoke in their own Valencian dialect and with whom the Ferrarese ladies were soon on the worst of terms. She even offended her conservative father-in-law, as she did many other Ferrarese, by introducing at court a Spanish costume, *zaraguelles,* wide, pleated pantaloons of silk or muslin worn under the skirt.

Duke Ercole, despite his affection for Lucrezia, was growing anxious about the cost of all the entertaining that he was expected to provide. Most of the marriage guests had departed; but several members of Lucrezia's court remained, and "these women," her father-in-law complained, "by remaining here cause a large number of other persons, men as well as women, to linger on. . . . [I]t is a great burden and causes heavy expense. The retinue of these ladies . . . numbers not far short of 450 persons and 350 horses." He also worried about the cost of maintaining Lucrezia's large and mostly Spanish household, declaring that the number of his daughter-in-law's ladies and servants must be reduced; and, despite her protests, he dismissed from her court all whom he considered unnecessary.

To the evident surprise of her critics, she accepted her father-in-law's decision with good grace; and not only this, she set about conciliating the most critical of the Ferrarese ladies. Among them

was a friend of Isabella d'Este, Teodora Angelini, who was frequently invited to dine at Lucrezia's table, an enticing privilege, especially during Lent, when the duke's table became excessively monotonous, while Lucrezia's was plentifully supplied with a variety of dishes from oysters and scampi to sturgeon, crayfish, and caviar.

The extravagance of the meals served at Lucrezia's table naturally horrified the duke. He consulted his daughter, Isabella, who declared that Lucrezia's needs could easily be met by an allowance of 8,000 ducats a year rather than the 12,000 ducats that the pope was demanding for her. The duke offered to compromise by allowing her 10,000 ducats; this the pope refused; and Lucrezia, anxious to escape the acrimonious gossip that this quarrel was causing at court and, suffering the symptoms that told her she was now bearing Alfonso's child, retreated to the convent of Corpus Domini.

The news that Lucrezia was pregnant, so soon after the marriage, delighted the duke and also the pope. "His Holiness has taken on a new lease of life in consequence of the news from Ferrara," wrote Burchard, "and every night he is commanding into his presence young women chosen from the best Roman brothels." As though in celebration of Lucrezia's pregnancy, he also sent for Jofrè, Jofrè's wife, Sancia, and even for Sancia's lover, Prospero Colonna; one particularly lurid account suggests that the pope then left the two men in an antechamber while he took Sancia off to one of the private rooms from which he returned after a while to tell Jofrè and Colonna that she was "still worth the serious attention of a young man."

The pope's cheerful mood in hopes of a grandchild, however, were soon to end in disappointment and worry. In May Alfonso

had left Ferrara on business, and Lucrezia had taken advantage of his absence to go to Belriguardo, one of the duke's many villas in the countryside and where, she hoped, the fresh air and beautiful surroundings would improve her health. She had felt much better on her return to Ferrara, but the sultry summer heat in the city soon caused a relapse. By the middle of that hot July of 1502, she fell dangerously ill. Her husband was sent for, so were several doctors in addition to Francesco Castello, the court physician. The pope, gravely concerned, maintained that the illness had been caused by his daughter's distress at being kept so short of money.

Meanwhile, the patient grew worse, suffering from paroxysms and fits of delirium. It was supposed, inevitably, that she had been poisoned; but it was soon clear that a virulent outbreak of the flux had gripped the entire court. Her condition grew worse, and it was widely feared she would die; her husband and her beloved brother hastened to her bedside and, miraculously, found her better, sitting up in bed. Days later she suffered another relapse; all August she lay close to death until finally, on September 5, she gave birth to a stillborn daughter.

Cesare arrived in Ferrara two days later to find her ill with puerperal fever and refusing to allow her doctors to bleed her. Cesare's company seemed to rally her, and he induced her to give way to the doctors' advice. "We bled Madonna on the right foot," one of the doctors reported. "It was extremely difficult to do, and we could not have done it had it not been for [Cesare] who held her foot, and made her laugh and cheered her greatly."

Lucrezia recovered slowly from her ordeal, and when she was well enough to travel, she was carried in a litter to the care of the sisters of the convent of Corpus Domini. She was accompanied by

her contrite husband, who, although he had made a vow to make a pilgrimage to the shrine of the Virgin at Loreto, a place much venerated by those who experienced problems with conception and pregnancy, intending to walk the 170 miles on foot should God spare her life, he contented himself with travelling there by boat and then making one of those inspections of military establishments that he undertook so often.

~ Chapter 22 ~

Castles and Condottieri

"THE AMOUNT OF A POPE'S INCOME
IS WHATEVER HE CHOOSES IT TO BE"

IN MARCH 1502, while Lucrezia was adjusting to life at the ducal court in Ferrara, an event occurred that demonstrated just how strong and resourceful both the pope and Cesare could be in moments of crisis. The two men—accompanied by six cardinals, one of whom was Lucrezia's brother-in-law Ippolito d'Este, seven prelates, and a large number of courtiers, secretaries, and servants—had travelled by boat to Piombino, where they had reviewed the defences of this strategic port captured by Cesare's troops the summer before. "Six triremes had been prepared," recorded Burchard, "using those prisoners incarcerated for petty crimes to man the oars"; others had been press-ganged "by violence or by trickery in the taverns of Rome," and the pope had also "requisitioned all barge owners and many fishermen."

Having finished their tour of inspection in Piombino, the pope proposed to his companions to take a day sailing around the coast "to amuse themselves." Unfortunately, an unexpected storm blew up, as sometimes happens in the Tyrrhenian Sea, making it impossibly dangerous for them to reenter the harbour at Piombino and forcing them to spend the next few nights at sea. On the fourth day the storm had worsened, bringing huge breakers crashing over the bows of their boats, and Cesare, "fearing great danger," risked his own life by leaving the galley in a small boat to row ashore to get help.

Then, according to Burchard, who recounted what he had heard from the survivors:

> The Pope stayed on the galley, unable to put into port. His companions, paralysed by fear, lay stretched out in the bottom of the boat; only His Holiness, seated on the poop, kept a resolute and brave stand. When the sea pounded the boat with anger, he cried "Jesus!" and made the sign of the cross and told the sailors to get on with preparing the meal. But they replied that the crashing waves and the roaring wind prevented them from lighting a fire. Finally the sea grew calmer and it was possible to fry fish for the Pope to eat.

Back in Rome a few days later, the pope and Cesare turned their thoughts to the next stage of the expansion of the duchy of Romagna and to the raising of the large sums of money required to prosecute it. With the northern border of the duchy secured by the marriage of Lucrezia to Alfonso d'Este, Cesare set his sights on two small papal fiefs, Camerino and Senigallia; more covertly, father

and son had plotted a far more ambitious scheme to seize the much larger fiefs of Urbino and Bologna and also to expand into Tuscany by fomenting rebellion in Arezzo and Pisa, two cities that much resented their subjugation to republican Florence.

With this campaign in mind, it was at about this time, in the summer of 1502, that Cesare appointed Leonardo da Vinci as his "Architect and General Engineer" and, as such, instructed him to "survey the strongholds and fortresses" of his territories. By this commission Leonardo was to be exempt from "all public toll for himself and his company" and to be given free access to "see, measure and estimate all that he may wish."

Leonardo, whose *Last Supper* in the convent of Santa Maria delle Grazie in Milan was so much admired by Louis XII, had been employed as a military engineer by the luckless Duke Ludovico Sforza since he was a painter. For Cesare he drew maps, proposed systems of defence works, and designed a canal connecting Cesena with the port of Cesenatico. For ten months he travelled across the Papal States, clearly fascinated by the character and ambitions of his gifted and mysterious employer; several maps survive among Leonardo's papers, including one showing the approaches to Arezzo.

By the beginning of June, Alexander VI and Cesare had laid their plans. By coincidence, a new ambassador arrived from Venice at about the same time; this was Antonio Giustinian, whose perceptive and illuminating dispatches were to keep the Venetian government as well informed about papal affairs as could be expected. His task, however, was hampered by Cesare, who, he reported, continued to clothe his intentions behind a curtain of secrecy and declined to give a date when he could spare time to see the envoy.

In one of his first dispatches, Giustinian reported that there were differences between Alexander VI and his son, especially regarding money. "Today the Pope has had some difficulties with the Duke, who requires another 20,000 ducats for his campaign, for which His Holiness has already paid a great deal," he wrote, before coming to the conclusion that "although the Pope is reluctant to give him the money, he will come round in the end, as he does with everything concerning his son."

In the end Giustinian did not have to wait long for the nature of Cesare's plans to be revealed. On June 5, within days of the envoy's arrival, news came through of a riot against the unpopular Florentine government in Arezzo, outside which Cesare's trusted condottiere Vitellozzo Vitelli and an army of three thousand men awaited orders; Vitelli entered the city two days later, where he was joined by another of Cesare's captains, Gianpaolo Baglioni. Almost immediately, news also arrived of a successful uprising in Pisa, and the city offered its allegiance to Cesare. Four days later Burchard noted that "the corpse of Astorre Manfredi, Lord of Faenza," who had been overthrown by Cesare after a long siege the previous year and imprisoned in Castel Sant'Angelo, "has been fished out of the Tiber, drowned by a stone tied round his neck." The master of ceremonies lamented his death: "This young man, just 18 years old, was of such beauty and stature that it would not be possible to find his equal among a thousand of his contemporaries."

Although both Alexander VI and Cesare vigorously denied any involvement in the taking of Arezzo, protesting instead that Vitelli had acted upon his own initiative, few in Rome believed them. And it was generally accepted that the murder of Manfredi was also committed on the orders of Cesare, who was anxious to avoid any

trouble from the supporters of the popular Astorre while he was away from Rome with his army.

A few days later Cesare was at Spoleto with his army of six thousand infantry and two thousand cavalry, and his condottieri captains, the Spaniards Ugo de Moncada and Miguel de Corella, and the Italians Paolo Orsini and his cousin Francesco, the Duke of Gravina; Oliverotto Euffreducci, Lord of Fermo; Gianpaolo Baglioni, Lord of Perugia; and Vitellozzo Vitelli, Lord of Città di Castello, who had reluctantly submitted to Cesare's request to withdraw from Arezzo. Massing in the Romagna, meanwhile, another army, led by Cesare's governor, Ramiro de Lorqua, prepared to move south.

There was at first some doubt in Rome as to where these armies were marching; some said Pisa, others Arezzo, though most assumed that their destination was Camerino, the state of Giulio Cesare da Varano, who had been excommunicated by Alexander VI on June 5 on a charge of fratricide. To this end, the Duke of Urbino had given permission for Ramiro de Lorqua and the Romagna troops to pass through his state; though he had also, unwisely as it was to turn out, offered help to Varano to defend Camerino.

In fact, Cesare was about to attempt a highly ambitious coup and seize Urbino itself, with its commanding position between the Romagna and Rome; and to justify this unprovoked attack by claiming that the duke, Guidobaldo de Montefeltro, had acted treasonably in his offer to assist Varano.

The Duke of Urbino, meanwhile, believing Cesare to be many miles away to the south and having no reason to doubt his protestations of friendship, had gone to enjoy an alfresco dinner in the park of a monastery just outside the walls of his capital. In the

middle of the meal, a courier was observed riding at speed into the park with an urgent message: Cesare's troops were marching on Urbino itself; they were less than twenty miles away. Guidobaldo fled and, evading Cesare's troops who had been ordered to intercept him, he arrived, dishevelled and exhausted, in Mantua a week later.

The exiled Guidobaldo da Montefeltro did, however, retain his dignity, refusing the offer of a cardinal's hat and a pension in exchange for his rights to the dukedom of Urbino. To humiliate the duke still further, it was revealed at this time that he was impotent, a misfortune that had remained a secret outside the family for years. Still, his loyal wife, Elisabetta, declared that she would rather live with him as his sister than no longer as his wife.

In an attempt to negotiate the restoration of their authority in Arezzo, the Florentines now sent to Urbino a high-ranking delegation led by Francesco Soderini, bishop of Volterra and brother to the head of the Florentine republic, which was required to report on the situation to the government back home. The secretary to this delegation was none other than Niccolò Machiavelli, who was deeply impressed with Cesare, so much so in fact that his enemies would later claim that the secretary had been bribed by the duke, though no evidence has ever emerged to support these rumours.

"This Lord is very splendid and magnificent," Machiavelli wrote in a letter signed by Soderini:

In war there is no enterprise so great that it does not appear little to him. In his pursuit of glory and lands he never rests, nor is he put off by danger or fatigue. He arrives in one place before it is known that he has left another. He is well liked by

his soldiers, and he had collected the best men in Italy. These things bring him victory and make him formidable, especially when combined with *una perpetua fortuna.*

Machiavelli might have added how exasperating was Cesare, who, having kept him waiting for hours on end for an interview, would suddenly summon him in the middle of the night or the early hours of the morning, often not appearing when some meeting had been arranged, and, on occasion, riding away to where his army was in camp at Fermignano, a few miles south of Urbino, where he could be seen early in the morning hunting with his leopards in the surrounding hills, accompanied by "a host of servants, his face wrapped in gauze."

When at Urbino, much of Cesare's time was spent supervising the dispatch by mule train of numerous Montefeltro treasures to the fortresses at Forlì and Cesena—those costly furnishings and works of art that had ornamented the magnificent ducal palace where Lucrezia had been much honoured as a guest just five months earlier. "He had all Guidobaldo da Montefeltro's furniture taken from the palace," a local chronicler reported, "so that, over the period of a month, 180 mules were employed each day; thus was an honoured family despoiled of silver and rich tapestries, and the magnificent library of rare books, which had been assembled with such loving care by Guidobaldo's father, Duke Federigo." In his notebooks, Leonardo also recorded the strings of "mules carrying rich loads of gold and silver, many treasures and great wealth."

Among these treasures were works of art that Isabella d'Este, who possessed by her own admission "an insatiable desire for antique things," was eager to acquire. She wrote to her brother in

Rome, Cardinal Ippolito d'Este, asking him to approach Cesare with a request for two antique statues, one of a Cupid attributed by some to the ancient Greek sculptor Praxiteles, and the other "a little antique marble Venus," which she hoped Cesare might be prepared to part with since he did not "take much pleasure in antiquities."

In fact, the Cupid was not an antique but a modern work carved by the Florentine sculptor Michelangelo, and Cesare could well spare it. Indeed, his agent delivered the statues to Isabella in Mantua on July 21. She had sought permission from the exiled duke, her brother-in-law, before purchasing these items, but when Guidobaldo tried to reclaim the sculptures later, she, somewhat meanly, refused to let them go.

After Cesare's success at Urbino, the seizure of Camerino offered few problems; and the aged lord of the place, Giulio Cesare da Varano, together with his two sons, was handed over to Cesare and was later strangled in the castle of La Pergola.

In Rome the pope celebrated Cesare's victory at Camerino in his usual exuberant manner with the customary cannonade from the ramparts of Castel Sant'Angelo and, that evening, as Burchard reported, with "bonfires, fireworks and a great party in the piazza of St. Peter's."

Firmly in control of an obedient Romagna, Cesare now set about raising money to feed and equip his army, which was said to cost him more than 1,000 ducats a day. He turned to his father for assistance, and although the pope was always of a far more cautious turn of mind where money was concerned, and constantly lamenting the extravagances of his son, Cesare did not turn in vain.

Indeed, the pope resorted to all manner of expedients in order

to raise the necessary amounts of cash. Large sums poured in from the imposition of fines and penalties upon Jews and from the creation of numerous offices in the papal administration that were profitably sold for as much as 700 ducats each. He adopted the questionable tactic of countermanding legal wills, appointing himself as heir and replacing the named executors with his own men; he even, so it was said, resorted to murder to help his son financially so far as he could.

Adding substantially to the papal coffers was the death on July 20, 1502, of Cardinal Gianbattista Ferrari, Alexander VI's erstwhile datary, who had paid 22,000 ducats for his red hat in September 1500, as part of the pope's efforts to raise funds for Cesare's campaign against Faenza, Rimini, and Pesaro. The cardinal had fallen ill in early June, Burchard reported, and "declined all medical treatment, refusing stubbornly to be given enemas, to be bled, to take syrups or pills or any other medicines." After a few days in bed, he had been well enough to dine on "bread soup and a pint of excellent Corsican wine," but soon suffered a relapse, severe enough to be given the last rites; however, he rallied again and lasted for another month, still refusing medicines of any kind.

The morning of his death, somewhat delirious, he complained that he had been robbed of 10 ducats in a transaction relating to a petition. Two monks who were present told him "Most Reverend Lord, do not trouble yourself about these transactions. You must recommend yourself to Him who will deliver you from all fraud and deceit." He kissed the crucifix and made the sign of the cross by striking his mouth with his right hand. Shortly afterwards he yielded up his spirit.

The cardinal's interment in Santa Maria della Febbre was not a dignified ceremony; a member of the dead man's household hurried toward the coffin to retrieve a pair of gloves that, he claimed, belonged to him, as well as a ring that, so he maintained, was also his property. Then it was found that the lid of the coffin would not close upon the corpse, so a carpenter was called to kneel on it to force it down.

Although a rich man who was reported to have accumulated a large fortune in ducats and in gold and silver, by extremely questionable means, Gianbattista Ferrari had been notoriously parsimonious; and Burchard recorded the joke that was being told of him at that time in Rome, that, on presenting himself at the gates of heaven, St. Peter had asked him for an entrance fee of 1,000 ducats. He protested that he could not possibly pay such a sum. Well, said St. Peter, he would settle for 500 ducats. That, too, was quite impossible; the price was eventually dropped to one ducat, but even this was too much for the miserly cardinal. "If you cannot pay a single ducat," St. Peter then exclaimed, "go to the Devil, and remain a pauper with him for all eternity."

So the death of the cardinal was not widely mourned; his stinginess and disregard for the plight of the poor had earned him an evil reputation; and while his last illness seems to have been caused by a fever endemic in Rome, there were many who believed that he had been poisoned in the manner in which he himself was supposed to have arranged the deaths of several of those who crossed his path. Certainly, much of the cardinal's fortune, which Burchard estimated at 80,000 ducats, not counting his clothes and jewels, passed into the hands of the pope, and thence into Cesare's battle chest.

Having taken Urbino and Camerino, Cesare was now ready for the next step in his ruthless campaign. For this he needed the cooperation of Louis XII, who was, conveniently for Cesare, on his way from France in person to visit Milan, where he was expected on July 28. So, just four days after the surrender of Camerino, Cesare galloped out of his camp at Fermignano, together with three companions, "disguised as a Knight of St. John of Jerusalem, with a cross on his coat," reported Burchard, and availing himself of the order's chain-of-post horses along the road.

At Borgo San Donnino, Cesare and his companions feasted on a huge quantity of chickens and pigeons, so many indeed that "they shocked the locals," claimed Burchard, "covering themselves with shame." They stopped briefly in Ferrara, where Cesare visited his beloved Lucrezia, who was seriously ill, and rode on to Milan, where they arrived on August 5.

A witness reported to Isabella d'Este the manner of Cesare's reception by Louis XII:

The King publicly embraced and welcomed him with great joy and led him into the castle where he had him installed in the chamber nearest his own, and the King himself ordered his supper, choosing diverse dishes . . . and he ordered that his guest should dress in the King's own shirt and tunic, since Duke Valentino had brought no baggage animals with him, only horses. In short—he could not have done more for a son or a brother.

The pope was displeased by his son's actions—about which he had been increasingly often kept in the dark—and, always inclined

to be wary of France, was "highly troubled by this journey of his son's to Milan," Giustinian had reported, "because I hear from a completely reliable source that he undertook the journey without any consultation or even informing His Holiness."

For Cesare, however, the journey was to prove highly profitable; not only did he cement his friendship and understanding with Louis XII, but he also succeeded in intimidating his enemies who had clustered around the French court. Cesare's reception by the king must have been galling for many of the other guests, notably for Giovanni Sforza and Guidobaldo da Montefeltro, both of whom had been usurped by Cesare and were hoping for French aid to regain their dominions.

Among the most outspoken of Cesare's enemies gathered at the French court was Isabella d'Este's husband, Francesco Gonzaga, who had sworn that he would fight a duel with Cesare, "that bastard son of a priest's," but now felt obliged to recant, and reported to a friend that he and Cesare had "embraced each other as good brothers," adding, "We have spent all this day dancing and feasting with His Majesty."

Despite his anger at the arrogance with which Cesare flaunted his military strength, and especially with his encroachment into the territory of Florence, which remained an important ally of France, the king needed the support of Alexander VI, and of the pope's son's army, to defend his authority in Naples, where the relations between France and Spain, unusually cordial in recent years, had begun to return to their customary hostility. And so, Louis XII and Cesare came to an agreement whereby the king agreed to give the duke a free hand in Bologna while Cesare was to lend support to French ambitions in Naples.

Cesare spent nearly a month with the French court, travelling with the king first to Pavia, where they were entertained with a ritual duel between two feuding members of the Gonzaga family, who were then seated opposite each other at the lavish banquet that followed. They then rode on to Genoa, where a spectacular reception had been planned to welcome Louis XII, at a cost to the city of 12,000 ducats.

On September 2 Cesare left Genoa and five days later was in Ferrara to cheer the ailing Lucrezia, who was suffering from puerperal fever. He then rode south to Camerino to confer with his father, who was in the city to install as the new Duke of Camerino the four-and-a-half-year-old Juan, the boy widely supposed to have been the result of Lucrezia's infamous affair with the papal valet Pedro Calderon. The pope and Cesare had much to discuss, not least the plan for seizing Bologna.

In fulfilment of his agreement with Cesare, Louis XII had sent an envoy to Giovanni Bentivoglio at Bologna, informing him that he would not oppose the wishes of Alexander VI, who now called Bentivoglio to Rome to answer charges of misgovernment.

Cesare's captains, however, had become increasingly suspicious of their master's intentions. If Giovanni Bentivoglio was about to lose his state, how safe were their own territories, which all lay on the edges of Cesare's duchy, their security guaranteed, so they thought, by their service in the duke's armies. Accordingly, Cardinal Orsini called a meeting at the castle of Magione, a short distance from Lake Trasimeno, which was attended by all the threatened rulers: Gianpaolo Baglioni of Perugia; Francesco Orsini, Duke of Gravina; Paolo Orsini of Palombara; Oliverotto Euffreducci of Fermo; even Vitellozzo Vitelli, Lord of Città di Castello,

who was suffering from an acutely painful attack of syphilis and had to be carried there on a stretcher. And those who could not come in person to Magione were represented: Giovanni Bentivoglio of Bologna sent his son, Ermes; Pandolfo Petrucci of Siena sent two courtiers; Guidobaldo da Montefeltro sent another; and so on.

Gianpaolo Baglioni warned those attending the conference that they all risked being "devoured one by one by the dragon" if they did not act against Cesare. Yet so long as not only France but also Florence and Venice declined to help them, the majority of the members of the conference were reluctant to face up to the danger that confronted them. On October 7, however, there was an uprising against the Borgias in the fortress of San Leo in Urbino; and, with this encouragement, agreement was reached; it was settled that Cesare was to be attacked simultaneously by Giovanni Bentivoglio in the Romagna and by the members of the Orsini family, who were to encourage the revolt in Urbino.

When he heard of this threat, which seemed for a time to weaken his hold on his state, Cesare withdrew his forces to Imola and the security of the Romagna. When Machiavelli joined him there, to offer the support of Florence, he found the duke to be quite unperturbed, even indifferent. He accepted the loss of Urbino with apparent nonchalance and prepared for war with evident confidence in victory, raising troops and money, and appointing new condottieri captains, many of whom were Spanish, to replace the conspirators. He also spent such large sums on his intelligence services that Machiavelli thought that he "laid out as much on couriers and special messengers in two weeks as anyone else would have spent in two years."

At first the military operations did not go well for Cesare; and toward the end of October, the duchy of Urbino fell to the conspirators, who, according to Burchard, after having assembled some five hundred cavalry and two thousand troops, restored the city of Urbino and all its territory to the illustrious Guidobaldo da Montefeltro, rightful Duke of Urbino.

But as more money came in and more troops were enlisted, the tide, as Machiavelli said, began to turn. His enemies were "tardy in pressing him"; they had failed to seize the moment, as he himself undoubtedly would have done, and, as they began to lose heart in opposing him, were eventually persuaded to come to terms with him.

As Machiavelli was later to write in *The Prince,* Cesare "overcame the revolt of Urbino, the uprisings in the Romagna, and the countless threats with the help of the French" to which he added his own not inconsiderable political skills:

> His former standing in Italy was restored, but he no longer trusted the French or the forces of others, and in order to avoid the risk of doing so, he resorted to stratagems. His powers of dissimulation were so impressive that even the Orsini, through Lord Paolo [of Palombara] reconciled themselves with him. The Duke used every device of diplomacy to reassure Paolo Orsini, giving him gifts of money, clothes and horses.

The general desire now to regain the good opinion of Cesare was, so Machiavelli said, reflected in the submissive letter addressed to him by Vitellozzo Vitelli, who excused himself for having joined

the alliance against the duke and saying that if he ever had the opportunity to speak to him personally, he had no doubt he would be able to justify himself completely.

Receiving no reply to his letter, and denied a personal interview with Cesare, Vitelli could but guess what Cesare intended to do next. Machiavelli was also kept in the dark. "I have not tried to speak to the Duke, having nothing new to tell him," he reported to Florence, "and the same things would bore him; you must realise that he talks to nobody other than three or four of his ministers and various foreigners who are obliged to deal with him about important matters and he does not come out of his study until late at night; and so there is no opportunity to speak to him except when an audience has been appointed.

"Besides," continued Machiavelli, "he is very secretive. I do not believe that what he is going to do is known to anyone other than himself. His secretaries have told me often that he does not reveal his plans until they are ready to be carried out. So I beg your Lordships will excuse me and not put it down to my negligence if I do not satisfy your Lordships with information, because most of the time I do not even satisfy myself."

So Machiavelli could not by any means discover what Cesare intended to do next. Then, just before Christmas, there was news; Cesare had summoned all the French officers in his army to come to see him and had told them that he no longer needed them; their upkeep in idleness was an expense that he no longer wished to afford. On the day of their departure, a ball was held in Cesare's honour at Cesena. The pretty wife of one of these officers attracted his attention, and he danced with her several times, closely watched by her husband.

While he was apparently enjoying this ball, the military governor of the Romagna, the fierce, aggressive Ramiro de Lorqua, was immediately arrested on his return from Pesaro and cast into prison. At dawn three days later, he was beheaded in the piazza at Cesena. His decapitated body was left on the block, his head displayed on a lance.

No explanation was given for this sudden execution other than that Ramiro had been guilty of corruption in the exercise of his office; but this solution to the mystery was not generally accepted. There was a rumour that Ramiro had been in correspondence with the conspirators, notably in some kind of plot with Giovanni Bentivoglio, Vitelli, and members of the Orsini family. "The reason for his death is not known," Machiavelli commented, "but perhaps it pleased the Prince who likes to show that he knows how to make and unmake men at his will."

Certainly Cesare's occupying troops had been ill-disciplined at first, while the Spanish officers, like the unpopular and corrupt Ramiro de Lorqua, who were installed as administrators, had dealt most harshly with recalcitrant people. But, in time, Italians replaced Spaniards; and, to the general satisfaction, a peripatetic court of appeal was established under the direction of a lawyer of good reputation, Antonio del Monte.

What at least seemed certain after Ramiro's execution was that Cesare was preparing some kind of move against the condottieri captains who had been plotting his own murder. In the meantime they agreed to take in Cesare's name the small town of Senigallia on the Adriatic coast south of Fano. Senigallia had been the fief of Giovanni della Rovere, brother of Cardinal Giuliano, but he had died in November 1501, leaving his wife, Giovanna, sister of

Guidobaldo da Montefeltro, acting as regent for his young son. Cardinal Giuliano della Rovere, mindful of the fate of Astorre Manfredi, had arranged for his twelve-year-old nephew, Francesco Maria, to be smuggled out of the area to the safety of his own palace in Savona. And, knowing Cesare's reputation for cruelty, the cardinal had warned Giovanna not to offer any resistance.

The town fell without a struggle, but its military commander refused to surrender the citadel to anyone other than Cesare Borgia himself. Wearing full armour, Cesare rode toward Senigallia on December 31, 1502, at the head of his army, the condottieri captains coming out to meet him and following him back into the town, the gates of which were closed behind them.

Cesare now called upon his captains to attend a conference in the house he chose to occupy as his headquarters. Responding to his invitation to join him at table, they entered the courtyard of this house as Cesare, according to one account, was mounting a staircase in order, so he said, to "answer a call of nature." When he was halfway up the stairs, he turned to nod to Miguel de Corella. And in obedience to this signal, the condottieri were suddenly surrounded by armed soldiers; only Vitelli had time to draw his sword and wound several of the soldiers, before they were all arrested and disarmed.

That evening Machiavelli arrived from Fano to find the town in an uproar. He sent a message to Florence reporting the arrest of the condottieri captains and added, ominously, "In my view they will not be alive tomorrow morning." Soon afterward Vitellozzo Vitelli and Oliverotto Euffreducci were garrotted by Cesare's "executioner," Corella, as they sat back to back on a bench. The three

Orsinis—Paolo, Francesco, and Roberto—had been taken away as prisoners, so Machiavelli was told, and "faced a similar fate," and Cesare sent an urgent letter to Rome ordering his father to arrest Cardinal Orsini as soon as possible. When the cardinal arrived at the Vatican the next morning in order to congratulate the pope on Cesare's seizure of Senigallia, he made his entrance into the Sala del Pappagallo, where, according to Burchard, "he was terrified to find himself surrounded by armed men and immediately cast into prison." Burchard added that "all his possessions were seized," before being "loaded onto mules and taken to the Vatican."

The punishment of the faithless condottieri was considered well merited. Even Isabella d'Este wrote to congratulate Cesare on his punishment of them, sending him a present of one hundred carnival masks and expressing the hope that "after the strains and fatigues" that he had undergone in "these glorious undertakings," he should now find time to enjoy himself. "He insisted on examining the masks with his own hand," Isabella said, "saying how fine they were, and how much they resembled various people of his acquaintance."

The day after the murders of Vitellozzo and Oliverotto, Cesare left Senigallia, having accepted the surrender of its citadel, and, in the pouring rain, set out to claim the states of his disloyal captains for his own. Città di Castello fell quickly. At Perugia, Gianpaolo Baglioni fled at his approach, seeking refuge with Pandolfo Petrucci in Siena. Cesare marched toward Siena, seizing the city's outposts along the way, his men sacking, pillaging, and raping at will. At San Quirico d'Orcia, his soldiers found just two men and nine women, all elderly, whom they hung up by their arms, kindling a fire

beneath their feet to torture them into confessing where their valuables were hidden; the old people did not know, or were not prepared to reveal anything, and they died.

Declaring that he acted as captain-general of the church and that he had no selfish motives, Cesare then drove Petrucci from Siena and, having done so, moved against the Orsini castles and lands in the countryside around Rome. The stronghold of Ceri surrendered after a savage bombardment on April 5, 1503. Other Orsini castles, including Palombara and Cerveteri, followed suit; Paolo Orsini, Lord of Palombara, was strangled; Francesco Orsini, Duke of Gravina, was also murdered, so it was widely supposed, on the orders of the pope. Only Giangiordano Orsini, Lord of Bracciano, was spared; like Cesare, he was a knight of the French royal Order of St. Michael, whose members swore a solemn oath on receiving their collar not to make war on one another.

Looking back on the events of the previous year, Machiavelli wrote: "Duke Valentino enjoys exceptional good fortune, courage and confidence that are almost inhuman, and a belief that he can accomplish whatever he undertakes." As a soldier, his talents lay in an extraordinary capacity for rapid movement and deceit. No sooner was he reported to be in one place than he suddenly appeared in another, miles away. He turned the art of war, so it was said of him, into the art of deceit. There are very few descriptions of him as a commander in the field; but there is one that demonstrates the astonishing power of his personality. His men were crossing a river when, in fear of drowning, they panicked. Shout as they did, their officers could not restore order. Cesare rode down to the riverbank. His men saw him sitting there, gazing upon the scene, silent and impressive. When they caught sight of him, the

soldiers were brought immediately to order; and they crossed the river quietly.

And in his present situation, Cesare accepted the fact that he would have to undertake a realignment in his relations with foreign powers now that Spain was emerging as the stronger power in her struggle with France over Naples, notably since April 28, when the commander of the Spanish army, Gonsalvo di Córdoba, won a decisive victory over the French at Cerignola, exposing the weakness of the French hold over Naples. Cesare had his eyes on Tuscany, and it was believed that he had it in mind to form an alliance with the Spaniards to gain his end.

Cesare could do nothing, however, until he had raised more money to replenish his coffers, which had been so drastically depleted by his campaign of the previous year, by his attacks on the Orsini, and by his wild extravagance. Once again he turned to his father.

When the rich Venetian Cardinal Giovanni Michiel died in mysterious circumstances on April 10, 1503, after days of vomiting and diarrhoea, it was widely conjectured that the pope himself had been instrumental in having him poisoned. Certainly, so the Venetian ambassador Antonio Giustinian was told: "As soon as the Pope heard of his death he sent a man to his house and, before dawn, it was completely plundered," adding that "the death of the Cardinal has brought him over 150,000 ducats."

Further amounts, so Giustinian claimed, were raised by the creation of cardinals. In May 1503 the nomination was agreed in a secret consistory of nine new cardinals; the three Italians were all Borgia men, one was German, a favour to the emperor, and the other five were Spaniards, all well disposed toward the Spanish

pope and a reflection of Alexander VI's change of policy; none, significantly, were French. "Today there was a consistory," Giustinian reported to the Venetian government, "and nine new cardinals were nominated, mostly men of dubious reputation and all have paid handsomely for their elevation, some 20,000 ducats and more, so that from 120,000 to 130,000 ducats have been collected; it is notorious that His Holiness is showing the world that the amount of a pope's income is whatever he chooses it to be."

A man who had worked for them in the past and had hoped to be rewarded with a red hat, Francesco Troche, did not trouble to conceal his disappointment and spoke slightingly of Cesare. "His Holiness the Pope told him that he was a madman to speak like that and if the Duke came to hear of it he would be killed," reported one ambassador to his master, "and it was because of the words of His Beatitude that, terrified, Troche took flight." He fled first to Genoa and then, by way of Sardinia, ended up in Corsica; but there he was caught and brought back to Rome, where he was strangled by Cesare's sinister lieutenant, Miguel da Corella. On the same day, another man who had fallen foul of Cesare, Jacopo di Santacroce, a Roman nobleman and former Borgia supporter, was hanged and his body displayed on the Ponte Sant'Angelo as a warning to all enemies of the Borgias.

Cesare was now at the height of his power. Having raised enough money by all the means at his disposal, and ridding himself of several enemies, he now enrolled an army of some twelve hundred light cavalry and over four thousand infantry, all wearing his red-and-yellow livery, with the word CESAR in large letters embroidered on the chests and backs of their uniforms. "All the best soldiers were with him," the chronicler Matarazzo wrote. "And he had so much

accumulated treasure and possessions that it seemed there was not as much elsewhere in all Italy. Nor were there as many well-disciplined soldiers so well supplied with arms and horses."

Cesare was ready for his next campaign. At the beginning of July, the pope confirmed him as ruler of Città di Castello and ordered the city of Perugia to accept his lordship; he expected soon to add the cities of Pisa, Lucca, and Siena to his dominion. Poised for his Tuscan campaign, Cesare's well-supplied and well-trained army began to march north up the Via Flaminia toward Perugia and the borders of Tuscany. Cesare himself remained in Rome, waiting for the right moment to start. With the Spanish army facing unexpected opposition in its conquest of the kingdom of Naples, its advance slowed; the French troops in northern Italy, meanwhile, had begun their long march south to relieve their beleaguered comrades. Cesare had to gamble on the Spanish winning through and fixed the date of his departure for August 9.

~ Chapter 23 ~

The Death of the Pope

THE WEATHER IN ROME that summer of 1503 was unusually hot and humid. Alexander VI had fallen ill in July, and when the Venetian ambassador had visited him in the papal apartments in the Vatican, he had found the pope "reclining on a sofa, fully clothed." Giustinian reported that Alexander VI "received me with good humour, saying that for three days he had been inconvenienced by a slight dysentery but that he hoped it would be nothing serious."

"There are many ill with fever here," a Florentine working in Rome wrote that July; "and people are dying in great numbers." One of the dead was the former Florentine ambassador, whose successor was now gravely ill. Despite his seventy-three years, the pope recovered his health quickly enough but not his normally ebullient demeanour. Alexander VI grew unusually depressed as the daily death toll grew of men, women, and children who had succumbed

to the fever—typhoid, typhus, or perhaps malaria—that raged in the city. He admitted as much to Giustinian, to whom he confessed that he was preoccupied with these reports: "All these deaths make us fearful and persuade us to take more care of our health." On August 1 his nephew Cardinal Juan Borgia died; and as the pope watched the funeral procession pass beneath his window, he remarked, with uncharacteristic mournfulness, "This month is fatal for stout men." The sultry months of July and August had indeed proved fatal for his five predecessors, Innocent VIII, Sixtus IV, Paul II, Pius II, and the pope's own uncle Calixtus III.

On August 5, just four days before Cesare was due to leave Rome, father and son accepted an invitation to dinner at the villa of Cardinal Adriano Castellesi in the countryside some miles outside of Rome. On this occasion it was Cesare's health that caused the greater anxiety, since he was not only suffering from pain in his stomach, but also, according to Burchard, he was "much irritated by the skin on his face in the lower part, which falls apart like rotten leaves and results in a pus that he is much concerned to hide with his mask."

On their arrival at Castellesi's villa, father and son were both extremely thirsty and asked for cups of wine, which they drank "most gratefully." It was a sultry evening, and the guests dined alfresco, thankful for the shade cast by the trees in the garden. The next day their host felt ill and went to bed; a week later the pope also took to his bed; Cesare then fell ill; so did several of the cardinal's other guests, as well as some of his servants. Poison was naturally suspected. Giustinian was among those who believed that a servant had been responsible; others suggested that Cesare was the poisoner. Yet others said that the pope himself was responsible, that he

had intended poisoning his former secretary for some reason but had inadvertently drunk the poisoned wine himself. It was not the wine that had been tampered with, others maintained, but poisoned sweetmeats that had been passed around among the guests after the meal.

But the pope himself declared that the putrid air in Rome during this intolerable heat wave was probably responsible. Beltrando Costabili, the Ferrarese ambassador in Rome, reported that it was not surprising that the pope and his son had both fallen ill, "since all the palace officials are in the same condition because of the unwholesome air here."

Burchard recorded daily bulletins on the pope's health. On August 12 he wrote that "His Holiness shows signs of a fever which does not abate." The next day Giustinian reported to Venice:

The Pope vomited yesterday evening and has been feverish all night; and Duke Cesare is in a similar condition. The doctors attend constantly and are considering whether or not to bleed . . . some of my informants talk of fourteen ounces of blood taken away; others of sixteen ounces. Perhaps ten ounces is more likely; and even that is a great quantity for a man of the age of His Holiness. But, great or small, it has had no effect and the fever does not abate. As for Duke Cesare, he is worse.

Costabili sent a similarly dispiriting report to Ferrara:

Yesterday morning I was told on good authority that His Holiness has summoned the Bishop of Venosa and another physi-

cian; and that these are not allowed to leave him. I was told
that the Pope was feverish and vomiting yesterday, and that
they have taken nine ounces of his blood. . . . During the day
His Holiness asked some of the cardinals to play cards in his
room while he rested. . . . But this afternoon there was a cri-
sis such as there was on Saturday and this makes his atten-
dants uneasy. Everyone is unwilling to talk of his condition;
and the more I seek, the less I am told. The physicians, sur-
geons and apothecaries are not allowed to leave him from
which I deduce that his condition is grave.

The same news was sent by other envoys to their various states.
Giustinian was particularly assiduous in this respect, reporting on
August 16, 1503: "Early this morning Our Lord the Pope, well aware
that his illness is dangerous, received his rites; and some cardinals
have been admitted into his bedchamber; the viaticum was given in
secret, for those about him try to conceal his condition as much
as they can." The bishop who had administered the rites "left
the room in tears saying that the danger was very great and com-
plaining of the ineffectiveness of the medicines that have been
administered."

By now Alexander VI was in a high fever and was violently sick
during the night. He was bled so copiously that Giustinian was
shocked to hear of it. Cesare also had been severely bled before
being plunged into a bath of ice-cold water, from which he emerged
with the skin peeling from his back. Both father and son were still
feverish the next morning, so Giustinian was told, the duke "more
severely with recurrent paroxysms of fever one after the other and
strange fits," and Giustinian added that Cesare had "sent for the

doctors who are looking after him and he will not let them leave, and is insistent that his condition must not generally be known."

The following day, Friday, August 18, Alexander VI died; as Burchard commented, he had "made his confession to the Bishop of Carignola who then said mass in his presence and, after the Bishop had taken communion himself, he offered the sacrament of the Eucharist to the Pope in his bed." After the Mass the pope told the cardinals gathered around his bedside "that he felt very poorly." The cardinals evidently left the room shortly afterward; the pope "received Extreme Unction from the Bishop of Carignola at the hour of Vespers and died with just the Bishop, the Datary and a papal groom present."

Cesare was informed immediately of his father's death. Although he was giving his doctors some hope that he would recover, Cesare was still desperately ill and very weak, barely capable of making the decisions and issuing the orders that the crisis now demanded. Fortunately for him, his loyal lieutenant, Miguel de Corella, was already in the palace and able to act on his master's behalf.

Keeping the news a closely guarded secret, Corella now took a party of men and locked all the doors leading into the papal apartments. He then marched into the pope's bedchamber, where he found Cardinal Casanova and, holding a knife to his throat, threatened to cut it open and throw him out of the window if he did not hand over the keys to the cupboards and closets, where, Cesare had informed him, a large sum of money was stored. The terrified cardinal handed over the keys without protest, whereupon Corella and his men unlocked the chests and appropriated the money and silver they contained; according to Giustinian's report to the

Venetian Senate, they removed coins, silver, and jewels worth 500,000 ducats.

Corella now made the public announcement that Alexander VI was dead, and immediately the pope's servants ran into the apartments to help themselves to the clothes they found in his wardrobe and other items. Nothing of value was left, so Burchard said, "except the papal chairs, some cushions and the tapestries nailed to the walls."

Though, in fact, when the cardinals came to make an inventory of the pope's possessions a few days later, they found a lot of "silver, jewels and precious objects," according to Burchard, items that Corella had overlooked or, perhaps, had been hidden by the pope even from his own son. "They found the tiara, two valuable mitres, all the rings which the Pope used at mass, and all the sacred vessels the Pope used when he officiated at mass, which filled eight large coffers." According to Burchard, they also found a "cypress chest covered with green tapestry, which too had escaped Corella and his men, inside of which they found precious stones and valuable rings worth 25,000 ducats."

It was not until early evening that Burchard himself was informed of the pope's death, and the loyal master of ceremonies hastened into the papal apartments. "After I had seen the Pope's body," which had already been washed, "I clothed it in red brocade vestments, with silken amice and chasuble." He could not find the pope's shoes but did find a pair of slippers properly embroidered with crosses "and two strings that I used for binding them to his feet," but he was unable to replace the pope's missing ring, which had, no doubt, been ripped off his finger by Corella and his men.

Burchard then had the corpse put on a bier in the antechamber be-
fore being taken into the Sala del Pappagallo, where it was placed
on a table covered with a crimson cloth and "a piece of fine tapes-
try"; and four monks began to recite the Office of the Dead.

Messages were sent to all the cardinals, instructing them to as-
semble in the Church of Santa Maria sopra Minerva the next
morning, and to all the clergy in Rome, instructing them to gather
for the funeral procession from the Sistine Chapel to the Basil-
ica of St. Peter's the following day. With an escort of cardinals,
monks, clerics, and the canons of St. Peter's, as well as members
of Alexander VI's household, many of whom carried the 140 tall
wax tapers that accompanied the procession, the pope's bier pro-
ceeded into St. Peter's. The bier itself was carried, as was the cus-
tom, by a number of paupers who were traditionally rewarded
with a token sum for this service, a service that was performed on
this occasion with more reverence than that displayed by the cler-
ics, who, according to Burchard, ambled along beside the bier "in
disorderly fashion."

There was further unseemly behaviour inside the basilica, where,
while the prayers were being chanted, the palace guards set upon
the members of the procession in order to seize the tall wax tapers
that they were carrying. The clergy fled to the sacristy, abandoning
the pope's body, while Burchard, "with the help of three others," so
he recorded, "took hold of the bier and moved it into a position
behind the high altar." Even here it did not seem safe; the bishop
of Sessa "wondered if the angry people might not climb up to reach
the body and someone who had been wronged by the Pope would
get his revenge; so the bier was moved behind the iron grille of the

chapel entrance and there the body remained throughout the day, with the iron grille firmly closed."

There Burchard left it and upon his return he was appalled to see the dead pope's face "had changed to the colour of the blackest cloth, and covered in blue-black spots; the nose was swollen, the mouth distended, the tongue bent back double, the lips seemed to fill everything and the appearance of the face was more horrifying than anything ever seen." Francesco Gonzaga confirmed this in a letter to his wife, Isabella d'Este; the corpse "had lost all human form," he wrote, adding that "everyone refused to touch it though eventually one of the porters dragged it to the grave by means of a rope attached to one of the feet."

The six porters made gruesome jokes about its appearance as they struggled to get the swollen corpse into a coffin that was much too small. "The carpenters," according to Burchard, "had made the coffin too narrow and too short and so they had to remove the mitre from the Pope's head and place it by his side, before rolling up his body in an old carpet, and pummelling and pushing it into the coffin with their fists." Burchard added, sadly, that "no wax tapers or candles were used and no priests nor any other persons attended the body."

The next day gruesome stories were spread about the city: The dead pope had been heard in conversation with Satan; he had bought the papacy for the price of his soul; he had struck a bargain with the devil and had agreed to wear the papal crown for eleven years and had done so for that period of time plus seven days. At the end, so it was rumoured, water had boiled in his mouth, causing steam to fill the room in which he died, and that, in the words of a

macabre jest, when rigor mortis set in, "in death as in life, he re-
mained erect." It was at least certain that, in the terrible heat of
that August, the skin of the corpse had turned black and the smell
that emanated from it was intolerable.

Inevitably there were rumours that the death was not a natural
one, that the wine he and Cesare had drunk so thirstily on their ar-
rival at Cardinal Castellesi's country house had been poisoned.
Many claimed that Cesare and his father had planned to kill the
cardinal for his great riches, but that the servant who had been
bribed to poison the wine served at the meal had poured the deadly
concoction into the wrong flagons. This report spread far and wide,
irrespective of the fact that none of the guests, who had drunk the
same wine, displayed any ill effects until a week later.

Lucrezia was at the villa of Medelana when Cardinal Ippolito
rode over from Ferrara to bring her the sad news; and on hearing
the dreaded words, she afterward said that her "only wish was to
die herself." Few were so moved. Machiavelli recorded, in verse,
how "the soul of Alexander was brought to rest, glorious among
the blessed," and following in "the Pope's saintly footsteps came
his three servants and beloved handmaidens, extravagance, simony
and cruelty."

Duke Ercole also had few regrets. In a letter to his ambassador
in Milan, which he was confident would be passed on by the French
governor of the city to Louis XII, he wrote:

Knowing that many will ask you how we are affected by the
Pope's death, we wish to inform you that it was in no way dis-
pleasing to us. . . . There never was a Pope from whom we re-
ceived fewer favours . . . even after concluding an alliance with

him. In fact, it was only with the greatest difficulty that we obtained from him what he had promised us, for which we hold the Duke of Romagna responsible. He was never frank with us, never telling us of his plans, though we always told him of ours.

He also hoped for better things from Alexander VI's successor, piously observing that "for the sake of Christendom he had often desired that divine goodness and providence would provide a virtuous and exemplary shepherd and that all scandal would be removed from the Church."

~ *Chapter 24* ~

Conclaves

"HE COULD NOT HAVE FORESEEN THAT,
AT THE TIME OF HIS FATHER'S DEATH,
HE SHOULD HIMSELF HAVE BEEN SO SERIOUSLY ILL"

THE SEDE VACANTE, the period of the "empty throne" between the death of one pope and the election of his successor, was often a tense and troubled time in Rome, and it was particularly so in the summer of 1503. On the morning of August 19, the day after Alexander VI died, all those cardinals who were in Rome, sixteen in all, assembled in the chapter house of Santa Maria sopra Minerva: "The great seal of Alexander VI was broken in their presence," the symbolic act whereby the college of cardinals formally assumed responsibility for the government of the church and of the city of Rome until such a time when the new pope would be elected. Although the first part of their task proved relatively straightforward, the second was fraught with difficulty and danger.

Rome was in an uproar. On August 24 the Orsini arrived in the city with twelve hundred armed men "and immediately started

sacking and destroying the houses of Spaniards," according to a re-
port made to the Venetian Senate; "there were weapons every-
where." The bulletins from the Vatican suggested that the
commander of the papal army was close to death: "The Duke is
more feverish than ever," Giustinian wrote of Cesare that day; and
there was "hope in Rome that he will shortly follow his father to the
grave." Certainly his enemies were eagerly awaiting this piece of
news. While Cesare's men, under the capable leadership of Miguel
de Corella, had taken hold of the Borgo—the area around the Vat-
ican and Castel Sant'Angelo—the rest of the city was out of their
control.

Much of the city was in the hands of supporters of the rival
Orsini and Colonna families, united for once in their hatred of
the Borgias, taking what advantage they could of the pope's demise.
As the rumours of Cesare's worsening condition spread rapidly
through Rome, gangs of men marched threateningly through the
streets, shouting, as they would never have dared to do while
Alexander VI was still alive, "Down with the odious Catalan."

The tension in the city intensified, moreover, when it became
known that three armies were approaching Rome. The French
troops, led by Francesco Gonzaga, Marquis of Mantua, were on
their way south to defend Naples and had reached Viterbo, just
forty miles north of the city walls; a force of Spaniards under Gon-
salvo di Córdoba was marching north from Naples; and Cesare's
own battalions, poised for the start of what was to have been his
Tuscan campaign, were now recalled from their camp near Perugia
to march back down the Via Flaminia.

Louis XII of France and Ferdinand and Isabella of Spain were
hoping to profit from Cesare's incapacity; all of them—Cesare,

perhaps, most of all—were intent upon using armed force to influence the forthcoming conclave in order to ensure that the new pope to be elected was a man sympathetic to their interests.

Cesare himself was still too ill to take personal control of the situation, unable to seize the advantage to establish his control of Rome or to defend his authority in his duchy. "He told me himself," Machiavelli wrote, "that he had foreseen every difficulty that could arise on the death of his father and had prepared adequate remedies; but he could not have foreseen that, at the time of his father's death, he should himself have been so seriously ill." Those whose lands had been dispossessed used the opportunity offered by Cesare's incapacity to take them back again. Italy was in an uproar, as his empire began to fall apart: Guidobaldo da Montefeltro returned to power in Urbino; Gianpaolo Baglioni came back to Perugia; the Varano family to Camerino; Giovanni Sforza to Pesaro; and the Orsini retook possession of their castles.

Yet Cesare's position was not as weak as his enemies hoped. He still controlled the Borgo; he had at his command a well-trained army and also the money needed to pay its men; most of the cities of the Romagna remained firmly loyal, and he would have considerable influence in the imminent conclave. According to Giustinian's reckoning, there were "eight cardinals who would follow him in everything," and several more besides. But he also had inveterate and influential enemies in the college, too, notably Ascanio Sforza and the cousins Raffaello Riario and Giuliano della Rovere, the latter of whom was on his way to Rome with an escort of one hundred crossbowmen in case of attack by Cesare's men, who had been ordered to intercept him.

In his weakened state, lying in bed in his rooms above the Borgia apartments in the Vatican, Cesare had been uncharacteristically hesitant during the first few days of the *sede vacante*. Now, in an attempt to make up for lost time, he started to make overtures at the same time to both French and Spanish candidates in the conclave, offending both factions when his behaviour became known. He had also been able to come to a secret agreement with Louis XII whereby he agreed to place all his men at the king's disposal on the understanding that Louis XII would protect the territories that Cesare still occupied and help him to recover those that had recently been lost.

He also swore his allegiance to the college of cardinals, and a few days later, a deputation of cardinals approached the Venetian ambassador, Antonio Giustinian, with a request that he should use his persuasive skills to induce Cesare to remove his troops from Rome so that a free conclave could be held. Since, as Giustinian put it, this was no business of his and he had no instructions from Venice in the matter, he, at first, declined. Under pressure, however, and persuaded that his actions would bring great credit to his government, the ambassador did, in the end, convince Cesare. And so, on September 2, having been confirmed by the college in his position as captain-general of the church until the election of a new pope, and having been informed that the soldiers of Prospero Colonna had indeed left the city, as he had requested, Cesare finally left for the castle at Nepi.

Cesare, too weak to ride, was carried out of the city on a litter borne by twelve halberdiers, concealed from view behind crimson damask curtains. Those who caught glimpses of him at this time

reported him as looking desperately ill, pale, and haggard, his feet so swollen that he could not stand up. Following the litter walked a splendid charger with trappings of black velvet, embroidered with his coat-of-arms and his ducal crown. According to Ferdinand Gregorovius, Cesare was also accompanied by his mother, Vannozza de' Catanei, and by his brother Jofrè, as well as more than one hundred wagons piled high with his luggage. "Now that Cesare has gone," Antonio Giustinian commented, "it is thought that the conclave will take place without any disturbance, since everyone respects the Sacred College."

The college, meanwhile, had been busy organizing the obsequies for the dead pope, which opened on September 4 with the first of the memorial Masses for his soul. They continued every day at the catafalque that had been erected in St. Peter's for the following eight days. These obsequies, however, were of scant interest compared with the heated discussions about the outcome of the imminent election. Many believed that the next pope might be Ascanio Sforza or the Frenchman Georges d'Amboise, cardinal of Rouen. But most supposed that Giuliano della Rovere, after ten years in exile, would be chosen; on his arrival in Rome in the hope that his long-held ambition to be elected was about to be fulfilled, he had told Giustinian, succinctly, "I have come to Rome to look after my own interests and not those of other people."

When the conclave finally opened on September 16, with thirty-seven cardinals in attendance, it was soon clear that the cardinal of Rouen could not win the tiara; both the Italians and Spaniards were against him, and in order to break the deadlock caused by rival national interests and by fears that Cesare Borgia might recover sufficiently from his illness to interfere in the election, the search

turned to a compromise candidate, one who was not expected to survive for long and who would provide a temporary measure allowing all parties to build up support for a candidate of their own. Their choice consequently fell upon Francesco Todeschini Piccolomini, archbishop of Siena, the kindly nephew of Pius II, who was racked by gout and already gave the appearance of a very old man, despite being only sixty-four years old. When he was elected, on September 22, he chose to be known as Pius III, in honour of his uncle.

Pius III was a learned and cultured man, a protégé of his uncle, who had taken him into his household and arranged for him to attend courses in legal studies at Perugia. At the age of twenty-one, he had become, again at his uncle's instigation, archbishop of Siena and soon afterward cardinal of Sant'Eustachio. For Cesare, everything now hinged on whether he would enjoy the favour of this man, his father's successor.

The enforced convalescence at Nepi had by now almost restored Cesare to his previous good health, though he was careful to ensure that reports of his worsening condition continued to circulate in Rome. And his spirits rose when he was given grounds to believe that he would soon be confirmed in his office as captain-general of the church by the new pope and returned to authority in his former estates in the Romagna. Certainly, Pius III seemed prepared to condone the indulgence of Cesare's ambitions, declaring that it had been God's will that those lords whom Cesare had dispossessed should lose their authority, even though it had been carried out by a "wretched instrument."

"In consequence of the pressure put upon me by the Spanish cardinals, I have been compelled to issue some briefs in favour of

Cesare Borgia," he explained to Giustinian, "but I will not give him any further help." Pius III's opinion of his predecessor's son was not encouraging: "I do not wish any harm to the Duke, since it is my duty as Pope to have compassion for all men, but I foresee that, by God's judgement, the Duke must come to a bad end." Giustinian reported that "the Duke has had good words from the Pope," adding later, "But His Holiness does not trust him."

Cesare now decided to return to Rome, where he hoped to be able to press Pius III to confirm him in his offices of captain general of the church and Duke of Romagna. He needed papal permission, however, to enter the city and ordered the Spanish cardinals to plead his case. "They tell me he is very ill," Pius III informed the Ferrarese envoy Beltrando Costabili, who reported that the pope had never imagined he would feel pity for Cesare but did now "indeed most deeply pity him," adding that "he wants to come to Rome to die, so I have given my permission." Much to the surprise of all in Rome, when Cesare returned on October 3, he seemed to be in the best of health.

A few days later Giustinian reported that Cesare was "not so ill as we all believed," and, moreover, "now speaks with his customary arrogance and boasts that he will soon regain possession of all his states." The ruse had worked, though, and on October 8, the day of his coronation, Pius III confirmed Cesare as captain-general of the church. Such was the pope's ill health, however, that the customary procession from St. Peter's to San Giovanni in Laterano had to be cancelled; Pius III was suffering so painfully from gout that he was unable to undertake this lengthy ceremony and retired to his apartments in the Vatican, where, ten days later, he died.

Cesare had spent those ten days making preparations to return with his army to the Romagna, where his grasp was weakening as each day passed, and seeking to acquire the safe-conduct passes needed to move his troops through Florentine territories. But Cesare, still obliged to spend much time in bed, and seemingly disturbed in mind as well as sick in body, was now apparently incapable of acting as decisively as he had been in the past; and when he did make decisions, they were not infrequently the wrong ones. His decision to come to Rome after the election of Pius III, rather than travel directly from Nepi to the Romagna, would prove to be one of these.

In the meantime, however, his plans soon had to be modified as his enemies Cardinal della Rovere and Cardinal Raffaello Riario, Gianpaolo Baglioni and Giovanni Bentivoglio, and the Orsini and the Colonna families, still in uneasy alliance, all began to move, one after the other, against him. Not only threatened by his enemies, Cesare was also troubled by a mutiny of his own soldiers, who were demanding better pay; then he became involved in a ferocious fight with Orsini supporters and, deserted by many of his men, was forced to take shelter first in the Vatican, then in Castel Sant'Angelo.

His situation seemed hopeless, but the death of Pius III a few days later rescued him from disaster, casting away his former gloom and renewing his hopes for the future. "The Duke still occupies quarters in the Castel Sant'Angelo," Machiavelli reported on October 27. "He is more confident than ever that he can still do great things for he believes that a pope favourable to him will now be elected."

Throughout this time, Cardinal Giuliano della Rovere had been strengthening his position in Rome. As the bargaining began between the cardinals for the election of the new pope, it was clear that he was the front-runner. His main rival was the Frenchman Georges d'Amboise, whose election was supported by Louis XII; Giuliano's emphatic protestations that a French pope might well take the papacy back to Avignon brought him much support among the Italian cardinals.

Cesare's own position weakened considerably when, toward the end of October, news arrived that Forlì, Faenza, Rimini, and Pesaro had fallen to his enemies. On October 29, two days before the conclave was due to open, Cesare and Cardinal Giuliano signed an agreement in the Vatican whereby all the Spanish cardinals agreed to vote for the cardinal on the understanding that, assuming he was elected pope, he would confirm Cesare in his offices of gonfalonier and captain-general and do his utmost to help Cesare establish himself once more in his possession of the duchy in the Romagna.

Machiavelli was astounded when he heard that Cesare had offered his support to Giuliano della Rovere, his father's old enemy. "No one can be unaware of the extreme hate which the Cardinal bears Cesare, since he cannot easily forget the exile in which he had been kept for ten years; the Duke, on the other hand, allows himself to be guided by a blind, unjustified confidence."

In the end, the conclave was no contest. When it came to the counting of the slips that had been placed in the golden chalice after the first round of voting, it was found that all but three of them bore the name of Giuliano della Rovere. He had acquired the necessary two-thirds majority in one of the shortest conclaves in the

history of the papacy, and he chose to be known as Pope Julius II. Francesco Guicciardini commented:

> Everyone marvelled greatly that the papacy should have been granted with such widespread agreement to a cardinal who was known to be very difficult by nature and formidable with everyone. He was notoriously restless and had spent his life in continual hardships and had inevitably offended many people, arousing the hatred and provoking the enmity of many great men. . . . He had been a very powerful cardinal for a long time . . . and his cause was greatly promoted by the immoderate promises which had been made to anyone who might prove useful to him.

~ Chapter 25 ~

Cesare at Bay

"THE DUKE'S CHOICE WAS A MISTAKEN ONE;
AND IT WAS THE CAUSE
OF HIS ULTIMATE DOWNFALL"

A MONTH SHORT of his sixtieth birthday when elected, Julius II was, unlike his predecessor, unusually vigorous and energetic; still in his prime and enjoying robust health, he was a strong-willed, purposeful, and resolute man, with a very determined view of the world and his position in it.

The grandson of a fisherman from Liguria in northern Italy, he was proud of his humble birth and much given to boasting of his poverty-stricken childhood and of having sailed down the coast with cargoes of onions. His plans to pursue a career in commerce had been dramatically cut short in 1471 when, at the age of twenty-seven, he was made a cardinal by his uncle Sixtus IV.

A tall, rough, impulsive, and handsome man, talkative, arrogant, and restless, he had a fiercely commanding expression and a very short temper. He habitually carried a stick with which he beat men

who annoyed or provoked him, and he would hurl anything at hand, including his spectacles, at messengers who brought him unwelcome news. He had had many mistresses in the past, from one of whom he had contracted syphilis, and as a cardinal he had fathered three daughters. But he had thereafter shown no interest in women, concentrating his sensual appetites on food and drink, which he enjoyed to the full. He relished game and suckling pig and the strong wines of Greece and Corsica; and during Lent, like many others who could afford to do so, he made do with large dishes of lampreys, prawns, caviar, and tunny fish. He paid no attention to his doctors' words of caution, and when ill, treated his indisposition by chewing quantities of strawberries and plums, which he believed had curative properties.

He was no scholar, he used to say with defensive pride; he was more suited to the life of a soldier. Indeed, he sometimes said that he ought to have been a soldier; and certainly when he personally led his armies out of Rome to compel the obedience of rebel cities in the Papal States and to recover lost territories for the church, he displayed a taste for hard campaigning that dismayed the less robust cardinals whom he obliged to accompany him. It was Julius II who, unwilling to rely upon capricious and often irresolute mercenaries, decided to form a professional papal army; and this decision led in 1506 to the creation of the Swiss Guards, who remained a fighting force until 1825, when they became a smaller domestic bodyguard, though still retaining their old uniform of slashed doublets, striped hose, and rakish berets, as well as their pikes and halberds.

When a sculptor asked him what should be placed in the hand of a statue of him, he replied, "Put a sword in my hand, not a book."

As a soldier he wore full armour, with a tiara taking the place of a helmet. One contemporary likened him to a ship guided neither by compass nor by charts. "No one has any influence over him, and he consults few or none," the Venetian ambassador wrote; "anything that he has been thinking about during the day has to be carried out immediately," the envoy added. "Everything about him is on a magnificent scale, both his undertakings and his passions."

One of his overpowering passions was a deep hatred of the Borgia family. As a cardinal, and fearing assassination, he had fled to France, where he had encouraged Charles VIII to invade Italy and had accompanied him on his campaign. He had failed in his attempt to have a council appointed to depose the pope for simony; but, deprived of the satisfaction of dethroning Alexander VI, "that Spaniard of accursed memory," he determined to pursue Alexander's son to the death, to reestablish the church's rule in the Papal States, and to restore the temporal power of the papacy, which he knew to be essential to his authority.

As Machiavelli wrote, Julius II's hatred of Cesare "was notorious; and it is not to be supposed that the Pope will so quickly have forgotten the ten years of exile which he had had to endure under Alexander VI." In a conversation with Giustinian, the new pope said, "We do not want [the duke] to be under the illusion that we will favour him, nor that he shall have even one rampart in the Romagna, and although we have promised him something, we intend that our promise shall only extend to the security of his life and of the money and goods that he has stolen." For the moment, however, he was prepared to give the impression that the past enmity, which had characterized the relationship between himself and "that detested family," was now to be modified.

The new pope, having at last achieved the position for which he had yearned for so long, seemed disposed to abide by the undertakings he had given Cesare before the conclave. The Florentines were told to grant the duke and his troops free passage through their territory to the Romagna; while so long as Cesare stayed in Rome, he was free to leave the dark rooms in Castel Sant'Angelo and to occupy apartments in the Vatican. Julius II also promised to confirm Cesare in his appointment as captain-general, and, initially at least, he continued to show respect for Cesare, going so far as to refer to him as "our beloved son" in a brief to Faenza written within days of his election.

Cesare's duchy had begun to disintegrate in the aftermath of Alexander VI's death: "Only the states of the Romagna stood firm," Francesco Guicciardini observed, and they did so because the government had been entrusted by Cesare "to the hands of men who ruled with so much justice and integrity that he was greatly loved by them." Other writers maintained that, in the words of the Perugian chronicler Matarazzo, "the people remained quiet from fear rather than contentment"; while the Venetians generally believed that his subjects were "full of discontent because of the tyranny and violence practised by the officials of the Duke Valentino."

Now Cesare could only count on the loyalty of his Spanish governors in Cesena, Imola, and the fortress of Forlì, but he could rely on the strength of these newly built fortifications. Julius II, however, despite the earlier promises reported by Machiavelli, had no intention of allowing Cesare to retain control of them. "We want the states to return to the Church," he declared. "It is our intention to recover them," and although "we made certain promises to the Duke," he explained, "we intended merely to guarantee his personal

safety and his fortune, even though, after all, it was stolen from its rightful owners."

Julius II was an old hand at playing the long game. Fully aware that by depriving Cesare of his duchy in the Romagna, he would create a dangerous political vacuum into which Venice would be the first to step, he needed at all costs to avoid the expansion of an already-powerful Venetian republic in order to preserve his own authority in the Papal States. Equally, he needed to ensure that he did not give Cesare the opportunity to reestablish his own position in the Romagna. He needed, in other words, to tread with considerable care.

It was not long before it became clear that Cesare was, indeed, overconfident in his belief that Julius II would favour him, even to the limited extent that he had been led to believe was his due; and the more clearly he realised that the pope was deceiving him, the more angry he became. When Machiavelli was granted an interview with him early in November, he found him in an unusually emotional mood, angry and resentful, rambling on at length "with words full of poison and anger." Cesare was no longer the forceful and competent leader Machiavelli had met eighteen months earlier in Urbino.

Other observers gave similar descriptions of "an angry, broken man, out of his mind and not knowing what he wanted to do." Francesco Soderini described him as "inconstant, irresolute, and suspicious, not standing firm in any decision." Machiavelli reported that his plans were uncertain:

No one knows whether or not he intends to stay in Rome. Some people seem to think he will go to Genoa, where he is

said to have deposited large sums with the merchants there, and from Genoa to go on to Lombardy to raise troops for an advance on the Romagna. He can do this apparently because he had 200,000 ducats deposited with the Genoese merchants. Others believe he will stay in Rome for the Pope's coronation when, as promised, he will be proclaimed Gonfalonier of the Church.

In fact, Cesare still hoped to march north from Rome to his strongholds in the Romagna, and accordingly waited anxiously for the letter he expected from Florence confirming his safe conduct through the republic's territories. But the Florentines, advised by Machiavelli that Julius II's support of Cesare was only a temporary measure, decided not to agree to Cesare's request.

And so, on November 18, his power and possessions crumbling around him, Cesare left Rome for Ostia, from where he intended to reach his strongholds in the Romagna, avoiding Florentine territory by travelling by sea to Livorno and from there marching east across the Apennines to Cesena. Before he could leave, however, two cardinals arrived in Ostia with orders from Julius II for Cesare to hand over the passwords he had agreed with his castellans for each of the fortresses. Cesare refused to do so.

Julius II, fearful of rumours that Venice planned to seize these strategically vital citadels for herself, was incensed with rage and ordered Cesare to return to Rome immediately; and if he declined to obey the order, he was to be brought back by force.

At the same time, the pope issued a warrant for the arrest of Cesare's lieutenant Miguel de Corella, who was to be questioned about the deaths of many persons: Juan, the Duke of Gandía,

Cesare's brother, whose body had been fished out of the Tiber in June 1497; Alfonso of Aragon, Lucrezia's second husband, who had been strangled on his sickbed; Astorre Manfredi, Lord of Faenza, and his brother, whose bodies, weighted with stones, had been found in the Tiber in June 1502; Giulio Cesare da Varano, Lord of Camerino, who had been strangled at La Pergola shortly afterward, and his two sons, who had had their throats cut; and many more.

So, on November 29, three days after Julius II's magnificent and extravagant coronation procession, Cesare returned to Rome, a prisoner. There were unconfirmed reports that, now in custody, his spirit had finally broken. There were stories that he wept when he was dragged into his cell in the Torre Borgia, that he had fallen onto his knees before Guidobaldo da Montefeltro, begged for forgiveness for what he had done in Urbino, and undertook to return the works of art that had been stolen from the ducal palace. And on December 1 came the news that a body of Cesare's troops, under the leadership of Corella, had been captured near Arezzo, thanks, it was said, to a warning sent to the Florentine government by Machiavelli that these men were on their way north.

Worse was soon to follow, when a number of wagons belonging to Cesare, but travelling under the name of Lucrezia's brother-in-law Cardinal Ippolito d'Este, came to the attention of the customs men in Bologna, who were inspecting baggage for taxable goods. "When they opened the chests and bales," wrote the Ferrarese chronicler Bernardino Zambotti, "they found inside great riches taken from the Church, namely, the cross of St. Peter, covered with gems of an infinite value," several other pieces of gem-encrusted jewellery that were the property of the church, priceless clothes and altar hangings, "a little gilded cat with diamonds for its eyes," and

even a little altarpiece of the Virgin, worth a total, so Zambotti estimated, of 300,000 ducats.

With his loyal lieutenant under arrest in Florence and much of his fortune confiscated in Bologna, there seemed little alternative to Cesare but to divulge the passwords he had been at such pains to conceal. Machiavelli commented that his life would not be worth much after the strongholds surrendered. "It seems to me," he wrote, "that this Duke of ours is slipping little by little down to his grave." The castellans, however, whether out of loyalty to their duke or following some prearranged plan, valiantly refused to surrender the fortresses until they had positive proof that Cesare was no longer a prisoner.

The stalemate continued, much to Julius II's fury, until the end of the year, when news arrived in Rome that much cheered Cesare: Gonsalvo di Córdoba had won a decisive victory over the French at the Battle of Garigliano on December 27. Hoping, indeed expecting, support from a Spanish Naples, Cesare signed a formal agreement on January 29, 1504, agreeing to surrender his Romagna fortresses in return for his freedom. Pending the surrender, Cesare was taken to Ostia while, one by one, his strongholds were taken by Julius II's troops.

In April 1504 he set forth, in optimistic spirits, in a galley bound for Naples and the court of Gonsalvo di Córdoba, Duke of Terranova, who had been appointed viceroy of the kingdom by Ferdinand and Isabella of Spain. He was not welcome, however. The Spanish monarchs, "their Catholic Majesties," had informed their ambassador in Naples that "we regard the arrival of the Duke with great displeasure and not for political reasons alone; for, as you know, the man is deeply abhorrent to us because of the gravity of

his crimes and we certainly do not wish that such a man should be considered to be in our service." They had, they informed the ambassador, also written to Gonsalvo di Córdoba, asking him to arrest Cesare and "to send the Duke to us and to provide two galleys for the journey so that he cannot escape elsewhere."

Even before Gonsalvo di Córdoba had received these orders, Cesare, his confidence by now restored, had set about planning a march into the Romagna to regain what he had recently lost. When the royal instructions arrived from Spain, he believed that as a fellow Spaniard, Gonsalvo would be prepared to overlook them, and he started to raise troops for a campaign in Italy that he hoped would restore him to power. Gonsalvo, however, remained loyal to his masters.

The Florentine ambassador in Naples reported what happened next:

On 1 June [Cesare] asked for an interview with [Gonsalvo di Córdoba] to discuss his affairs. He had already prepared the artillery for his proposed campaign and had ordered wine, bread and other things necessary for his expedition. In the evening he had his interview with Gonsalvo . . . [who] was accompanied by Niugno del Campo, castellan of the Castel Nuovo in Naples, and when [Cesare] turned to descend the stairs, Niugno stopped him saying, "Signore, your way lies here," and led him into a room in the Torre dell'Oro. . . . On Tuesday he was transferred to another room which was very beautiful but very strong with windows protected by iron bars. It is called "the oven" and several important people have been

held prisoner there at one time or another. He is there now with two servants. The Grand Captain refuses to talk to him. There is not a single man who does not praise this deed. In truth, it is pleasing to all.

Soon after this dispatch was received in Florence, Cesare was put onto a galley bound for Spain, where, so his sister heard, he was "shut up with a page" in the castle of Chinchilla, high in the mountains behind Valencia.

Cesare's fall had been as dramatic as his meteoric rise. Machiavelli blamed it on Cesare's decision to support Julius II's election, though it is difficult to see how he could have organized an alternative candidate to counter the front-runner and ensure enough support in the conclave to achieve the required two-thirds majority among the cardinals.

As Machiavelli commented in *The Prince:*

[Cesare] should never have allowed the election of one of those cardinals he had injured, or one who would have cause to fear him. Men do you harm either because they fear you or because they hate you. . . . The Duke's aim, first and foremost, should have been to engineer the election of one of the Spanish cardinals and, failing that, to enable it to be Rouen [Georges d'Amboise] not San Pietro in Vincoli [Giuliano della Rovere]. Whoever believes that great men allow new services to erase old injuries is deceiving himself. So the Duke's choice was a mistaken one; and it was the cause of his ultimate downfall.

~ Chapter 26 ~

Duchess of Ferrara

"MY JOY IN SEEING YOU IS NEVER DONE"

THE DEATH OF HER FATHER, Alexander VI, followed so rapidly by the collapse of Cesare's empire and his ambitions, and his humiliating imprisonment so far away in Spain, must have been devastating to the twenty-three-year-old Lucrezia. All the more so, isolated in Ferrara, where, according to the chronicler Bernardino Zambotti, it was widely believed that the pope had been poisoned; Cesare, too, "was found to have been poisoned," he reported, adding that "it was chiefly due to the fact that he was placed inside the still warm entrails of two mules that he was cured."

The torrential rain that lashed Ferrara that September and October, causing the Po to burst its banks, flooding both fields and city streets, matched the depths of her misery. Couriers arrived daily with news of Cesare's cities and fortresses as they fell, one by one, some returning to their earlier rulers, others seized by Venice;

of the new tenant of her old home, the Vatican Palace, and how the new pope had shut up her father's apartments, where she had once danced and laughed so gaily, and vilified "that Spaniard of accursed memory."

It was not just her private grief at the loss of her father and brother that overwhelmed her; it was clear from the gossip at court that Lucrezia's position as wife of the heir to the duchy was now also under threat. One friend advised her to do all she could to assuage her grief lest people thought she was overcome by apprehension about her own future.

Louis XII himself was ready to repudiate both Cesare and Lucrezia now that Alexander VI was dead; and he told the Ferrarese envoy that he knew very well that the Este family had never been pleased with the Borgia alliance, and "therefore the French court did not regard Madonna Lucrezia as Don Alfonso's real wife." Alfonso, however, had become attached to Lucrezia. Hearing of her father's death, he came home to Ferrara to comfort his wife and thus to show that although the marriage had lost its political raison d'être, it still retained its private lustre.

They seemed to have been "quite satisfied with one another," and they may well have been so, but their temperaments were very different; while he still continued to spend a large part of each day in the lecture halls of the university or in his workshop, poring over proposals for public works, military engineering, and firearms, she enjoyed the life at court, where masques and tableaux, drama and poetry occupied the evening hours.

Music was the interest closest to Lucrezia's heart, and one she shared with her husband, who was himself an accomplished player of the viol. She employed her own singers, pipers, and lute players,

even her own dancing master, spending a large part of her income on the patronage of music. She was particularly fond of songs, of the lovely Spanish poems that were set to music by her musicians; and she vied with her rival, Isabella d'Este, to attract the best players and composers to her court.

The court at Ferrara was famous throughout Italy as a centre of culture. Duke Ercole had doubled the size of the city and transformed it into a setting worthy of ducal grandeur, enclosing a huge hunting park, complete with its own racecourse, where ladies of the court could watch their knights displaying their skills, jousting at the ring or pursuing game with trained leopards; he added new gardens and gilded reception rooms to the ducal palace and, in 1504, decided to build on the grounds the Sala delle Comedie, the first purpose-built theatre since antiquity.

Among the many foreign writers and musicians attracted to this lively cultural centre were the scholarly humanists Ercole Strozzi and Pietro Bembo. A member of the Florentine family whose grand palazzo, built for Filippo Strozzi, is one of the most imposing in Florence, Ercole Strozzi was a poet of distinction. Much disliked by Lucrezia's husband but admired and sponsored by her father-in-law, Strozzi was a distinctive figure in Ferrara, where he hobbled about on crutches that his clubfeet rendered indispensable.

Strozzi was clearly and immediately attracted to Lucrezia, as she was to him. He sympathised with her in her differences with her father-in-law, who kept her, so she complained, so short of money that she was not able to dress with the distinction that was her due. Strozzi made light of her complaints; she could always borrow money; and since he himself was shortly to go to Venice, he would

buy for her there such materials as those for which that city was celebrated. He returned with large bundles to the delight not only of Lucrezia but also of her ladies, who were presented with rolls of material to be made up into dresses of exceptional splendour.

Pietro Bembo, on the other hand, was a Venetian poet, handsome and charming, a man in his early thirties whose company Lucrezia found especially alluring. Indeed, there were whispers at court that the duke's new daughter-in-law might have succumbed to Bembo's charms; it was generally supposed that they soon became lovers. Certainly she was always ready to enjoy the company of the lively brilliant poet when he was in Ferrara or a guest at Ercole Strozzi's lovely villa at Ostellato, on the shores of the lagoon at Comacchio, travelling there from time to time along the waters of the Po in her painted barge.

When apart, the two wrote passionate letters to each other in the fashion of their times. Lucrezia called him "Messer Bembo mio" (my Mr. Bembo), and he wrote to her with deep affection. She gave him a lock of her lovely blond hair, which can still be seen today, on display in the Biblioteca Ambrosiana in Milan, along with much of their correspondence and the poems they wrote to each other; seeing "those beautiful locks that I love ever more deeply," ran one of Bembo's verses, "my heart was torn from me and caught." One of his letters to her ends: "With my heart do I now kiss that hand of yours, which soon I shall kiss with my lips that ever have your name engraved upon them."

"Were I an angel as she is," Bembo told Lucrezia's cousin Angela Borgia, "I would take pity on anyone who loved as I love." And in one of the verses he sent her, he wrote:

Avess'io almen d'un bel cristallo il core
Che quel ch'io taccio, Madonna non vede
De l'interno mio mal, senza altre fede
A suoi occhi traducesse fore.

[Had I a heart made of fine crystal
rather than the one I hide, which Madonna does not see
from inside me my pain
would betray itself in her eyes.]

 When Lucrezia replied (the letter is dated June 24, 1503) that in
the crystal of her heart she had found a perfect conformity with
Bembo's, he replied that his own crystal was now more precious to
him than "all the pearls of the Indian seas."
 When Bembo heard of the death of Alexander VI, he immedi-
ately rode the ten miles or so from Ostellato to the ducal villa at
Medelana where Lucrezia was staying to see what he could do to
comfort her in her grief. But she was, for the moment, beyond grief.
"As soon as I saw you lying in your darkened room, wearing your
black gown, weeping and desolate," he wrote to her the following
day, "I was so overcome by my feelings that I stood still, as though
struck dumb, not knowing what to say. Instead of offering sympa-
thy, I felt in need of sympathy myself. I left, fumbling and speech-
less, overcome with emotion at the sight of your misery." He could
offer little in the way of solace: "I know not what else to say except
to remind you that time soothes and eases all our sorrows," he said,
adding that although Alexander VI, "your very great father," had
died, "this is not the first misfortune which you have had to endure
at the hands of your cruel and malign destiny."

As summer turned to autumn and the plight of her beloved brother grew worse and worse, Bembo continued to offer what help he could to comfort Lucrezia, writing to her when they were apart with that romantic passion she found so beguiling. "The whole of this night in my dreams, and in the wakeful watches, however long they were, I was with you," one of his letters ran. "And I hope that every other night of my life, whatever it holds in store for me, the same thing will happen."

Lucrezia, in return, asked Bembo to translate one of her own Spanish sonnets into Italian:

> Yours is the radiance which makes me burn,
> And growing with each act and gracious word
> My joy in seeing you is never done.

But these contented days at Medelana were soon to end: Bembo's younger brother, Carlo, fell seriously ill at Venice; Bembo hurried to his bedside too late to see him before he died. "I am sending for my books which I left behind in Ferrara," Bembo wrote to Lucrezia in early 1504, to say that "I shall remain here for a while in order that my aged and sorrowful father need not remain entirely alone for it is clear he has much need of my company."

It was to be many months before he and Lucrezia saw each other again, and by then the ardour of their attachment to each other had cooled to friendship, one that was to last until the end of her life. In 1505 he dedicated his dialogues on Platonic love, *Gli Asolani,* to Lucrezia, whose visit to him on one occasion when he had been ill had "cured him of every feverish *languore*" that beset him. The following year he moved from Venice to the lively court of

Guidobaldo da Montefeltro and Elisabetta Gonzaga, now rein-
stated in Urbino, and he was one of the leading characters in Bal-
dassare Castiglione's *Book of the Courtier.* A few years later he moved
to Rome to take up his appointment as secretary to Pope Leo X
and would later be made a cardinal by Paul III. Having established
a reputation for Latin lyric poetry, he turned to Italian verse, the
collected edition of his Italian poems appearing in 1530.

One of the last letters Lucrezia wrote to him was quite perfunc-
tory; certainly she had not written much of late, she told him, but
he must rest assured that there were many good reasons why she
had not been able to do so. She remained, she added caringly, as
anxious as ever to please him.

It was around the time when Bembo left for Venice that Lucrezia
began to appear more frequently in public, fulfilling her duties and
responsibilities as Duchess of Ferrara. Using the skills she had
learned at her father's court, she received embassies with a grace
that her husband was quite unable to muster on such occasions.
With her extensive knowledge of political affairs, she took an un-
feigned interest in the government of the duchy and its relation-
ships with the other Italian states and with foreign powers.

She was also busy fulfilling her primary duty as Alfonso's wife,
endeavouring to produce an heir for the duchy, a subject particu-
larly close to Duke Ercole's heart. A year after the disappointment
of her stillborn daughter, Lucrezia was pregnant again, and yet
again she miscarried. At Christmas 1504 Lucrezia was pregnant
once more, bearing Alfonso's child for a third time, much to the
joy of her seventy-one-year-old father-in-law, whose own long life
was finally drawing to a close.

During the previous summer, the duke had travelled to Florence in order to visit the miraculous image of the Virgin in the Church of Santissima Annunziata, but on his return, "much fatigued by the journey," according to the Ferrarese chronicler Bernardino Zambotti, he had fallen seriously ill. Alfonso, who was on a trip to France to visit Louis XII, was informed immediately by a courier sent posthaste to the French court, and he rushed home to join Isabella, who had arrived from Mantua, at their father's bedside. Alfonso arrived, according to Zambotti, "healthy and safe but very downcast with anxiety and sorrow"; he was "much concerned with what might have occurred if his father had died in his absence." With four brothers, one of whom was illegitimate, he did have occasion to worry.

The old duke finally died on January 25, 1505, much mourned by his family and by his subjects; Alfonso was proclaimed his successor later that same day before riding in a grand ceremonial procession through the streets of Ferrara, accompanied by his court, dressed in the ducal mantle of white satin lined with fur and the great gold chain of state hanging across his breast. When Lucrezia dutifully knelt before him to offer her homage, the new duke embraced her warmly and kissed her before leading her out onto the balcony, her hand in his, to display the new duchess to her people.

During the summer of 1505, the rivalry between Alfonso's brothers erupted dramatically into open hostility. Life in the hot, humid city of Ferrara was more unpleasant than usual that year; on May 17, reported one chronicler, "there was no wheat for sale in the market place, nor fodder of any sort, except for rice," which was selling at double the normal price, "and for two days there was no

bread for sale either." When the wheat did arrive, it was found to be full of weevils, and the poor could be seen across the city, "crying out for a slice of bread." In the middle of June, with the price of foodstuffs rising daily, a ten-year-old boy was found dead on the street, and when the neighbours went to his house, they found that his parents had died of the plague.

Lucrezia, concerned by reports of the outbreak of the plague, decided to take her household to Modena both for her own sake—since her fluctuating temperature had induced her to consult her doctor, who advised her to leave the city—and for the sake of the child she was carrying. Her brother-in-law Giulio d'Este, Duke Ercole's bastard son, asked if he might go with her. He was a rather tiresome young man, conceited, frivolous, quick-witted, and headstrong; but Lucrezia enjoyed his amusing company and so she readily assented. The old duke, well aware of the young man's extravagance, had only granted him a modest allowance and had wanted him to go into the church. But Giulio had strongly resisted this plan and was much relieved when his brother, the new duke, presented him with a generous income as well as a palace.

Cardinal Ippolito was exasperated by the indulgence that Alfonso had shown to such a flighty and arrogant wastrel; and, as an opening gambit in the dispute that was developing between Ippolito and his illegitimate brother, he had a chaplain in Giulio's household arrested and imprisoned. Giulio promptly broke into the prison and released the man.

The cardinal was a sardonic, elegant, supercilious, and argumentative man. He much regretted having been made a cardinal and certainly did not allow his unwanted eminence in the church to interfere with his passions for hunting and women. His out-

bursts of temper were notorious; on one occasion he flew into a rage with one of his father's crossbowmen and had him beaten so savagely that he was almost killed. Lucrezia was intrigued by him, and she was seen so often in his company that the Roman ambassador in Ferrara reported that "she belonged to her husband at night, and to the Cardinal by day."

Meanwhile, Lucrezia, accompanied by Giulio, was forced to leave Modena, where plague had by then also broken out, and made for Reggio, where they were intercepted by a messenger from Duke Alfonso with an order banishing Giulio to a remote estate. At first Giulio refused to go there, but eventually he was persuaded to leave, while Lucrezia induced the chaplain whom Giulio had released from prison to return there voluntarily for the moment.

Nor was this the only aspect of Giulio's behaviour that was provoking such fury in his brother the cardinal. For months Giulio had been pursuing the pretty, alluring Angela Borgia, Lucrezia's cousin; and when she became pregnant, it was generally supposed that he was the father of her child. Here was another problem for Lucrezia, for, while conducting an affair with Giulio d'Este, Angela was simultaneously being pursued by a besotted Cardinal Ippolito.

It was at Reggio on September 19, 1505, that Lucrezia gave birth to another child, a boy this time, who was named Alessandro in memory of her father. Bembo offered his congratulations. "It gave me infinite pleasure," he wrote, "to hear of the happy birth of a male child to your ladyship; all the more so," he added, after "the cruel disappointment and vain hopes" that had accompanied her miscarriage of the previous year. He prayed also that this "dearly awaited son" would grow into a man "worthy of so fine a mother." His hopes, and those of Alfonso and Lucrezia, however, were to be

once again cruelly dashed. The infant proved poor and sickly; Alfonso sent his own doctor to Reggio to care for the baby, but despite his ministrations, barely a month later Alessandro was dead.

Writing to comfort Lucrezia, who had also suffered a bout of puerperal fever after the birth, Francesco Gonzaga, Marquis of Mantua, invited her to stay at Borgoforte, a castle on the border of Ferrara and Mantua that belonged to his family.

The thirty-nine-year-old Francesco was by no means a captivating personality, but his presence would be some comfort to Lucrezia after the departure of Giulio and the death of her baby. Besides, it would annoy Isabella d'Este, who was eight months pregnant, and whose discomfiture Lucrezia always found pleasurable. So she agreed to meet Gonzaga at Borgoforte, where, in his brusque and didactic way, he did his best to comfort and entertain her, even offering to send an envoy to Spain to hear news of Cesare; and when the time came to leave the castle, she wrote to Alfonso to tell him that she had been invited to accompany the marquis to Mantua on her way home to Ferrara. "I have been urged with such passion," she wrote to him, "to go tomorrow to visit the illustrious Marchioness, that, although I resisted strongly, I could not but obey."

She had reason to be grateful for having done so. The Mantuan court possessed an enviable collection of works of art that Isabella was delighted to show her guest, books and jewels, enamels, glass and silver, and paintings not only by Perugino and Lorenzo Costa but also by Andrea Mantegna.

Mantegna, appointed court painter in 1460, had completed work on the Camera degli Sposi in the ducal palace in 1474, a project commissioned by Francesco's grandfather, Marquis Lodovico. For Francesco himself, he had painted the nine huge canvases of the

Triumph of Caesar, which were later bought by King Charles I and are now in the Orangery at Hampton Court. For Isabella, Lucrezia's hostess, he had painted the *Parnassus* in 1497 and, three years later, the *Triumph of Virtue,* both now in the Louvre.

By the time he had finished work on the *Triumph of Virtue,* Mantegna was nearly seventy years old, a grumpy old man, by no means so well off as he thought he ought to be and in constant dispute with his neighbours. He was also in dispute with the illustrious Isabella over an antique bust of the Empress Faustina, which he had offered to sell her for 100 ducats, far less than he thought it was worth. Eventually, after treating the offer with disdainful silence, Isabella agreed to acquire it by settling the old artist's debts up to that amount.

Lucrezia left Mantua at the end of October, having greatly annoyed the heavily pregnant Isabella by having so obviously aroused in her husband the passions and desires he was more in the habit of feeling for his wife's maids-of-honour. Travelling in Francesco's ceremonial barge, she arrived at Belriguardo, where she was greeted by Alfonso and by Giulio, his banishment rescinded by his indulgent half-brother.

A few days later, Giulio was returning to Belriguardo from a hunting expedition, riding along the road toward the villa, when he was met by a furiously jealous Cardinal Ippolito d'Este; he had been spurned, yet again, by the pretty Angela Borgia, who had scornfully told the cardinal that his brother's liquid brown eyes were worth more to her than "the whole of your person." In an excess of rage, Ippolito now shouted orders to his four footmen to kill the man and put out his eyes, those eyes that Angela had told him she so extravagantly admired. Ippolito's footmen obediently

pulled Giulio from his saddle to the ground, where they stabbed at his eyes with their daggers until his face was covered with blood and his eyelids almost severed.

Ippolito rode back to Belriguardo with the news that he had found Giulio lying on the ground and wounded; the footmen fled abroad. Men were sent out to carry him back to the villa, and urgent summons were sent to surgeons at Ferrara. Giulio seemed to be on the point of death or, at least, blinded for life.

Cardinal Ippolito at first denied all responsibility for the incident; then he claimed that the four footmen were "formerly in our household." Alfonso, reluctant to have his own brother arraigned on a charge of murder, took care that this version of the events was sent to every court in Italy, where it soon became the subject of gossip. In a private letter to Isabella, however, Alfonso confessed the terrible truth, begging his sister not to reveal the true details of "this shameful act"; Isabella replied that it was too late, that every barber in the marketplace knew what had really happened. Like Alfonso, she was also shocked; when Ippolito himself fled to Mantua hoping to find refuge at his sister's court, she was so horrified by what he had done that he was soon forced to leave.

Eventually, when Giulio had partially recovered his sight, Ippolito was admitted back into Ferrara, where he was induced to make a guarded apology; and that, Alfonso hoped, would be the end of the matter. But Giulio, still in great pain and finding comfort only in darkened rooms, remained bitterly resentful, not only of the cardinal but also of Duke Alfonso, whom he blamed for not charging Ippolito with his crime.

The duke and duchess returned to Ferrara, as was the custom, to celebrate Christmas, New Year, and Carnival in the ducal capi-

tal. Lucrezia clearly enjoyed herself, joining in the dancing, relishing the saucy comedies that she asked to be performed at the ducal theatre during Carnival, when she became a familiar figure in the streets, through which she rode wearing a mask, sometimes in a white dress, at other times gold. She did what she could to comfort Giulio, endeavouring to find him a profitable appointment with the Knights of Malta. She also went out of her way to help the tiresome, importunate Angela Borgia, who had discarded the no longer handsome Giulio without, apparently, a second thought and had recently been betrothed to the young Alessandro Pio and now badgered Lucrezia for help in purchasing an extravagant trousseau, including an extremely expensive dress of cloth-of-gold.

While the court laughed and joked and danced, Giulio remained in his darkened room, his resentment growing as he listened to the revelries outside on the city streets. He had begun to recover his sight; at first murky outlines could be seen of faces and objects, but his vision soon cleared. Still in intolerable pain, however, he thought of little other than the revenge he would inflict on Ippolito and Alfonso. He was joined by his half-brother Ferrante, his companion in the carefree exploits of earlier days, who had hopes of usurping Alfonso as Duke of Ferrara. They discussed ways of achieving their aims; they drew others, as incompetent as themselves, into their conspiracy; they discussed methods of poisoning, possible ambushes, traps and snares and disguises. "Something sinister is being planned," Isabella d'Este's friend Bernardino di Prosperi wrote to her at Mantua. "I don't think things will ever be right again between Don Giulio and the Cardinal."

Meanwhile, Cardinal Ippolito's informers had begun to hear rumours of the plotters and their wretched schemes; during the

summer several men, including one of Giulio's servants, were arrested. Giulio himself took advantage of Alfonso's absence from Ferrara on a trip to Venice, to escape to the security offered by Isabella in Mantua. When the duke came home in early July, he ordered his half-brother to return home. Giulio refused, claiming that his life was in danger in Ferrara. In an attempt to mediate between the brothers, Francesco Gonzaga formally requested Alfonso to guarantee Giulio's safety. Alfonso replied that he promised to stand surety for Ippolito's actions but warned Giulio that he could not protect him from the law if he was to be found guilty of treason.

Finally it was Ferrante who betrayed the conspirators and told of Giulio's involvement in the affair. Alfonso was appalled at the realization that his own brothers were plotting his assassination. Ferrante was arrested, along with the other plotters, with the exception of Giulio, who preferred to remain in Mantua under the protection of Francesco and Isabella.

The trial opened on August 3; and a month later all were found guilty and condemned to death by execution. Alfonso, however, had been fond of his brothers and decided to reprieve them, sentencing the two young men instead to life imprisonment in the castle dungeons. For Ferrante, life imprisonment entailed captivity for forty-three years until his death; for Giulio, fifty-three years, until he was released by his great-nephew, Lucrezia's grandson Duke Alfonso II.

At the end of November 1506, after a year that had seen her husband suffer so much anguish, Lucrezia brought him news that gladdened both their hearts; she was pregnant again and would, God willing, bear this child. At the same time welcome news arrived from Spain: Cesare had escaped from prison and was on his way to

the safety of the court of his brother-in-law, who was now king of Navarre. Lucrezia awaited eagerly to hear what he would do next; she herself was prepared to do all she could to help him.

Her gaiety was plain for all to see that year during Carnival in 1507, when Francesco Gonzaga, now captain-general of the papal forces, came to Ferrara to discuss future operations with Duke Alfonso, who, by now quite unconcerned by his wife's obvious attraction to this man, raised no objection to the attentions that she and Gonzaga paid to each other, to the time they spent in each other's company, to their dancing together at ball after ball. Abandoned yet graceful, she threw herself energetically into the excitement of the palace dances until she had to take yet again to her bed.

All the excitement had proved too much for Lucrezia, who, in the middle of January, suffered yet another miscarriage. Alfonso despaired and chided his wife for her lack of proper care for her condition; too much dancing, he remonstrated, and too much revelry. She also had to endure the news, which arrived a few weeks later, that Isabella had given birth to her third son, whom she named Ferrante, in honour of her brother, languishing a prisoner in the castle dungeons.

~ Chapter 27 ~

The End
of the Affair

"The harder I try to please God,
the harder he tries me"

ONCE SHE HAD RECOVERED from her miscarriage, Lucrezia took up with a reforming friar in the tradition of Savonarola who proposed, among many other penances, a tariff of "fines to curb profanities"—1 ducat for taking the name of a saint in vain, for example, or 2 ducats for an oath involving Our Lord or the Virgin Mary. This was too much for the good citizens of Ferrara, who proposed invoking the help of Duchess Lucrezia by sending a deputation asking her to propose to the friar that, rather than urging the punishment of blasphemers and the forsaking of cosmetics and décolletages, he should preach against more heinous sins. Lucrezia undertook to speak to him but seems to have contented herself by remonstrating with her ladies about their often scandalous behaviour.

Then, on April 22, 1507, an unexpected visitor arrived in Ferrara with dreadful news. It was one of Cesare's squires, who had travelled from Navarre to tell Lucrezia that her brother was dead, killed in battle, as Cesare had always suspected he would be, some six weeks earlier, fighting for the king of Navarre. "The harder I try to please God, the harder he tries me," wept Lucrezia when she heard. In reply to a letter from her husband, who was in Genoa with Louis XII and had penned a hasty note to her commiserating with her loss, she wrote that she hoped he could "return home as soon as possible, which is what I wish with all my heart." She then, in her grief, took to her bed; indeed, she was not seen in public for so long that rumours abounded that she was pregnant again.

By the summer, however, she had recovered enough to renew her affair with Francesco Gonzaga, who she knew was deeply attracted to her and with whom she was in love. This was a dangerous liaison and became even more so when Ercole Strozzi—who had acted as go-between when Lucrezia was entangled with Pietro Bembo—and Ercole's brother Guido Strozzi, who lived in Mantua, now became carriers of letters between the marquis and Lucrezia.

Their correspondence was interrupted at the end of 1507 when Lucrezia again became pregnant. On this occasion she was far from being so nervous as she had been during previous pregnancies. Indeed, she entered enthusiastically into discussion about the design of the baby's elaborate cradle and its clothes and the interviewing of would-be wet nurses. She relished the sweetmeats that were sent to her from Spain by her sister-in-law as well as the almond pastries filled with honey and nougat that she ate in the steaming water of her bath or while playing idly with her countless pearls.

And during Carnival at the beginning of 1508, it was noted, with relief, that Lucrezia was finally heeding the advice of her doctors, and the urgent entreaties of her husband, and was avoiding the excesses in which she had indulged in previous years, even to the extent of forgoing her pleasure in dancing. There was, however, plenty for her to enjoy: watching the jousts and the other displays of horsemanship; enjoying the daring feats of the tightrope walkers and acrobats; laughing at the ribald comedies performed in the theatre; and listening to the new songs she had commissioned specially for Carnival, which were performed, along with some of her old favourites, by the court musicians.

On April 3 Duke Alfonso had to leave his heavily pregnant wife for a few days to go to Venice on urgent business, no doubt optimistic that this pregnancy would end more satisfactorily than its predecessors. So he was absent when, the next day, Lucrezia gave birth to a boy, which, all who saw the baby agreed, appeared to be perfectly healthy; and he was named Ercole after his paternal grandfather.

The birth of an heir was greeted with great excitement and joy in Ferrara; the church bells rang out across the city; guns were fired; fireworks lit the skies. In their enthusiasm for celebrations, according to a local chronicler, the populace made bonfires of

all the screens in the market place and elsewhere and all the benches of the notaries and the table of the judges from the Palazzo della Ragione, as well as all its windows and doors, and they also burnt the ladies' pews from the cathedral and the other large churches, and all the benches, tables, stools and

doors in the public schools at San Domenico and San Francesco, and the celebrations went on for three nights.

Ercole was christened in the chapel of the ducal palace soon after his birth. "He was not baptized in public," reported the chronicler, "and it is not known who held him at the font," though he did know the identity of the wet nurse employed to feed him, who was the daughter of a carpenter in the city. Nor is there any evidence that the apparently hasty and private christening betokened any infirmity on the part of the baby. Indeed, once Duke Alfonso returned from Venice a few days later, he proudly displayed his little heir to the ambassadors and other dignitaries, who were asked to examine little Ercole lying naked on his back, less handsome than he had first been reported but evidently "complete."

Alfonso announced the birth of his heir in jubilant letters dispatched to courts throughout Italy and beyond. The duke had informed his brother-in-law Francesco Gonzaga in a letter sent before he left Venice, and the marquis returned this gesture of friendship by sending his own secretary to Ferrara to offer congratulations on his behalf. Lucrezia, following the conventions of the period, sent her news to Isabella d'Este. Aware that the friendship between his wife and his brother-in-law was causing food for gossips at court, Alfonso was determined that Lucrezia should behave in the usual formal manner and forbade her to communicate the news to the marquis; Lucrezia had been furious and made it quite plain that she was so. Could it be, the question was inevitably asked, that the baby was not the child of Alfonso d'Este, Duke of Ferrara, but of Francesco Gonzaga, Marquis of Mantua,

a man whom Alfonso much disliked? Certainly the baby's nose looked rather squashed as does Francesco Gonzaga's in Mantegna's *Madonna della Vittoria*. Certainly, also, Lucrezia, now that her baby was born, continued to urge Gonzaga to come to Ferrara to see her.

When Isabella's informant Bernardino di Prosperi saw the baby, he also pronounced the heir to be handsome and lively. He was also full of praise for the cradle that Lucrezia had commissioned, a classically inspired structure, all gilded, with coverlets of cloth-of-gold and fine cambric sheets, which had been beautifully embroidered: "of such splendour," he thought, "that I do not have words to describe it."

On April 12, just over a week after Ercole's birth, Duke Alfonso departed once again on business, this time to France, leaving Lucrezia alone once more and hopeful that Francesco Gonzaga would pay her a visit. "You would be more dear to her than 25,000 ducats and more, if you were to come," Ercole Strozzi assured the marquis. Every day, he said, we talk of you. "I cannot describe the passion which has overwhelmed her," he wrote; "she is most anxious to hear why you have not answered her letters."

No reply came to this letter. It may well have been that Francesco Gonzaga was concerned by what might happen to him if he were to go to Ferrara to see Lucrezia. He had recently been troubled by a man purporting to represent her who had arrived at Mantua with the suggestion that he might go to Ferrara to see her in secret. Gonzaga suspected a trap and paid no attention to this suggestion, whereupon the man offered him a miniature of Lucrezia that Gonzaga declined.

Meanwhile, still no word for Lucrezia came from Mantua. Strozzi's letters on her behalf became almost desperate. "She loves you passionately, much more than you can imagine. If you knew this you would be much more ardent in your letters and much more anxious to come to see her wherever she was. Do at least give her some sign of loving her. She asks for nothing more. . . . Do make every effort to come to her. In any case write to her and don't appear so cold."

Still Francesco Gonzaga did not respond; and it seemed that his caution was well justified. On June 5 Lucrezia had written to him with the news that the Spanish priest who had helped Cesare escape from prison and who had joined her household in Ferrara had been found "treacherously murdered"; that very night Ercole Strozzi also was killed. The chronicler Giovanni Maria Zerbinati reported the death of this "most distinguished poet," who, he said, "was found dead outside the church of San Francesco, in the middle of the street by the picture of the Virgin that is on the pilaster attached to the wall of the church"; the body was found to have received "twenty-two stab wounds and his throat was cut and no one knows who killed him," though many in Ferrara and Mantua had their suspicions that Cardinal Ippolito, or even Duke Alfonso, had a hand in the crime.

Lucrezia now had to find a new messenger for her letters to Gonzaga; and she found one in Ercole Strozzi's brother. "Lorenzo Strozzi is coming to Mantua," she wrote to Gonzaga. "He is as devoted a servant as was Ercole, his brother."

But Gonzaga had no intention of going to see Lucrezia. He wrote to say that he was ill, too ill to travel. She pleaded with him;

he was still too ill. In that case, she said, she would come to look after him; and she was on the point of joining him when her husband and Cardinal Ippolito heard of her intentions and took her back to Ferrara.

As had been the case with Pietro Bembo, their ardour cooled to affection and the two remained on friendly terms, corresponding regularly for the rest of their lives. Meanwhile, Lucrezia mournfully resumed her life in Ferrara, once again the dutiful wife and consort, and now, with age, less the happy, lively, young woman she had once been, who had rejoiced in wearing those extravagant hats she had designed for herself and her ladies to attend Mass in the cathedral.

On April 26, 1509, news arrived in Ferrara that Duke Alfonso had been given the post of captain-general of the church by Julius II, much to the fury of his brother-in-law Francesco Gonzaga, but to the joy of his subjects, who greeted the announcement with the customary peals of bells, thunder of artillery, and flashing fireworks. This appointment was particularly important in the light of the fact that the pope had recently arranged an alliance to curb the growing power of Venice, declaring that he would join forces with anyone in order to reduce the city once more "to a little fishing village"—and, indeed, he had been joined by most of the ruling heads of Europe: Emperor Maximilian, Louis XII of France, Ferdinand of Spain, and most of the Italian powers, including both Mantua and Ferrara.

Duke Alfonso was to be absent from Ferrara for a considerable part of the next three years, first leading Julius II's armies against Venice, which was resoundingly defeated in May 1509 at the Battle of Agnadello; when Julius II abruptly changed sides the following

year, to ally himself with Venice and to launch an attack on the French forces in Italy, in order to drive the "barbarians" back beyond the Alps, Alfonso remained loyal to Louis XII, and the pope used this as the excuse he needed to excommunicate the duke and deprive him of his fief before moving north, leading his armies in person, to attack the duchy of Ferrara.

"Having been unable to separate the Duke of Ferrara from his loyalty to the French King," wrote Guicciardini, "the Pope had made every effort to occupy the duchy, pretending that he had done so on account of a dispute over the taxes and tolls on salt." For Alfonso, the autumn of 1510 was exceptionally busy as he strengthened his fortifications, something about which he knew a great deal. Nevertheless, Modena soon fell to the papal forces, and they now marched on to lay siege to Alfonso's strategic fortress of Mirandola, which had been garrisoned with the help of French soldiers.

Julius II had already proved himself a formidable opponent on the battlefield when, in 1506, having dismembered Cesare's empire, he had turned his attention to Bologna, conquering the city and removing Giovanni Bentivoglio from power. He returned to Rome in triumph. The Venetian envoy thought that never had any emperor or victorious general received so remarkable a welcome. A few thoughtful men, however, regretted that the Vicar of Christ should resemble more the Lion of Judah than the Lamb of God. The Dutch scholar Erasmus, himself ordained a priest, wrote ironically of Julius II's entry into Bologna as though in the pope's own words: "Ah, would to God you had seen me borne aloft into Bologna! The horses and chariots, the marching battalions, the galloping commanders, the flaming torches, the pretty page boys, the pomp of bishops and glory of cardinals . . . and I borne aloft, head

and author of all!" His satirical attack on Julius II was vicious: "Your name suits you perfectly," he wrote, likening the pope to Julius Caesar. "You unjustly seized tyrannical power, despising and ignoring the gods, and plunging your country into war"; the only difference Erasmus could see was that Julius II was of common stock.

In January 1511 Julius II arrived at Mirandola to oversee in person the siege of the castle; he took up lodgings, according to Guicciardini, "in a farmer's hovel where he was within range of the enemy artillery." He went about the camp in the bitter cold and driving snow, his armour concealed by a white cloak, his head in a sheepskin hood, cursing his enemies, moving his quarters when they were hit by cannonballs, and shouting orders to his captains, his energy and enthusiasm "not chilled in the slightest degree," added the historian, "by the bitter cold which his troops were scarcely able to endure."

Inspired by his restless energy, his men breached the walls of Mirandola, their task much eased by the icy cold that had caused the water in the moat to freeze deep enough to bear the weight of the papal troops. With no chance of relief, the castle surrendered. This fresh victory encouraged other cities to join the pope. Spain came to his aid against the French, who were Duke Alfonso's principal allies, while both Parma and Piacenza, abandoned by the French, declared themselves willing to join the Papal States. Julius II annexed them immediately, announcing that he hated the Spanish quite as much as the French, and that he would not rest until they had been driven out of the peninsula too.

Ferrara, however, was to prove a harder proposition for the bellicose pope. On November 28, 1510, the French army arrived at

Ferrara to help the defence of the city. Two days later, the duke, in the presence of the French captains, had addressed the "courtiers, citizens and artisans" who had gathered early in the evening in the town hall to hear their duke speak. The chronicler Zerbinati takes up the story:

> He told the people how he was expecting the Pope's army to arrive soon and asked the people to remain as faithful to him as they always had been to the house of Este, and he promised the people that he would not abandon them, as he had been abandoned by everyone except by the French, and that if they stayed faithful to him he was sure of victory because the city was strong, that they would fortify it and that we were well supplied with artillery and with food and with a large population; then he repeated that if the people kept their trust in him then he had no doubts at all. . . . Messer Antonio Costabili replied wisely that his people had always been most faithful to the house of Este, and for the future and for the present they would always be so, and that he was not to worry about this because the people were ready and prepared to fight against his enemies and everyone started to shout: Duke Alfonso! Duke Alfonso! And so His Lordship and the French captains left the room well satisfied with the populace who now prepared for the arrival of the enemy army in Ferrara.

The following day Duke Alfonso had published a decree ordering all warehouses and shops to close for the week and for everyone to work instead on fortifying the city. And then they waited for the enemy to arrive, going about their business as normally as possible

while the winter months passed and Julius II's forces fought relentlessly for the possession of Mirandola, knowing that once that fortress had fallen, it would be their turn next.

On Maundy Thursday, April 17, the chaplains of the cathedral held the customary confirmation service behind closed doors, "which they did, not having permission from the Pope to do because of the excommunication," reported the chronicler Zerbinati, who added in the margin of his notebook that "I was told about this, because I was not there."

The winter of 1511 had been unusually long and hard, "the greatest cold, the thickest ice and the heaviest snow that I have ever seen," commented Zerbinati, adding that "the winter has lasted for so long that today, the last day of April, we are still lighting our fires and we are still wearing our fur-lined coats." Three weeks later, however, came news that warmed the hearts of the brave populace: the Bolognese had rebelled against Julius II, and the Bentivoglio were once again in power. The celebrations that night were exceptionally loud—bells, fireworks, cannonades, shouting, songs, youths roistering on the streets brandishing branches of trees on which blossoms had begun to bloom—to rejoice at the defeat of the mighty papal army "which has threatened us all the past winter." The next day "all the shops were closed, as if it were a Sunday."

Throughout these difficult years while Alfonso had been frequently absent, fighting first for Julius II and then against him, it was Lucrezia, his duchess, who took his place as ruler of the city, writing regular letters to him, sometimes as many as three a day, reporting the news from the marketplace, the gossip at court, planning policy, and asking his advice. She had pawned her jewels to raise money for her husband and also managed, in what must have

been exceptionally difficult circumstances, to preside over their court, acting as a gracious hostess to the many French nobles who had come to Ferrara with the French army and were quartered in the ducal palace or in the residences of the courtiers. "She is a pearl," one Frenchman remarked; "there has never been such a wonderful duchess," he extolled, praising Lucrezia's beauty and benevolence, her kindness and charm, and, he added, "a great service to her husband."

~ Chapter 28 ~

The Death of the Duchess

"OTHER WOMEN ARE TO LUCREZIA
AS TIN IS TO SILVER, COPPER TO GOLD"

NOW THAT THE ANXIETY and worry of the much-feared papal invasion was over, Lucrezia, as so often happens on such occasions, fell ill and retired to the convent of San Bernardino to recover, which she did, after some months of convalescence, and of mourning for the death of the twelve-year-old Rodrigo Bisceglie, her first son, whom she had not seen since he was a toddler when she left Rome for the last time. She did, however, have the comfort of knowing that her other son Juan, the result of her affair with the papal valet Pedro Calderon, was safe and well. Since 1505 he had been living in nearby Carpi and was frequently a visitor in Ferrara, where, thanks to her father's bull "explaining" the parentage of the boy, he was always assumed to be her half-brother.

In August 1509, at the start of the conflict with Julius II and just sixteen months after the birth of Ercole, Lucrezia had given birth

to another healthy son, named Ippolito in honour of Alfonso's brother, the cardinal. During the troubled years that followed, she had taken refuge with her young sons, spending long hours playing games with them, taking part in masquerades, telling them fairy stories, listening with them to strange surreal tales told by her dwarf, Santino, who sat perched upon a chair placed upon a table like a miniature stylite. On occasions the children's father would look in on the scene with an indulgent eye, no longer jealous of such threats to the composure of his marriage as Francesco Gonzaga and Pietro Bembo.

Julius II's threat to Ferrara finally ended on April 11, 1512, when his armies were decisively defeated by the French at the Battle of Ravenna. Duke Alfonso's knowledge of artillery had played an important part in the victory, which had been fought at the cost of ten thousand lives, including that of Cesare's erstwhile captain, Yves d'Alègre. And a year later, toward the end of January 1513, Julius II, complaining of being suddenly taken ill, took, uncharacteristically, to his bed. By the end of the week, feeling that the end was near, he summoned his master of ceremonies to dictate detailed instructions for his funeral; and on February 21 he died.

Age never mellowed Julius; to the end he was a *papa terríbile*. As a sick old man, he still spoke of waging a war to drive the Spanish out of Italy. He was, indeed, a great patriot and, unlike so many of his contemporaries, he thought of Italy not as a mere collection of rival states but as an entity of its own. Yet, however much the warrior pope he may have been, Julius II was also one of the most enlightened and discriminating patrons of art that the Western world had ever known. He had much of the Vatican Palace reconstructed and rebuilt the main courtyard as well as the immense courtyard

that stretches from the palace toward the Belvedere. Beneath its walls he laid out an extensive and lovely garden, the first great Roman pleasure garden since the days of the Caesars.

Julius II hired artists as if recruiting an army—including most of the great living masters of the Italian Renaissance. One of these was Raphael, who worked for the pope on the decoration of the new official quarters of the palace, the Vatican Stanze; another was Bramante, who undertook to rebuild the ancient and venerated Basilica of St. Peter's, clearing the site of the decaying medieval structure with such eagerness that he became known as "*maestro Ruinante,*" master Ruiner. He also hired the Florentine artist Michelangelo to paint the memorable frescoes on the ceiling of the Sistine Chapel and to cast an enormous statue of the pope— fourteen feet high and weighing six tons—which was set up on the facade of the cathedral in Bologna and then torn down by the mob after the city rebelled against Julius II's rule. The ruined statue was given to Duke Alfonso, who melted it down and made it into a cannon, which he wittily named La Giulia.

He had been a great champion of the Church and of its capital city. The Romans, recognizing this, were deeply grateful. When he died in 1513, people wept in the streets and, according to Francesco Guicciardini, they "thronged to kiss his feet and gaze upon his dead face, for all knew him to be a true Roman pontiff." Although "full of fury and extravagant conceptions," Guicciardini concluded, "he was lamented above all his predecessors and . . . is held in illustrious remembrance."

A few days later, twenty-five cardinals assembled in Rome for the conclave that was to elect his successor. Less than a week later, Cardinal Giovanni de' Medici, the son of Lorenzo il Magnifico and

Alfonso's prisoner after the Battle of Ravenna, was elected pope as Leo X, and Pietro Bembo, once Lucrezia's lover, was appointed papal secretary.

It was not until the summer of 1513, four years after the birth of her last child, Ippolito, that Lucrezia found herself pregnant once more; but upon this occasion, the baby boy to whom she gave birth was far from being as handsome as Ippolito and Ercole. Despite being named Alessandro after her beloved father, it clearly pained Lucrezia to look upon the child with its strangely large and misshapen head, and she was relieved rather than distressed when he gave up the struggle to live, aged just two years old.

Meanwhile, in July 1515, when Alessandro was just fifteen months old, Lucrezia had given birth yet again, this time to a daughter, named Eleonora after Alfonso's mother. By the time Alessandro died, she was pregnant again with Francesco, who was born in November 1516 and, perhaps, as the name chosen had featured in neither her own family nor that of Alfonso's, the baby was named after its uncle Francesco Gonzaga; but, anyway, it was a pretty baby whom she clearly adored.

So, with no little pleasure, Alfonso found himself the father of a number of children—all his legitimate heirs. He was engrossed in his own affairs; but, nevertheless, he was highly satisfied with the esteem and admiration now bestowed on his wife. The admiration she excited in former years was due to her youthful beauty; it was not owing to her virtues. She, who as a young girl had been the most vilified woman of her times, had, in middle age, won a place of the highest honour.

The ducal couple, now clearly at ease in each other's company, shared an interest in all the arts, not solely music, and as the patron

of artists and poets that all Renaissance princes were expected to be, Alfonso relied upon the taste and discernment of his wife to guide him. It was she who persuaded him to take into his service the poet Ludovico Ariosto, who, in return, praised Lucrezia with wild hyperbole in his *Orlando Furioso:* "Other women are to Lucrezia as tin is to silver, copper to gold . . . coloured glass to precious stones."

It was evidently Ariosto who introduced Titian to the court at Ferrara. At this time Titian was about twenty-five years old. The son of a minor official, he was born in the village of Pieve di Cadore north of Venice, and at the age of nine, he had gone with his brother to live with an uncle in Venice, where he became an apprentice to a mosaicist before moving to the workshop of the elderly Giovanni Bellini, the most celebrated Venetian painter of his day. Also working in Bellini's studio at that time was Giorgione, an artist some ten years older than himself, with whom he worked on the frescoes of the Fondaco dei Tedeschi, the great storehouse of the German merchants close to the Rialto Bridge in Venice.

Having moved to Ferrara to work for Alfonso d'Este, apparently at Lucrezia's instigation, Titian worked on a cycle of mythological compositions for the Camerino d'Alabastro, a room that had recently been rebuilt in the castle at Ferrara and where Alfonso proposed to display his collection. He had bought Giovanni Bellini's canvas of the *Feast of the Gods* in 1514 and, four years later, commissioned Titian to paint two companion pieces, the *Worship of Venus* (now in the Prado at Madrid) and *Bacchus and Ariadne* (now in the National Gallery in London).

These masterpieces were but three of the magnificent works of art to be seen in Ferrara. The tapestries hanging on the walls of the

ducal palace were renowned; so was the cycle of frescoes, mostly by Cosmè Tura, in the Palazzo Schifanoia in Ferrara and the *Annunciation* on the organ doors in the cathedral; so, too, was the magnificent gold and silver dolphin service designed by Cosmè Tura. Both the works and the company of these artists clearly delighted Lucrezia, as did the company of her lively ladies, who accompanied her on her expeditions to other ducal villas in the countryside outside Ferrara.

She was accustomed to leaving Ferrara each spring, with her ladies and her musicians, to spend weeks on end in the country, choosing to stay in a villa near a convent where she could be a regular worshipper at the services held there. At the villa there would be games of charades, songs, and stories, or, on occasion, the company would be entertained by tales related by Santino, the dwarf, or the wild fantasies and strange behaviour of the mad girl Catarina, whom Lucrezia had done her best to educate. And on warm sunny days, Lucrezia would bathe in the clear waters of some secluded reach of the Po.

Yet in quieter moments, an aura of sadness surrounded Lucrezia, who had taken to wearing sackcloth beneath her silk dresses and had joined a lay order of the Franciscans. Her only surviving brother, Jofrè, died in 1517, having remarried after the death of the childless Sancia in 1506, and was able to pass the title of Prince of Squillace on to his eldest son. She took to making regular confessions to her priest and was just as assiduous in attendance at services in the cathedral. She put aside the "pomp and vanities of the world to which she had been accustomed since childhood," in the words of Paolo Giovio, "and gave herself up to pious works, founding

convents and hospitals. She did what she could to help the poor in times of distress, going so far as to pawn some of her jewels to help pay for their relief."

She was now far from well; the succession of pregnancies and births, some difficult and all debilitating, had weakened her sadly. She had little appetite and fainted often. There were still evenings, however, when Lucrezia would call for her musicians, singers, and dancers, and then Alfonso would appear with his viol, which he played with a virtuosity that astonished those who knew him only as a hardworking ruler and a general devoted to his artillery. Yet her husband, in his insensitivity, still made love to her in his rough, perfunctory way, and in the autumn of 1518, she found she was pregnant once again.

In November that year news arrived in Ferrara of the death of her mother, Vannozza de' Catanei, who, unlike Lucrezia, had always been spoken of with respect, in Rome on November 16, 1518. As well as her three inns in Rome and various other properties, Vannozza left several flocks of sheep beyond the city's outskirts, all of which were bequeathed to various religious and charitable institutions in the city. The Venetian envoy Marin Sanudo wrote in his diary:

The day before yesterday died Madonna Vanozza, once the mistress of Pope Alexander and mother of the Duchess of Ferrara and the Duke Valentino. . . . The death was announced, according to the Roman custom, in the following formal words: "Messer Paolo gives notice of the death of Madonna Vanozza, mother of the Duke of Gandía; she belonged to the Gonfalone Company." She was buried yesterday

in Santa Maria del Popolo, with the greatest honours—almost like a cardinal. She was 76 years of age. She left all her property—which was considerable—to San Giovanni in Laterano. The Pope's chamberlain attended the obsequies, which was unusual.

As Lucrezia's pregnancy progressed, she no longer felt the inclination to bathe; at the age of thirty-nine, she felt herself to be growing too old for bearing children. On March 24 Francesco Gonzaga died; the following month she was not well enough to watch her nine-year-old son, Ippolito, be confirmed and be installed as archbishop of Milan, one of the premier sees in Europe. Soon afterward she complained that her head had grown too heavy for her. Her hair was then cut off and swept up on the floor. She felt, she said, that she was going blind.

On June 15 she gave birth prematurely to another girl, who was baptized Isabella Maria that same day, and this time the chronicler had no doubt that the child was sickly. Lucrezia herself contracted puerperal fever, and, pale and drawn, she took to her bed and thereafter rarely left it. Knowing that she had not long to live, she wrote a letter to Leo X:

Most Holy Father and Honoured Master, with all respect I kiss your Holiness's feet and commend myself in all humility to your holy mercy. I approach the end of my life with pleasure, knowing that in a few hours I may . . . be released. Having arrived at this moment, I desire, as a Christian, although I am a sinner, to ask your Holiness in your mercy, to give me all possible consolation and your Holiness's blessing for my

soul. . . . 22 June 1519 at Ferrara, in the fourteenth hour, your Holiness's humble servant.

She died two days later, on June 24, 1519. Duke Alfonso lost consciousness during her funeral in the Church of Corpus Domini. Devastated with grief, he wrote to his nephew, now Marquis of Mantua, that "it has pleased our Lord God to call to Himself the soul of our most illustrious Duchess, our well beloved wife," and "I cannot write these lines without weeping[,] so hard is it to find myself separated from such a dear wife."

~ Chapter 29 ~

Saints and Sinners

ACCORDING TO THE standards of the time, Lucrezia had done her duty as Duchess of Ferrara, leaving her grieving husband with five children, three of whom were boys. Alfonso mourned his loss but in the end took another wife, choosing, much to the surprise of his courtiers, to marry his mistress, Laura Dianti, the lascivious daughter of a Ferrarese bonnet maker, who produced two more sons for him.

When Alfonso died on October 31, 1534, he was buried in a tomb next to his beloved Lucrezia in Corpus Domini and was succeeded by Ercole, for whom he had chosen as a bride Renée of France, the daughter of Louis XII and sister-in-law of the new king of France, Francis I. Ercole II recognized six children, two boys and four girls—two of his daughters, one illegitimate and one legitimate, were named Lucrezia, a testament to the love he bore her. Ippolito,

destined from an early age for a career in the church, would be made a cardinal and be the French candidate for election in six conclaves. Renowned for his extravagant lifestyle and his patronage of the arts, he would spend much of his life in Rome, the city of Lucrezia's birth, and be the patron of that splendid monument to Renaissance architecture and garden design, the Villa d'Este at Tivoli.

The baby Isabella, whose birth had killed Lucrezia, died just short of her second birthday, leaving Eleonora as the only surviving daughter; she became a nun at the age of eight and, ten years later, was made abbess of Corpus Domini, Lucrezia's favourite retreat in times of trouble and the site of her tomb. Of the palace where Alfonso and Lucrezia lived, sadly little remains after the building was devastated by an earthquake in 1570.

When Ercole II died in 1559, he was succeeded by his eldest son, Alfonso II, who, despite his three wives, proved unable to produce an heir, a misfortune that became a useful pretext for Pope Clement VIII to succeed, where Julius II had failed, in restoring Ferrara to the Papal States, leaving Alfonso II's illegitimate nephew, Cesare, as duke only of Modena.

Alexander VI had been extraordinarily ambitious for his children; yet, in the end, few traces of the Borgia name appear in the annals that trace the history of the illustrious families of Rome.

Cesare left three children: Louise, his legitimate daughter by Charlotte d'Albret, married into the upper echelons of the French aristocracy, and her descendants are still alive today. Little is known of his many illegitimate offspring; one daughter, Camilla, was brought up by Lucrezia in Ferrara, and, like her cousin Eleonora,

she became a nun, choosing to be known as Sister Lucrezia in honour of her aunt and later becoming abbess of San Bernardino.

Jofrè's descendants ruled as princes of Squillace to the end of the sixteenth century, when the title passed to the Borgia family in Spain, the descendants of Alexander VI's favourite son, Juan, the second Duke of Gandía. His wife, Maria Enriquez, produced a son, another Juan, the third Duke of Gandía, and a daughter, Isabella, who, like her cousins in Ferrara, preferred the convent to the matrimonial bed. Juan III of Gandía produced seventeen children, the eldest of whom, Francisco, inherited the title only to abdicate several years later in 1546 in favour of his son, after the death of his wife, to become a Jesuit and then the order's third general.

Francisco was in Ferrara in May 1572 when news reached him of the death of Pius V, and of the hopes of many influential people in the church that he should be elected as Pius V's successor. He was too weak to travel but did return to Rome later that year and died two days later. In one of those curious accidents of which history is so fond, Alexander VI's great-grandson would be canonized in 1671.

~ Suggested Further Reading ~

Primary Sources

Ariosto, Ludovico. *Orlando Furioso.* Translated by B. Reynolds. Harmondsworth, UK: Penguin Books, 1975.

Burchard, Johannes. *At the Court of the Borgia,* excerpts from the *Diarium.* Edited and translated by Geoffrey Parker. London: Folio Society, 1963.

———. *Le journal de Jean Burchard.* Paris: Les Éditions Rieder, 1932.

Castiglione, Baldassare. *The Book of the Courtier.* Translated by George Bull. Harmondsworth, UK: Penguin Books, 1976.

Cellini, Benvenuto. *Autobiography.* Translated by George Bull. Harmondsworth, UK: Penguin Books, 1956.

Giustinian, Antonio. *Dispacci di Antonio Giustinian.* Edited by P. Villari. 3 vols. Florence: Successori Le Monnier, 1876.

Guicciardini, Francesco. *The History of Florence.* Edited by Mario Domandi. New York: Harper & Row, 1970.

———. *The History of Italy.* Edited by Sidney Alexander. New York: Collier Books, 1969.

Landucci, Luca. *Diario Fiorentino.* Florence: Sansoni Editore, 1985.

Machiavelli, Niccolò. *Florentine Histories.* Translated by Laura F. Banfield and Harvey C. Mansfield Jr. Princeton, NJ: Princeton University Press, 1988.

———. *Legazioni, commissarie e scritti di governo.* Edited by F. Chiapelli. 4 vols. Bari: G. Laterza, 1971.

———. *The Prince.* Translated by George Bull. Harmondsworth, UK: Penguin Books, 1961.

Michelangelo Buonarroti. *Lettere.* Edited by Enzo Girardi. Arezzo: Ente Provinciale per il Turismo, 1976.

———. *The Sonnets of Michelangelo.* Translated by E. Jennings. London: Folio Society, 1961.

Piccolomini, Aeneas Sylvius. *Secret Memoirs of a Renaissance Pope.* Abridged ed. Edited by F. A. Gragg and L. C. Gabel. London: Folio Society, 1988.

Sanudo Marino. *Diarii.* Bologna: Forni Editore, 1969–70.

Vasari, Giorgio. *Le opere di Giorgio Vasari.* Edited by G. Milanesi. 8 vols. Florence: Sansoni Editore, 1981.

Zambotti, Bernardino. *Diario Ferrarese dall'anno 1476 sino al 1504.* Edited by G. Pardi. Bologna: N. Zanichelli, 1928.

Zerbinati, Giovanni Maria. *Croniche di Ferrara.* Ferrara: Deputazione Provinciale Ferrarese di Storia Patria, 1989.

SECONDARY SOURCES

Ady, Julia Mary Cartwright. *Isabella d'Este, Marchioness of Mantua 1474–1539.* London: John Murray, 1904.

Bentini, J., A. Chiappini, G. B. Panatta, and A. M. Visser Travagli. *A Tavola con il Principe.* Exhibition catalogue. Ferrara: Gabriele Corbo Editore, 1988.

Bradford, Sarah. *Cesare Borgia.* London: Phoenix Press, 1976.

———. *Lucrezia Borgia.* London: Viking Books, 2004.

Brown, C. M. "Lo insaciabile desiderio nostro de cose antique: New Documents on Isabella d'Este's Collection of Antiquities." In *Cultural Aspects of the Italian Renaissance: Essays in Honor of Paul Oskar Kristeller,* edited by C. H. Clough, 324–53. Manchester: Manchester University Press, 1976.

D'Amico, John F. *Renaissance Humanism in Papal Rome.* Baltimore: Johns Hopkins University, 1983.

Dean, Trevor, and K. J. P. Lowe, eds. *Marriage in Italy 1300–1650.* Cambridge: Cambridge University Press, 1998.

Eiche, Sabine. "Towards a Study of the 'Famiglia' of the Sforza Court in Pesaro." *Renaissance and Reformation* 9 (1985): 79–103.

Erlanger, Rachel. *Lucrezia Borgia.* London: Michael Joseph, 1979.

Gardner, Edmund G. *Dukes and Poets in Ferrara.* London: Constable, 1904.

Gregorovius, Ferdinand. *Lucretia Borgia According to Original Documents and Correspondence of Her Day.* Translated by J. L. Garner. London: John Murray, 1904.

Guerzoni, Guido. *Le Corti Estensi e la Devoluzione di Ferrara del 1598.* Ferrara: Archivio Storico, 2000.

Gundersheimer, Werner L. *Ferrara: The Style of a Renaissance Despotism.* Princeton, NJ: Princeton University Press, 1973.

Hay, Denys. *The Church in Italy in the Fifteenth Century.* Cambridge: Cambridge University Press, 1977.

Hollingsworth, Mary. *Patronage in Renaissance Italy*. London: John Murray, 1994.

Jardine, Lisa. *Worldly Goods*. London: Macmillan, 1996.

Johnson, Marion. *The Borgias*. London: Macdonald Futura, 1981.

Knecht, R. J. *Renaissance Warrior and Patron: The Reign of Francis I*. Cambridge: Cambridge University Press, 1994.

Krautheimer, Richard. *Rome: Profile of a City, 312–1308*. Princeton, NJ: Princeton University Press, 1980.

Lockwood, Lewis. *Music in Renaissance Ferrara 1400–1500*. Oxford: Oxford University Press, 1984.

Lowe, K. J. P. *Church and Politics in Renaissance Italy*. Cambridge: Cambridge University Press, 1993.

Luzio, Alessandro. "Isabella d'Este e i Borgia." *Archivio storico lombardo* 41–42 (1914–15).

Magnuson, T. *Studies in Roman Quattrocento Architecture*. Stockholm: Almqvist and Wiksell, 1958.

Mallett, Michael. *The Borgias*. London: Bodley Head, 1969.

———. *Mercenaries and Their Masters*. London: Bodley Head, 1974.

Martines, Lauro. *Fire in the City*. Oxford: Oxford University Press, 2006.

Mitchell, Bonner. *The Majesty of the State: Triumphal Progresses of Foreign Sovereigns in Renaissance Italy 1494–1600*. Florence: Leo S. Olschki Editore, 1986.

Partner, Peter. *The Lands of St Peter: The Papal State in the Middle Ages and the Early Renaissance*. London: Eyre Methuen, 1972.

———. *Renaissance Rome 1500–1559*. Berkeley: University of California Press, 1976.

Pastor, Ludwig von. *The History of the Popes from the Close of the Middle Ages*. Vols. 5–6. St. Louis, MO: B. Herder Book Co., 1950.

Schulz, J. "Pinturicchio and the Revival of Antiquity." *Journal of the Warburg and Courtauld Institutes* 25 (1962): 35–55.

Shankland, Hugh. *The Prettiest Love Letters in the World.* London: Collins Harvill, 1987.

Shaw, Christine. *Julius II.* Oxford: Blackwell, 1993.

Sowards, J. K. *The "Julius Exclusus" of Erasmus.* Bloomington: Indiana University Press, 1968.

Stinger, Charles L. *The Renaissance in Rome.* Bloomington: Indiana University Press, 1985.

Strong, Roy. *Feast.* London: Jonathan Cape, 2002.

Thomson, John A. F. *Popes and Princes 1417–1517.* London: George Allen & Unwin, 1980.

Tuohy, Thomas. *Herculean Ferrara.* Cambridge: Cambridge University Press, 1996.

Vancini, Gianna, ed. *Lucrezia Borgia nell'opera di cronisti, letterati e poeti suoi contemporanei alla corte di Ferrara.* Ferrara: Este Editori, 2002.

~ Index ~

d'Alviano, Bartolomeo, 97

d'Amboise, Georges, 122, 127, 131–133, 258, 262, 273

Andrew, St., 23

Angelini, Teodora, 217–218

Anne of Brittany, 116, 119, 122, 131–134

Arezzo, 223, 224–225

Ariosto, Ludovico, 306

d'Aubigny, Lord (Robert Stuart), 180–182

Augustus, 28

d'Auton, Jean, 180

Aversa, 181–182

Avignon popes, 2–5, 7

Baglioni, Gianpaolo, Lord of Perugia, 168, 224, 225, 233–234, 239, 256, 261

Bagolo, Fioramonte, 65

Barbo, Pietro, 26. *see also* Paul II, Pope

Baths of Diocletian, 30

Behaim, Lorenz, 155

Bellini, Giovanni, 306

Bembo, Carlo, 279

Bembo, Pietro, 276, 277–280, 283, 291, 296, 303, 305

Beneimbene, Camillo, 24–25, 30, 45–46

Bentivoglio, Ermes, 234

Bentivoglio, Giovanni, 176, 209, 233, 234, 237, 261, 297, 300

Bessarion, John, 11, 17

Betto di Biagio, Bernardino di (Pinturicchio), 84–85, 86, 90–91

Bichio, Giovanni di, 22

Bisceglie, Rodrigo, 302

Boccaccio, Giovanni, 83–84

Bologna, 7, 144, 175, 222–223, 232, 297–298, 300, 304

Boniface IX, Pope, 5

Boniface XIII, Pope, 155–156

Borgia, Angela, 277–278, 283, 285, 287

Borgia, Cesare, 49–51, 68–72, 105–106, 112–119, 128–138, 140–152, 162–167, 191–196, 198, 199–201, 203–206, 208–209; Alfonso of Aragon and, 159–164; birth of, 30; as cardinal, 50–53, 76–77, 93, 94, 116, 119, 122–124, 135; Carlotta of Aragon and, 122, 133–134, 135, 137; children of, 159, 312–313; death of brother, Juan, 106–110; death of father, 248–250, 255–263; decline of, 268–273, 274–275, 288–289, 295; described, 93, 125, 126–127, 130, 132, 151, 155, 170; as

Duke of Valence, 122–127, 129–133, 142–144, 146, 154, 167, 187, 195, 204; Forlì and, 142–148, 151, 153; France and, 65–66, 76–77, 123–127, 125–127, 137, 140–143, 148, 232–233; friction with father, Alexander VI, 194–196; Golden Rose and, 153–155; as head of papal armies, 115, 153–155, 260–261, 267; horse racing and, 203–204; illness of, 79–80, 115, 125, 129, 155, 192, 245–248, 255–261; Imola and, 142–148, 151, 153; Julius II versus, 266–273, 297; Louis XII of France and, 122–138, 140–142, 164, 182, 212, 232–233, 255–257; Dorotea Malatesta and, 172–174, 185, 207, 209; marries Charlotte d'Albret, 135–138; Milan and, 164–165; military campaigns of 1502–1503, 221–243; mother of, 31, 105; murder and, 117–118, 161–164, 237, 238–240, 242; Naples and, 59, 60, 75–77, 79–80, 165–166, 179–183, 191–193, 232, 271–272; Order of St. Michael, 122, 130, 137, 151, 240; as papal legate, 114–115; Papal States and, 141–143; resignation as cardinal, 123–124; rivalry with Juan Borgia, 96–97; Romagna and, 143–144, 155, 165, 167, 168–178, 185–187, 189, 222, 234–235, 253, 259–261, 266–269, 271–272; Sancia of Aragon and, 95–97, 119; Caterina Sforza-Riario and, 146–148; uprising of captains, 234–235, 238–239; as il Valentino, 124; wealth of, 59, 242–243

Borgia, Francisco, 41, 167, 205

Borgia, Gerolama, 31

Borgia, Isabella, 31

Borgia, Jofrè, 139, 150, 258; birth of, 30; children of, 313; death of, 307; described, 95; marriage to Sancia of Aragon, 49–50, 59, 92–93, 94–96, 116, 138, 139–140, 218; mother of, 31; as Prince of Squillace, 49, 50; wealth of, 59

Borgia, Juan: birth of, 30; children of, 313; described, 96–97; as Duke of Gandía, 49–50, 85, 96, 105, 269–270; as head of papal armies, 97–98, 109–110; marries Maria Enriquez, 92; mother of, 105; murder of, 105–112, 118, 269–270; as Prince of Tricarico, 50; rivalry with Cesare Borgia, 96–97; Sancia of Aragon and, 109; wealth of, 59

Borgia, Juan, Cardinal, 144, 245

Index